ALEXAND.
teacher. Born in Dunfermline in 1943 he studied painting at Edinburgh College of Art. He was the Director of the New 57 Gallery in Edinburgh from 1968 to 1978.

He is an elected member of the Royal Scottish Academy and the current Chair of the RSA's exhibitions committee. He has painted portraits of many of Scotland's greatest writers, culminating in the iconic *Poets' Pub*, now hanging in the Scottish National Portrait Gallery.

ALAN RIACH is a poet and Professor of Scottish Literature at Glasgow University. Born in Airdrie in 1957, he studied at Cambridge and Glasgow then worked in New Zealand at the University of Waikato, from 1986 to 2000. He is the author of five books of poems: *This Folding Map, An Open Return, First & Last Songs, Clearances* and *Homecoming* and of critical books, including *Hugh MacDiarmid's Epic Poetry* and *Representing Scotland in Literature, Popular Culture and Iconography*. He is the President of the Association for Scottish Literary Studies and his radio series *The Good of the Arts* was first broadcast in New Zealand in 2001.

LINDA MacDONALD-LEWIS is a poet, historian and storyteller. She lives in Oregon, USA, and has dedicated herself to bringing Scottish culture to America.

... an important book that by its very existence and form makes the right kind of intervention at just the right moment... It is a further measure of how provocative and stimulating it is that one instinctively wants to join the argument, order another round and jab a nicotined finger in the virtual Milne's Moffat and Riach conjure up. There's much to learn from Arts of Resistance.

Brian Morton, SCOTTISH REVIEW OF BOOKS

... it contains some of the most striking images and famous portraits by Scottish artists over the last 150 years... a breathtaking collection.

THE SCOTSMAN

... punchy... memorable and stimulating...

THE SCOTS MAGAZINE

... a unique exploration of the importance of art and poetry in modern Scotland...

SCOTTISH ART NEWS

... unusual and fascinating...

SCOTTISH AFFAIRS

... enthusiastic... scholarly... with a winning mixture of lightly-worn but immense erudition and nuanced, never chauvinistically reductive intellectual ardour. This [is a] huge hearted, tough minded work of celebration and cerebration...

Donny O'Rourke, SCOTTISH LEFT REVIEW

... an inspiration, a revelation and education, as to the extraordinary richness and organic cohesion of 20th century Scottish culture... [Moffat and Riach] are full of passion and intelligence.

TIMES LITERARY SUPPLEMENT

Arts of Resistance

Poets, Portraits and Landscapes of Modern Scotland

Alexander Moffat and Alan Riach

with Linda MacDonald-Lewis

Luath Press Limited

EDINBURGH

www.luath.co.uk

for Marshall Walker

'a torchlight procession of one'

First published 2008
This edition 2009

ISBN: 978-1-906817-18-3

The publishers acknowledge the support of

towards the publication of this volume.

Printed and bound by Scotprint, Haddington

The paper used in this book is recyclable. It is made from low chlorine pulps produced in a low energy, low emission manner from renewable forests.

Typeset in 9.5 pt Quadraat by 3btype.com

Design by Tom Bee

Contents

Acknowledgements

We are immensely grateful to both Dr Duncan Thomson (former Keeper of The Scottish National Portrait Gallery) and Dr Joanna Soden, Collections Curator, The Royal Scottish Academy, for their expert help and advice in all matters relating to the reproduction of artists' work. We are also indebted to Janis Adams and Shona Corner of the National Galleries of Scotland for their kind assistance in supplying many of our most important images. We had valuable support from Susan Charlas, The Aperture Foundation, New York; Andrew Tullis, Copyright Manager, The Tate Gallery, London; Deborah Kell, RMJM, Glasgow; Peter Trowles, Mackintosh Curator, The Glasgow School of Art; and Mungo Campbell, Deputy Director, The Hunterian Art Gallery, University of Glasgow.

Our special thanks are reserved for Helen Monaghan, Talks and Events Programmer at the National Galleries of Scotland whose invitation to deliver a series of lectures entitled 'Poets, Portraits and Landscapes of Modern Scotland' led directly to the writing of our book; and to Linda MacDonald-Lewis for insisting we compile the book and not taking no for an answer.

Our warmest thanks go to all of the artists who have readily supplied images of their work and copyright permissions. We would also like to thank all of the copyright holders who have so generously supported this publication.

Jennie Renton took on the task of reading our early versions of the text and her recommendations proved invaluable. We are most grateful to her.

In addition we wish to express our gratitude to Tom Bee whose expertise in all aspects of book design brought a rare elegance to the finished product and to Senga Fairgrieve whose typesetting skills made it all possible. And, of course, all at Luath Press.

The book was completed thanks to a Sir William Gillies Bequest Award from the Royal Scottish Academy, and the generosity of the

Department of Scottish Literature and the Faculty of Arts at Glasgow University.

Our thanks are due to the authors, publishers and estates who have generously given permission to reproduce poems:

Robert Garioch, 'The Puir Faimly', 'Letter from Italy', 'Elegy', 'At Robert Fergusson's Grave (October 1962)', 'After a Temperance Burns Supper' from *Collected Poems* (Polygon, 2004), Liz Lochhead, 'Something I'm Not' from *Dreaming Frankenstein and Collected Poems* (Polygon, 2004), Norman MacCaig, 'Five Minutes at the Window', 'Toad', '19th Floor Nightmare', 'New York' from *The Poems of Norman MacCaig* (Polygon, 2005) all reproduced courtesy of Polygon, an imprint of Birlinn Ltd, www.birlinn.co.uk; Sydney Goodsir Smith, 'There is a Tide' reproduced courtesy of Calder Publications Ltd.; Iain Crichton Smith, 'Poem of Lewis' from *Collected Poems* (Carcanet, 1992), Hugh MacDiarmid, 'You Know Not Who I Am' from *Selected Poems* (Carcanet, 2002), Edwin Morgan, 'Joan Eardley', 'A Little Catechism from the Demon', 'Siesta of a Hungarian Snake' and 'Message Clear' from *Collected Poems* (Carcanet, 1996) all reproduced courtesy of Carcanet Press Ltd; W.S. Graham, 'Loch Thom' from *New Collected Poems* (Faber, 2005) reproduced courtesy of Michael and Margaret Snow; George Mackay Brown, 'Afternoon Tea' and 'Hamnavoe Market' reproduced courtesy of Archie Bevan.

Every effort has been made to trace the copyright holders of poets and artists published in this book. If any material has been included without the appropriate acknowledgement, the publishers would be glad to correct this in future editions.

Introduction

All art is a long conversation, usually with the dead. But it is a living dialogue. This book is a series of conversations between an artist and a poet. It developed from a series of lectures we gave at the National Galleries of Scotland, presentations and discussions of modern Scottish art and poetry.

All art, whether poetry, painting or prose, represents and interprets the world. It resists the numbing of the senses, it helps us to live more fully, engaged with the world and critical of it. *Arts of Resistance* is about the work the arts do, particularly the arts of Scotland through the 20th century, in resisting all the efforts to confine and limit our creative potential in an age of distraction.

No national literature is more connected to particular locations than Scottish literature, and the 20th-century poets of Scotland have specific associations with geographical areas from which they derived great strengths and virtues. Hugh MacDiarmid, both from his native Border landscapes and from the Shetland islands where he lived in the 1930s; Sorley MacLean, from the small island of Raasay and its neighbouring Skye; Norman MacCaig, both from Edinburgh where he lived and worked as a teacher and from the north-west of Scotland, around Assynt and Lochinver, where he spent many summers; George Mackay Brown from Orkney; Edwin Morgan from Glasgow; Robert Garioch and Sydney Goodsir Smith from Edinburgh; Iain Crichton Smith from Lewis – all the poets discussed in this book drew from their hinterland of different geographies, different imaginative landscapes, seascapes, cityscapes. The geography of the imagination is what we set ourselves to chart. So our book is an exploration and evocation of these different parts of Scotland, their enduring and reliable shapeliness and strengths, their swiftly changing aspects through a century most typified by rapid alterations and speedy movement. Beauty is in the eye of the beholder, but perspectives change in time and depend on where you are and how fast you're moving. Our poets and artists are

our best guides to how the world can be seen and understood, how the challenges of modernity can be addressed and how we can make the best of our lives. Their work is to help us to live.

And yet, our education system in Scotland has for many generations failed to introduce our young people to the great artists and poets of our country, people who have painted and written in our own languages, about our own earth.

We are committed to an openness of mind and the capacity for self-extension to which human nature is healthily prone. We would always encourage people to look further – to read Rabelais, Flaubert, Dante, as well as Melville and Shakespeare, George Eliot and Emily Dickinson, to study the work of Picasso, Munch, Jack Yeats, Turner, to listen to Sibelius, Richard Strauss, Mahler. But we should never neglect or scorn the work of our own people. Everyone in Scotland should be able to express the informed opinion that Raeburn, Wilkie, the Colourists, Johnstone, Gillies, Eardley are great artists, that Carver, McEwen, Chisholm and Scott are great composers and that Henryson, Dunbar, Burns and MacDiarmid are great poets. They should be able to express why and what is great about their work, the pleasures it gives, the knowledge it brings, the help it offers to the lives we lead. Until all the schools in Scotland are fully enabled to provide this knowledge, confidence and enjoyment, until every university in Scotland has an established Chair of Scottish Literature and an established Chair of Scottish Music, until every Art History Department and every School of Art pays full attention to the whole inherited file of Scottish cultural production, people will continue to suffer the deprivations of dullness and ignorance to which we have become so long inured. If more people understood how great the artists, composers and writers of Scotland are, what a difference that would make to their self-confidence. This book, we hope, in however modest a fashion, will help redress this wrong.

When we had finished our lecture series – the audience gradually grew in number and was generously appreciative of our rather modest and anecdotal method, nothing too stentorian and no jargon – we were approached by an American woman who told us there was a book to be made of this. Nothing like it exists, she said – a study of modern Scottish art and poetry that would bring together the works themselves, paintings and poems, but also link them with the lives the artists and poets lived, who they knew and loved, where they lived, how their lives were intertwined, the century and the Scotland they lived through, what sense they made of it. The problem, however, was that our lectures were unscripted. We were talking freely, ranging widely, drawing simply from our own knowledge and friendships with the artists and poets we were talking about. Linda MacDonald-Lewis was insistent, however. Whether or not we had written notes, we could still find a way of reproducing and extending the lectures for a book, perhaps through recorded conversations based on her notes and recordings of the lectures. We thought this was worth trying, so Linda is present in these conversations as a prompt and leader of the discussions, bringing us back to our focus and dedicated topics whenever we are in danger of straying too far from what we'd promised to talk about.

You might imagine three people: Alexander Moffat, Alan Riach and Linda MacDonald-Lewis, sitting around an oval table in Riach's office in the Department of Scottish Literature at Glasgow University with a tape-recorder running as they follow through three conversations, each one based on the three lectures delivered at the National Galleries of Scotland a few months previously. The office is walled by books on three sides; on the fourth, a big window overlooks the trees in University Avenue. Whenever the moment requires a reference, a book can be taken down from one of the shelves, or a newspaper cutting brought from a box-file, or a magazine searched

for a relevant article. This is picturesque, and close enough to actuality to be fair, although the book is much more a literary reconstruction than a series of recorded conversations.

While the book is based on our lectures, we have also taken the opportunity to extend and elaborate from them to consider the whole story more fully. So the 'conversations' you're about to read are really a literary creation – 'dialogues' might be a better term – and their spontaneity records our considered thinking about the subjects as well as immediate anecdotes and off-the-cuff remarks. The words of this book come from conversations we actually had, but they've been complemented by things we thought appropriate after further consideration. As a literary form, dialogue is a neglected genre, although there is the recent inspiring example of *Parallels and Paradoxes: Explorations in Music and Society* by Daniel Barenboim and Edward Said. We hope the form we've practised in this book is attractive and engaging – certainly it has the virtue of immediacy and absolutely rejects exclusively specialist vocabularies; maybe you'll feel like joining in the discussion, disagreeing with us. That would be to the good, of course, but we also hope there are some things we can agree on, ground rules that offer foundations for friendship. All art works to sensitise the world. It's always better to talk, write, draw, paint, to create the opening for dialogue, than be forced to the resort of violence – physical or linguistic. We hope that, in a world so badly given to violence in its various forms, the dialogue that sustains this book is a different example.

We open our conversation with the end of the 19th century, the beginning of Modernism and the role of art in the modern world. Above all, from the 1920s on, Hugh MacDiarmid is acknowledged as the pioneer and driving force of the Scottish Literary Renaissance, leading to a renewal of understanding and revaluation of all the arts in modern Scotland. To our eyes, his vision, so hard-earned, has borne unquantified fruit in the late 20th and early 21st centuries.

MacDiarmid lived a long life – from 1892 to 1978. He literally came out of the 19th century. He was born in the decade of the Battle of Wounded Knee and he died in the nuclear era, when a small country like New Zealand could reject the technology of nuclear weapons and nuclear power, by virtue of its own statehood and self-determination, offering another different example. MacDiarmid's life runs through two world wars and the rise of mass-media and globalisation. He joined the British Army for the First World War, thinking, he said, like thousands of other young men, 'Here comes Armageddon, let's join the party!' Yet when he heard of the Easter Rising in 1916 in Ireland, he said that if it had been possible he would have deserted the British Army and joined the Irish fighting British Imperialism. He was at the epicentre of Scottish artistic, literary and intellectual life in the 1920s, but was in virtual exile and isolation in the Shetland islands in the 1930s, writing some of the most profoundly enquiring poems of the century, counting the cost, asking deep questions about what life is worth and how much it has been wasted. And in the 1940s, 1950s and later, he was still producing great, epic poems, finding ways to celebrate the languages of the world, the ways people speak, live and all the different cultures we produce in all the different places of the earth.

The foundation of his praise is the nation: the idea that national self-determination can fuse and ignite art, safeguard its provision, be the ground from which self-knowledge, love of others and the intrinsic optimism of curiosity, can grow. To be truly international, he would say, you have to be national to begin with. The ethos of his work provides the example by which all of us have found benefit: to see Scotland in its entirety from the point of view of Scotland, and not from the Anglocentric or Anglo-American perspective that

dominated broadcasting media and cultural analysis for most of the 20th century.

MacDiarmid's presence and example informed, abraded, catalysed and spurred his contemporaries. The poets we go on to discuss were all, in varying degrees, friendly with him.

The second part of this book considers the poets of the Highlands and Islands and the third part looks at poets of the city. To some extent, there is an arbitrary allocation of Norman MacCaig to this section, for he is better known as a poet of the natural world of the Highlands, writing about toads, frogs, basking sharks, lochs and mountains. But when he calls a thorn bush 'an encyclopedia of angles', a country-bred wiliness is blended with a city-sophistication. His finely-modulated voice, his careful use of tone and register, are among the steeliest instruments on the tray. MacCaig's Edinburgh is as vivid as his vision of Highland landscapes and people. The ambivalence of his comprehension, accommodating both country and city, indicates an essential aspect of modern Scotland's story.

The 19th century began with most of Scotland's population living in the country. It ended with most of us living in cities, especially in industrialised Glasgow. So while most of our poets come from rural locations – Langholm, Stromness, Stornoway, Skye – relatively few, pre-eminently Edwin Morgan, are completely urbanised. Perhaps this suggests one way in which Morgan has been lastingly and widely influential on the younger generation of poets emerging in the 1980s and 1990s. In 2008, at the age of 88, Morgan is the last survivor of that great generation and the first National Poet of Scotland, appointed on 16 February 2004 by the First Minister of the newly-resumed Scottish Parliament. But we wanted to look at the whole generation of poets in that marvellous constellation of which Morgan was one, and to consider their strengths and qualities singly and in context.

We would like to acknowledge a crucial precedent for this approach, the seminal work of 1980, the landmark *Seven Poets* exhibition and book collated by Christopher Carrell of what was then the Third Eye Centre in Glasgow's Sauchiehall Street, one of the truly vibrant and exciting arts venues of post-war Scotland, opening in 1975 and thriving through the 1980s. The legacy of that exhibition is a terrifically valuable book, bringing together Alexander Moffat's portraits, photographs of the poets by Jessie Ann Matthew, essays about them by Neal Ascherson and interviews with them conducted by Marshall Walker, as well as a sampling of their poems. We are happy to note here our thanks for the example of that book and exhibition. But we wanted to do more. We wanted to locate the poets in a broader context, relating them to the artists – mainly painters but also some architects, composers, photographers and social visionaries – who were their contemporaries. So the 'arts' in our title encompass a whole range of different activities.

The artist closest to MacDiarmid throughout his long life was his fellow-Borderer William Johnstone and there could be no doubt that MacDiarmid's views on the visual arts were often influenced by Johnstone. MacDiarmid also collaborated with William McCance and J.D. Fergusson though his friendship and admiration for W.G. Gillies appears to have gone unnoticed by the art world and unmentioned by literary critics. Gillies, seriously underestimated at the present time, is in many ways MacDiarmid's equivalent: his interpretations of both the Highlands and Lowlands, in thousands of drawings, watercolours and oil paintings, give us a new way of seeing our country, making us more aware of, and so enriching, the life around us. The Colourists, Fergusson, Peploe, Cadell and Hunter, have also been misrepresented in recent years, perhaps because of their success in the auction houses, and the rising prices their paintings now command. This popularity has obscured understanding of the

radical nature of their early works. By stressing light and colour as essential, they swept away centuries of Presbyterian gloom. By linking with France rather than London, they set Scottish art on an independent path. In the early 1980s, a group of young Glasgow painters, most notably Stephen Campbell and Ken Currie, seemed to stumble across MacDiarmid's call to arms and began to re-imagine Scotland afresh in their epic pictures. Campbell addresses the MacDiarmid of the *Drunk Man*, with his psychological exploration of the self, while Currie stresses the political, communist vision in his historical narratives. The arrival of Paul Strand and Josef Herman in the Hebrides in the late 1940s and early 1950s – at precisely the time when Sorley MacLean was beginning to publish his poetry – is also something which deserves appraisal in the light of the cultural revival taking place in the Highlands which is much more visible in the 21st century. In this context, we see William McTaggart as a proto-modern artist, with profound things to say about his own people, their land and their lives.

The book begins with the visionaries of architecture and town-planning, Charles Rennie Mackintosh and Patrick Geddes, and the idea that their work sets the precedent for an internationalist *and* a distinctively Scottish identity. Geddes founding the Scottish College in Montpellier and Mackintosh being lionised in Berlin and Vienna in the early 20th century are part of an international story that is too often neglected. That international context begins the trajectory of our conversations, which run through to the 1960s, when Alexander Moffat and John Bellany, as students, first met MacDiarmid, and to the 1970s, when Alan Riach also met him. As we've noted, MacDiarmid's example and influence crosses to the young Glasgow painters of the 1980s, and remains a potent force in the 21st century. As one Whitehall censor, intercepting MacDiarmid's letters from Shetland in the 1930s, put it, 'The man is a menace!'

We've been selective and no doubt critics will pounce on our omissions. Why are there so few women? What about W.S. Graham and other poets and artists who lived mainly outside of Scotland? Well, one answer is that not all our omissions are due to neglect, and we don't regret all of them either. The main focus of our dialogues is poetry and painting but we have allowed ourselves to discuss a number of questions about music, sculpture and architecture. There are a small number of references to photography, but for a full discussion of Scottish photography, we would recommend Tom Normand's *Scottish Photography: A History*.

Some difficult questions are raised in the course of these conversations. There are some questions and sometimes hard answers that the strictures of political correctness inhibit. We've tried to resist such inhibitions and face up to the questions. So we hope that *Arts of Resistance* carries further the perceptions and pleasures afforded in *Seven Poets*, and carries them on, to another generation of people to whom it might all still be new. For beyond all the individual arts we're discussing, it's the people they're for that matter in the end.

Alexander Moffat, Edinburgh
Alan Riach, Glasgow
November 2008

List of Illustrations

Part Two: Poets of the Highlands and Islands

3.6 James MacIntosh Patrick
 1907–98
 *The Tay Bridge from My Studio
 Window* 1948
 76.2 × 101.6 cm
 McManus Galleries and Museum,
 Dundee (© The artist's family)

3.7 Stewart Carmichael
 1867–1950
 Self–Portrait in the Artist's Studio
 1947
 51.1 × 61.2 cm
 McManus Galleries and Museum,
 Dundee

3.8 David Foggie 1878–1948
 The Young Miner 1926
 76.2 × 64 cm
 Royal Scottish Academy (© The
 Executor of the late Mrs M.A. Foggie)

3.9 James Pryde 1866–1941
 Lumber: A Silhouette 1921
 182.9 × 152.4 cm
 Scottish National Gallery of
 Modern Art

3.10 Alexander Moffat b.1943
 Muriel Spark 1984
 183 × 91.4 cm
 Scottish National Portrait Gallery
 (© The artist)

3.11 William Crozier b.1933
 Burning Field, Essex 1960
 91.4 × 76.2 cm
 Scottish National Gallery of
 Modern Art (© The artist)

3.12 Pittendrigh MacGillivray
 1856–1938
 The Byron Statue c.1913
 Aberdeen Grammar School

3.13 Alexander Moffat b.1943
 The Rock (The Radical Road),
 1989–90
 137 × 183 cm
 The Royal Scottish Academy
 (Diploma Collection) (© The artist)

3.14 Alexander Nasmyth
 1778–1840
 *Edinburgh from Princes Street
 with the commencement of the
 building of the Royal Institution*
 1825
 122.5 × 165.5 cm
 National Gallery of Scotland

3.15 James Craig 1744–95
 Edinburgh New Town Street Plan
 1767
 National Library of Scotland

3.16 Muirhead Bone 1876–1953
 *A Shipyard Scene with a Big
 Crane,* 1917
 46.5 × 36.4 cm
 Hunterian Art Gallery, University of
 Glasgow (© The Estate of Muirhead
 Bone) All rights reserved DACS
 2008

3.17 Ian Fleming 1906–94
 *Air-Raid Shelters in a Tenement
 Lane* 1942
 14.9 × 21.3 cm
 Hunterian Art Gallery, University of
 Glasgow (© The Fleming Family)

3.18 John Quinton Pringle
 1864–1925
 *Muslin Street, Bridgeton,
 Glasgow* 1895–6
 35.9 × 41.2 cm
 City Art Centre, Edinburgh

3.19 Alexander Moffat b.1943
 Berliners 2 1978
 119 × 188 cm
 Private Collection (© The artist)

3.20 Bet Low 1924–2007
 *Sauchiehall Street with Unity
 Theatre* 1947
 78 × 48 cm
 Scottish Theatre Archives, Glasgow
 University Library (reproduced by
 courtesy of the Trustees, Estate of
 Bet Low)

3.21 William Gillies 1898–1973
 Studio Window, Temple
 c.1970–73
 89.2 × 113.6 cm
 Royal Scottish Academy

3.22 Alexander Moffat b.1943
 Norman MacCaig 1968
 122 × 91.5 cm
 Scottish National Portrait Gallery
 (© The artist)

3.23 Michele Tripisciano
 1860–1913
 *Giuseppi Belli Monument,
 Rome* 1913
 Photograph Alexander Moffat

3.24 Walter Geikie 1745–1837
 *I Can Whistle Fine, Now,
 Grannie* 1831
 etching · 18 × 15.5 cm
 Royal Scottish Academy

3.25 Alexander Moffat b.1943
 Robert Garioch 1978
 175 × 113 cm
 Scottish National Portrait Gallery
 (© The artist)

3.26 Denis Peploe 1914–93
 Pote and Penter c.1946
 From Sydney Goodsir Smith,
 The Deevil's Waltz 1946
 (reproduced by courtesy of Guy
 Peploe, The Scottish Gallery)

3.27 Rendell Wells
 The Auk
 Frontispiece of Sydney Goodsir
 Smith's *Carotid Cornucopius.*
 M. MacDonald, Edinburgh 1964

3.28 Eduoardo Paolozzi 1924–2005
 *The Doors of the Hunterian Art
 Gallery* 1976–77
 360 × 410 cm
 Hunterian Art Gallery, University of
 Glasgow (© Trustees of the
 Paolozzi Foundation Licensed by
 DACS 2008)

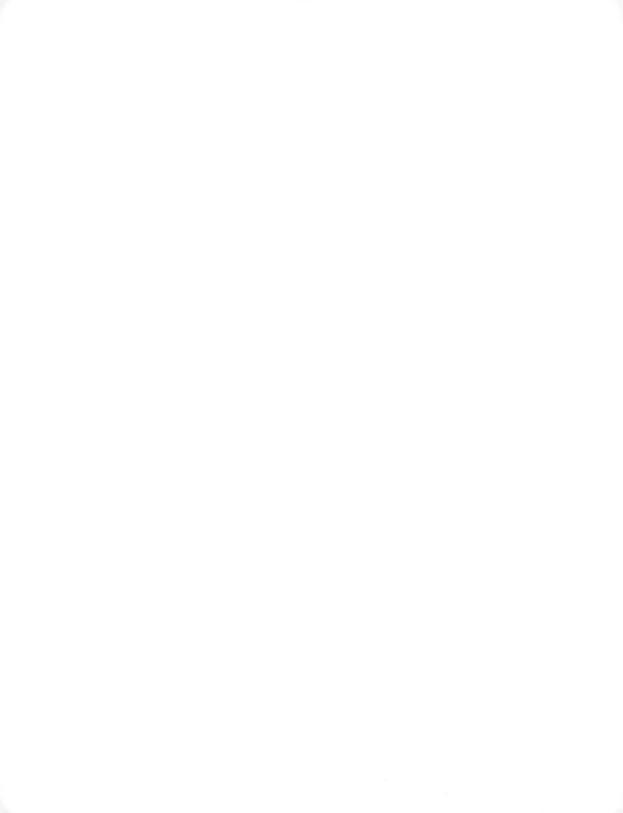

Part One

Hugh MacDiarmid and the Arts of Modern Scotland

Art, Poetry and Time

ALAN RIACH: Really, what we are talking about is time, and the way art intervenes in time and changes the past. So although the historians will look at events in the past and historicise them and contextualise them, and give them dates, and say 'this is what happened *then*' – what we're talking about is different.

SANDY MOFFAT: What we're talking about is the way works of art, poems, paintings, portraits, landscapes – works of art of any kind – intervene and have a permanent value, both in terms of what they're saying and continue to say. And also in the way they change the possibilities for what comes later, so younger artists and interested people can then have a different attitude to what has gone on in the past. When you look at Scottish painting, poetry and literature from the 19th century till now, look at the great writers, the great artists and their works, you can see that particular people make a major intervention in the story.

ALAN: When a radical break with the past happens, it cuts you off, and you can throw old things out, and it liberates you to establish new connections with the past. New perceptions of continuity become possible. You ask what's really valuable, what is it that we want, and what is it that we can't get...

SANDY: I think that's a good way of putting it. The best Scottish art has always got something to do with some kind of radicalism. It's also got to do with reaching out beyond the frontiers of Scotland.

ALAN: And that radicalism can take many forms. Not just the obvious, say, Burns's 'A man's a man for a' that' – put that alongside Scott. Unlike Burns, Scott was a middle-class aspirant to the aristocracy. But he was certainly a revolutionary writer in that he was the first to attempt to bring into literature a comprehensive image of Scotland. And whether that was subsequently exaggerated and distorted in

terms of kitsch and tartan later on is really not his fault, because what he actually did was to bring the Highlands and the Lowlands, and the whole complex question of what a Scottish identity might be, into focus. It's not uniform, you see. It's not a conformity. So his vision is radical in terms of its depth and scale and its sense of different identities and different languages coexisting in one nation, and in its engagement with the European concerns of his time.

That radicalism is there in Burns, it's there in Scott and in the 20th century, overwhelmingly, it's there in MacDiarmid. That's why we can truthfully call these writers 'great' – it's a question of magnitude.

SANDY: So what we're going to talk about is MacDiarmid, the artistic context of his origins in the 19th century and his explosive work after the First World War, and then we'll go on to talk about the later generation of poets and artists, after the Second World War.

The Manifesto of the Scottish Renaissance

LINDA: What was the Scottish renaissance movement of the 1920s really all about?

ALAN: There are two quotations from MacDiarmid which give a handle on this:

> A certain type of critic is apt to say that the movement so far has consisted only of propaganda – only 'of the posters' – that the actual work has still to be done. This is a mistake. The Scottish Renaissance has taken place. The fruits will appear in due course. Earlier or later – it does not alter the fact. For the Scottish Renaissance has been a propaganda of ideas and their enunciation has been all that was necessary.

MacDiarmid wrote that in December 1925. It's a wonderful thing. He's not talking about the achievement of a number of poems or a number of works of art. He's talking about new ideas. Let's make a complete break with the past and see what the future will bring. He spells it out:

> From the Renaissance point of view, it is utterly wrong to make the term 'Scottish' synonymous with any fixed literary forms or to attempt to confine it. The

Scottish Renaissance movement sets out to do all that it possibly can to increase the number of Scots who are vitally interested in literature and cultural issues; to counter the academic or merely professional tendencies which fossilise the intellectual interests of most well-educated people even; and, above all, to stimulate actual art-production to a maximum.

That's from February 1926. Imagine that you have a Minister for the Arts, in Scotland, now, whose sole directive was those three points:

1. Increase the number of Scots who are vitally interested in literature and cultural issues;
2. Counter the academic or merely professional tendencies which fossilise the intellectual interests even of well-educated people;
3. And, above all, stimulate actual art-production to a maximum.

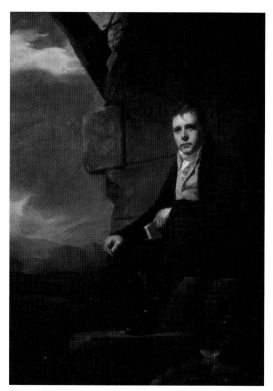

1.1 **Henry Raeburn 1756–1823** Walter Scott 1808

Go for it, get it done! That's all you need. You don't need thousands of pounds spent on cultural commissions to tell you that. And that's what we need right now, in Scotland, today. Yes, please, Minister.

SANDY: So MacDiarmid is saying that we want to find a continuity with what matters in that past. We want a complete break with the past if we have no use for it. We want to grasp the vitality of the Scots language – it's not just for jokes and eccentric behaviour and funny stuff. We've got to use it to deal with serious issues. English, of course, is a Scottish language. Its roots are intertwined with those of Scots but they developed differently. Gaelic needs to be part of the scenario too. The various, different voices that people have are all valid, and they need to be made valid in literature for literature to be vital.

ALAN: In an essay about growing up in Langholm, a wee village in the Borders at the confluence of three rivers where he was born, he says that at a certain point he decided he would be the great national poet of Scotland. Remember, his given name was Christopher Murray Grieve. He took the name Hugh MacDiarmid in 1922. Talking about his family, he said:

> As boys my brother and I wore the Graham tartan. Our mother was Elizabeth Graham. If my father's people were mill-workers in the little Borders burghs, my mother's people were agricultural workers. My alignment from as early as I can remember was almost wholly on the side of the industrial workers and not the rural people. I have never had anything but hatred and opposition for deproletarianising and back-to-the-land schemes; my faith has always been in the industrial workers and the growth of the third factor between man and nature – the machine.

SANDY: Well... That's the manifesto, isn't it?

ALAN: MacDiarmid once said that he thought one of the great pities about modern Scottish art was that so few modern Scottish artists issued manifestos. Painters or poets or other artists, write or paint or work at their art, with a purpose –

but wouldn't it be more fun, wouldn't it be more challenging and really curious in terms of the ideas they're dealing with, if they put it all down on paper and said, 'This is what we believe!' Artists always tell the same old story, they deal with the way things are, but what they say will be new to every new generation. And the technology does change. There are new ways of telling the story and there are new languages, new technologies to use. There's the balance between the world of nature and the world of technology that MacDiarmid saw in his childhood.

'But even as a boy,' he says, 'from the steadings and cottages of my mother's folk and their neighbours in Wauchope and Eskdalemuir and Middlebie and Dalbeattie and Tundergarth, I drew the assurance that I felt and understood the spirit of Scotland and the Scottish folk in no common measure, and that that made it possible that I would in due course become a great national poet of Scotland.'

SANDY: You have to take that with a pinch of salt.

ALAN: What he's actually saying is that on the one hand, there's the machine world, and on the other hand, there are the country folk, the rural folk, and he's in touch with them both. He might place his faith in the industrial workers, but he's actually in touch with the rural world as well. His family lives below the local library and with an appetite second to none, he reads as much as he can. On the other hand, he has these beautiful essays, affectionately describing himself going out to play as a child, in the honey-scented heather hills, the forests, and the rivers, around Langholm. So he was exploring intellectual ideas as well as experiencing the natural world around him.

SANDY: The two artists closest to MacDiarmid in their love for the Borders were William Gillies and William Johnstone. There's a hilarious account of MacDiarmid meeting William Gillies for the first time in the early 1960s, in a book called *Pilgrim Souls* by Mary MacIver:

Chris was coming home with us to spend the night for he was going on to Queen Margaret Drive, Glasgow, next day. We had a late meal and Hector had invited Bill Gillies in to meet him. At first, Bill, being a little straitlaced, was unwilling to come and Hector had practically to drag him in. But after he had settled down in the Boutique [the MacIvers' name for their sitting room], with his cigarette, and a brimming glass of whisky in his hand, he soon overcame his reluctance and joined in the conversation. He discovered that Chris, like himself had served in the Royal Army Medical Corps in the First World War, and realised that they must both have been working in Marseilles at the Hospital for shellshocked patients, about the same time. They all passed from that to talking about poetry and painting. Chris, I always liked, for he never sounded affectedly pretentious but always seemed to me to be stating simply what he honestly felt. At this particular time, he said unaffectedly, how much he liked Bill's landscapes in watercolour. They began to talk about various particular landscapes in the Borders, etc, that had moved both of them, one to paint, the other to write a poem...

ALAN: That's fascinating – I never knew MacDiarmid admired Gillies like that...

SANDY: Wait, though – there's more:

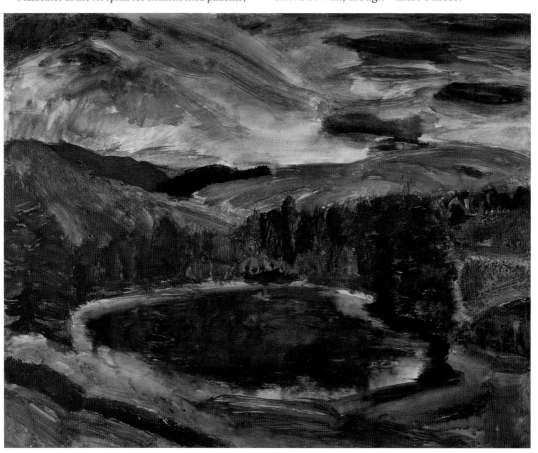

1.2 **William Gillies** 1898–1973 The Dark Pond c.1934

As time went on, however, even Bill, unusually for him, got very merry and, in the end, so abandoned did the three of them become that they decided to treat me to a display of a Highland Reel. Hector started to sing a 'puirt-a'-beul'; with the grace of elephants, the two white-haired men and the dark man pranced round my coffee-table. As Burns says: 'They reeled, they set, they crossed, they cleekit'. As the merriment grew louder, I don't know why nor could Bill remember either, next day, he suddenly took a comb out of his pocket and started to comb Chris's mane of hair down on his forehead, as he squared up to him. Thinking this apparently, was no less than a stroke of genius, the others whipped combs out of their breast pockets also, and for the rest of the dance, each and every one of them, combed the hair down on the forehead, of whoever happened to be prancing opposite to him. When the dance ended the panting heads resembled those of seals, the eyes peering forth from jungles of sweat-sodden, lank locks. After this, they seemed incapable, and this did not surprise me, of further effort and taking a loving farewell of each other, they staggered off to bed.

ALAN: The spirit of the Borders. You know MacDiarmid's little poem about his birthplace?

> I had the fortune to live as a boy
>
> In a world a' columbe and colour-de-roy,
>
> As gin I'd had Mars for the land o' my birth
>
> > Instead o' the earth.
>
> Nae maitter hoo faur I've travelled sinsyne,
>
> The cast o' Dumfriesshire's aye in me like wine;
>
> And my sangs are gleids o' the candent spirit
>
> > Its sons inherit.

There are three rivers that run through Langholm and he said that as a boy, he could tell them apart by their sound alone. That's a beautiful image. It makes me think of scented gardens for the blind... Anyway, you have these sounds, of the natural world, something he understood at a deep level. So his language, Scots, is spoken in

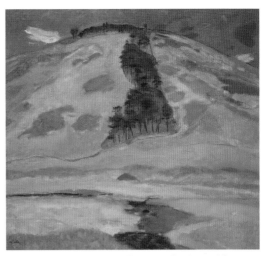

1.3 **William Gillies 1898–1973** Between Raeshaw and Carcant on Heriot Water c.1968

Langholm, and it's connected to the sound of the natural world around him, and the physicality of it, which impresses him profoundly. But that's not exclusive from the world of the machine. With his commitment to the modern age and the aggressively idealist politics of that era, he questioned what could be made of the machine, in terms of saving human labour, if it were used properly and not as exploitation. All of these things come into his thinking.

Correspondences in the Visual Arts

ALAN: When we're talking about correspondences we're also thinking of influences and it's best to be clear about this. People use the word influence without ever defining it and there's a very helpful little note by the American poet Louis Zukovsky that does this. He says basically that there are three kinds of influence.

One is *a presence in the air*, what you might call the *zeitgeist*, something almost inescapable that's social and cultural as well as consciously part of the artist's concern. In some way, you see this with the writers and artists and composers associated with

major movements such as Romanticism or Modernism, though there are exceptions, sometimes important ones like Thomas Mann or William Blake or Sibelius, who don't fit into the accepted ethos.

The second is *a coincidence of temperament*, two or three or more people writing or painting or working in a similar way but in different places and not in contact with each other. Examples might be Willam McTaggart (1835–1910) and French Impressionism – McTaggart never was part of the Impressionist group but he came to very similar conclusions about what painting could do, without knowing anything about them. You could say something similar about John Quinton Pringle (1864–1925) with reference to the theory of Pointilism. A different kind of example of a very real affinity would be MacDiarmid and the composer F.G. Scott (1880–1958), where the piano settings and the lyric poems are absolutely attuned to each other in temperament and illuminate each other but belong to different artistic genres, the literary and the musical.

The third is *a conscious choice or rejection of a tradition*. The most famous example might be T.S. Eliot, toppling Matthew Arnold and reinstating the metaphysical poets and the Jacobean dramatists to endorse his own position in a literary tradition. But MacDiarmid would be appropriate here too, rejecting the 'phoney' Scottishness of exaggeration and caricature and trying to re-establish a literary tradition that goes back well before Scott, before Burns, back to William Dunbar: an independent Scottish tradition. But MacDiarmid's push here is not only to clear a way of seeing that tradition but also to make that tradition available for others.

SANDY: There are variations of course. Picasso rejects Post-Impressionism to clear a way for his next move into Cubism, but then after the First World War, he goes back to a type of neoclassicism.

ALAN: Similarly with Stravinsky: you have the primal scream in *The Rite of Spring*, but then Stravinsky too returns to neoclassicism.

SANDY: You have followers who imitate Stravinsky and Picasso. And this, in turn, means that what was the avant-garde and the really revolutionary suddenly becomes an establishment of its own. If you don't fit in, you're anathema to their artistic authority, however unconventional that authority might have been a moment ago. So when Schoenberg, and then Boulez, became central authorities in musical culture, Shostakovich was out, irrelevant – let alone Richard Strauss or Sibelius or Benjamin Britten!

ALAN: It's very evident with Schoenberg: you had to follow his forms, write in the 12-tone scale. And in poetry, there's a whole anthology of poets who read Ezra Pound, thought that's how it's done, and tried to imitate it.

SANDY: But with MacDiarmid this doesn't happen. It's rather that he's opened the door, not only for himself but for others.

ALAN: Poets who do try to imitate him sometimes, like Alan Bold in his punchy, belligerent moods, actually write their best work when they're not in that imitative mode – I'm thinking of Bold's elegy for his father, a very moving poem that has its own emotional intimacy. And the major poets who are writing alongside MacDiarmid, MacCaig, MacLean, Mackay Brown and so on – none of them imitate MacDiarmid but they all seem to write in a constellation that has been brought into vision after MacDiarmid's work of the 1920s.

SANDY: MacDiarmid goes out with a scythe, clears the ground, and his own writing opens up all sorts of possibilities; whereas Pound, Eliot, Stravinsky and Schoenberg, all have a kind of righteousness about their own position and there's a dictatorial aspect to their aesthetic positions. MacDiarmid wasn't like that. George Davie used to insist that I should acknowledge this point: 'MacDiarmid *never*

had disciples,' George repeatedly told me. 'He *never* had disciples!'

ALAN: But in a sense, in the 1930s, George Davie, Sorley MacLean and the librarian Bill Aitken, W.R. Aitken, all visited MacDiarmid in the Shetlands and they were profoundly impressed not only by his poetry and his personal integrity and isolation, but also by the ideas he believed in. Were they not disciples, in a way?

SANDY: In a sense, perhaps, but think of Schoenberg, who insisted on disciples. Think of his attitude towards Webern and Berg. What does that tell us? The Viennese composer and conductor H.K. Gruber, who was a student in the early 1960s, said he 'felt terrorised by the Second Viennese School, especially Schoenberg, who was effectively saying to the world, "I have discovered a musical technique which enables us to dominate the world for the next 100 years." I thought, "Is that a goal for composers, to dominate countries?" What a fascistic idea for a Viennese composer whose name is Schoenberg and who was Jewish.' Now, MacDiarmid never insisted on disciples in that way.

ALAN: Maybe the single main inspiration for what MacDiarmid had in mind was Patrick Geddes (1854–1932). He really instigated the Scottish Renaissance – his comprehensive vision sparked off MacDiarmid's 'worldview' and his appetite for inter-disciplinarity – joining the dots. MacDiarmid certainly acknowledged Geddes. They met in Edinburgh in 1922. In 1891, Geddes was the first person to use the phrase 'Scottish Renascence' (and he used that spelling), heralding a new, comprehensive vision on the horizon.

SANDY: Geddes wasn't an artist himself but he was closely involved with the likes of Phoebe Anna Traquair (1852–1936) – whose remarkable murals for the Catholic Apostolic church suggest a combination of Fra Angelico and William Blake; they remain a unique achievement in the field of large-scale wall painting in Scotland; and with

1.4 Desmond Chute 1895–1962 Patrick Geddes 1930

Pittendrigh MacGillivray (1856–1938), the sculptor and poet whose public commissions are considerable works of art. They were hailed as such by MacDiarmid in 1923, in *The Scottish Nation*. MacGillivray also wrote poetry in Scots, again, much admired by MacDiarmid.

ALAN: Geddes was a botanist, sociologist and town planner who envisioned Scotland restored to 'something of the older pre-eminence in the world of thought' and Edinburgh recreated as an active centre. He thought that this would help resist the dominant centralising power of London. He wanted to replace the stereotyped methods of education by 'a more vital and synthetic form and to encourage national art and literature.'

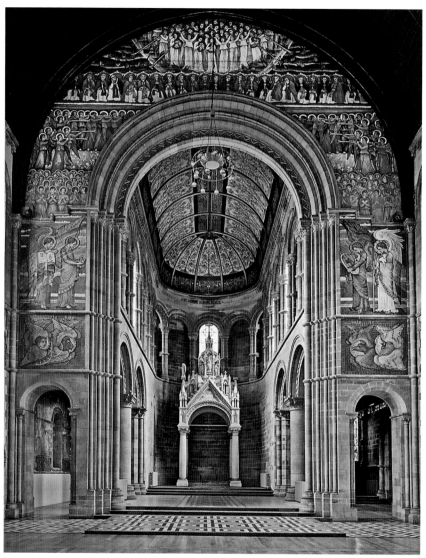

1.5 Phoebe Anna Traquair 1852–1936 The Chancel Arch: Catholic Apostolic Church, Edinburgh 1893–95

SANDY: One can imagine all of this having a profound effect on the young MacDiarmid, who described Geddes as a 'Scottish Patriot' and 'a prophet unsung in his homeland'. Geddes's interests and work took him all over the world and after a period in India, he settled in France, where he established a Collège des Ecossais, the Scots College, at Montpellier which he hoped would become an international centre for the study of human ecology and the examination of social, cultural and environmental issues.

ALAN: You have to think of these people as part of another kind of constellation: Geddes and MacGillivray. MacGillivray was contemporary with Rodin and again, it's an affinity, as though his brilliance as a sculptor of figures – Burns and Byron, literary and cultural figures, just as Rodin sculpts Balzac or Mahler – is technically evolving at the same time as Rodin, but without literal correspondence. Certainly MacGillivray came to know Rodin's work and he recognised him, as the only sculptor he knew of 'who worked or created from within rather than from without'. But he denied that he was ever a 'follower' of Rodin and insisted that his own technique in clay was worked out in the 1870s, long before Rodin was heard of in Scotland. MacGillivray was also the editor of *The Pictish Review*, to which MacDiarmid contributed under more than one byline, a rather eccentric but passionate periodical about the cultural variety of Scotland and the need for a revival of Scotland's ancient languages, pre-eminently Gaelic. Yet if he was looking to the ancient past, he was also addressing the contemporary scene. There's a tremendous pathos in his memorial sculpture of the First World War, *The Wife of Flanders*.

SANDY: And of course in that constellation was their now world-famous contemporary, Charles Rennie Mackintosh (1868–1928).

LINDA: What makes Mackintosh so special and where do his ideas come from?

SANDY: We know that he wanted to build with 'native' Scottish traditions in mind. Of his work, he said that he wanted to ensure 'that it is an architectural style of the modern as distinguished from the ancient world. That it is pre-eminently the architecture of our own forefathers and of our own land.' That's what he says in a lecture of 1891.

Mackintosh was recognized as a pioneer of the modern movement and his inclusion in the Secession exhibition in Vienna in 1900 signalled his importance in Germany and Central Europe.

His masterwork is the Glasgow Art School building – completed in 1909, but ignored in professional journals till 1924. No published plan of the building appeared till 1950. That's a staggering chronology. We should come back to that in regard to the reception of other artists and art works in Scotland during the 20th century.

ALAN: Mackintosh is probably now the most famous Scottish artist of this era and it's easy to forget that this was not always so. He was certainly a visionary. An artist-architect who believed in *gesamtkunstwerk* – the total work of art: he was designing everything from the shape of the building to the numberplate on the door... But he went into eclipse as an influence. That chronology of achievement and then the lack of available information about his buildings, in terms of public

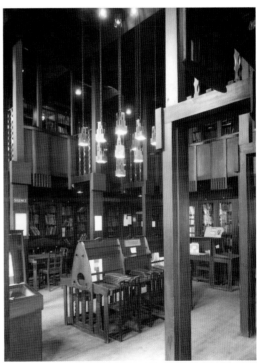

1.6 Charles Rennie Mackintosh 1868–1928 Glasgow School of Art, Library Interior 1909

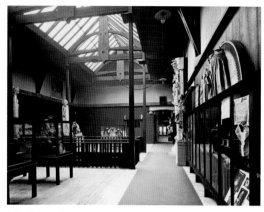

1.7 Charles Rennie Mackintosh 1868–1928 Glasgow School of Art, Museum 1898

understanding, has parallels with MacDiarmid writing the lyrics and *A Drunk Man Looks at the Thistle* in the 1920s and *In Memoriam James Joyce* in 1955, but there being no *Collected Poems* until 1962 and no *Complete Poems* appearing until the year of his death. He saw the proofs before he died. But even then, even at 1,400 pages, they're not complete.

SANDY: Mackintosh was an artist-architect, like Van de Velde, Le Corbusier or Mies van der Rohe. His genius was revealed in his all-encompassing approach to design, architecture and painting. As James McCauley points out: 'the library of the Glasgow School of Art is not only an aesthetic experience, but the translation of philosophical thought into three dimensions...given the poetry of the art school, the glittering façade of the library windows, the mystery of its internal life, the command of spatial complexities, the union of simplicity and sophistication, one has a poetic masterpiece which appeals to the chords of the human spirit. On a practical level too, the building appeals.' Even so, Mackintosh does not prosper in Glasgow and like Geddes, ends up in the South of France. Few younger architects in the 1920s and 1930s are inspired or influenced by his example. Paradoxically, since his rediscovery over the past

forty years or so (beginning with the Edinburgh Festival exhibition of 1968), his work – or certain aspects of it – has been appropriated and pastiched all over Glasgow.

There is one notable exception, a work of homage rather than pastiche, that of the Scottish Parliament building and its architect, Enric Miralles. That such a distinguished and successful Catalan architect, operating a global practice, counted Mackintosh as a major influence, is food for thought.

How is the past to be used? And ideas about history, how might they be used in the future? Many great artists have clearly been influenced by the past but it is a key element in the modern movement in Scotland that to be truly 'modern' you had to re-connect with the nation's past, to find a way forward...

ALAN: And the GSA is now regarded as one of the great iconic buildings of early Modernism, with architecture students and all sorts of other people from all over the world arriving almost every day of the week to study it and photograph it and draw it, so that Mackintosh is now lionised as a major but isolated figure. Yet the influence of traditional Scottish architecture on Mackintosh is undeniable. He actively sought out native traditions that could be used in a new context, in a new way...

SANDY: The fact that he was methodical in his search for this link connects him with Geddes, MacGillivray and in fact, with MacDiarmid. They were all conscious as to how the past could be used, how historical precedents might be used in a modern way, how they might make use of the links between new ideas and native traditions...

ALAN: And that's what Miralles's Scottish Parliament building is really grounded upon, isn't it?

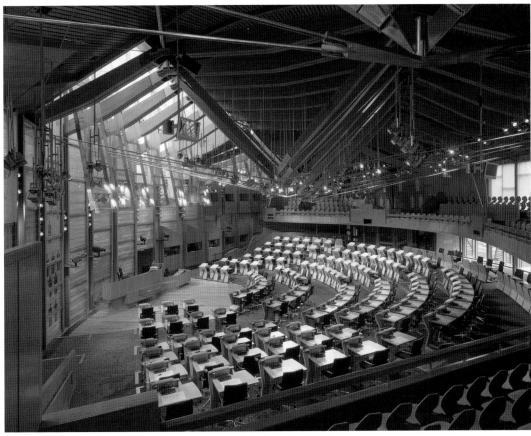

1.8 Enric Miralles 1955–2000 Debating Chamber, the Scottish Parliament 1999–2004

The Scottish Modernists

SANDY: Let's turn our attention to what was happening in painting, which in the early years of the 20th century was a battleground for new ideas. At the centre stood Paris, where every ambitious young artist wanted to be. There was the Spanish Picasso, the Russian Chagall, the Mexican Rivera, the Dutch Van Dongen, the Romanian Brancusi, the Italian Modigliani – and the Scots J.D. Fergusson (1874–1961) and S.J. Peploe (1871–1935). The Scottish Colourists have become so popular that their initial radicalism has been forgotten. Their desire to connect with the advanced painting in France in order to re-vitalise Scottish art was of the greatest significance. Just try to imagine the last hundred years without their intervention. Another of the Colourists, Leslie Hunter (1879–1931), records in a notebook of 1914 the colours used on the palettes of Van Gogh, Gauguin, Cézanne, Whistler – and, interestingly, William McTaggart. This emphasis on the liberating role of colour helps to define most of the developments in Scottish painting in the 20th century. Looking critically at the Colourists, we might say they embraced Post-Impressionism, to which they added something from Cézanne and

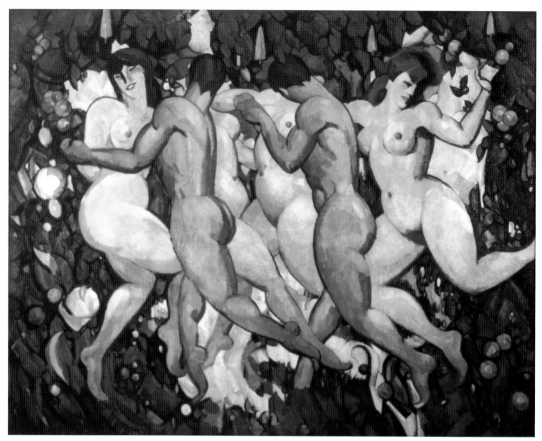

1.9 J.D. Fergusson 1874–1961 Les Eus c.1911–12

even a little bit of Cubism. Peploe and Fergusson attended performances of the Ballet Russes and this comes through in some of Fergusson's paintings, particularly *Les Eus* – a Scottish *Rite of Spring* or *Demoiselles d'Avignon*.

But there is a feeling that they ultimately pull back from the radical implications of their time in Paris. No one in the visual arts comes close to MacDiarmid's fearless risk-taking, both in terms of formal experimentation and challenging subject matter.

ALAN: I guess there was an undeniable sensual motivation in the work of the Colourists – but this is not a matter of mere hedonism or self-serving pleasures but was actually an immersion in the life, light and colour of the places and the people of these places. There's a wonderful comment about this by Margaret Morris in her biography of J.D. Fergusson:

> One year we went together to Islay. In others it was to Etaples, Paris-Plage, Dunkirk, Berneval, Dieppe, Etretat and Le Treport – all happy painting holidays. We worked all day, drawing and painting everything. And we thoroughly enjoyed the food and wine. We agreed on the importance of good food and drink, not fantastic food, but good peasant food in France and good Scots food in Scotland – what's better than good steaks and good Burgundy, good beef and good

1.10 S.J. Peploe 1871–1935 Ben More from Iona 1925

beer? We enjoyed and took time over our meals – time to eat and talk and draw the things on the table. SJ [Peploe] loved a book about food I had lent him, *Cakes and Ale*, by Nathaniel Gubbins, (how he would have loved that wonderful book, *The Scots Kitchen*, by Marian McNeill). We got a taste for French food and wine and we found a different way of living. We were always glad to get back to it.

LINDA: Fabulous!

SANDY: That's a total rejection of pious Presbyterian frugality of temperament. The point is, though, that Scotland was in desperate need of both the sensuality *and* the intellectual apprehension, both the qualities of mind of Geddes and

Mackintosh and the sensual art of the Colourists. MacDiarmid picks up both of these aspects...

LINDA: Do these qualities persist through the 20th century?

SANDY: They do. Indeed, you can trace that tradition coming from the Colourists to Glasgow. By choosing to take their coordinates from France, the Colourists set a precedent for bypassing London and London fashions altogether. Their influence runs through the work of David Donaldson, John Cunningham and James Robertson, all three of whom made a tremendous contribution to the life of Glasgow School of Art.

1.11 James D. Robertson *b.***1931** Shallows 2008

ALAN: They were all experiencing this world of the senses in Scotland. They shared an appetite for the good things in life and that marvellous sensuality and savour permeates their paintings of landscapes and still life compositions. Just as the Colourists had done, they soaked up all this light and boldness along with an immense subtlety and

1.12 John Cunningham 1926–98 Raised Beaches, Colonsay
*c.*1975

certainty of balance and sharpness of eye.

SANDY: John Cunningham favoured the west coast, especially Ardnamurchan. No matter how bold and assertive his painting was, it was always open and receptive to the information given to him by that experience of those places and the people who lived there. There's an honesty about his approach. And that's another aspect of the work of these artists. Not in any party-political sense but in a specifically immediate way, Donaldson and Robertson and Cunningham were pursuing their own distinctive vision of Scotland.

ALAN: That's a crucial factor, the question of national self-possession. Maybe the one key literary figure who should be thought of as a precedent from the 1890s and pointing towards the early 20th century, who could be seen in that group with Geddes, Mackintosh, the Glasgow Boys and the Colourists, is Robert Louis Stevenson (1850–1894). Stevenson is Scottish to the bone, but he's also an international traveller, first, to France, so there's sensuality and cultural relativism right there; then, to America and right across the continent, so there's a sense of global scale; and finally, into the Pacific, to Samoa, where he experiences at first hand what you might call cultural anthropology and the relativity of histories. All these things come into his understanding. And as all this is happening, there is a deepening sense of Scotland as a national identity worth affirming. You remember that letter he wrote to the popular 'kailyard' writer S.R. Crockett? He's writing from America, Saranac Lake, Spring 1888. This is the final paragraph he added after he had signed the letter:

> Don't put 'NB' in your paper: put *Scotland*, and be done with it. Alas, that I should be thus stabbed in the home of my friends! The name of my native land is not *North Britain*, whatever may be the name of yours.

Crockett was a Free Kirk minister at Penicuik and Stevenson was writing to him from New York State, asserting a distinctive Scottish identity in an international context; and his own work was exploring

psychological and cultural relativities, prefiguring Modernism and key aspects of the modern movement. I think that *The Strange Case of Dr Jekyll and Mr Hyde* will probably come to be seen as the most crucial proto-text for the 21st century, just as *Heart of Darkness* and *The Picture of Dorian Gray* were a prefiguration of so much that Modernism and 20th-century literature came to be concerned with. The main themes of the story are also explored deeply in *The Master of Ballantrae*, *Kidnapped* and *Catriona* – all of these novels explore the relativity of perspective in modern society, an essential theme in international Modernism. Stevenson is doing this within a Scottish frame of reference. But in *Jekyll and Hyde*, he envisages what happens when a wanton, childish appetite is energised by adult power, and violence follows. The book shows what happens when you separate adult reason and childish lusts. Isn't that a model of contemporary western society?

SANDY: So far the artists and writers we've talked about are all men, apart from Phoebe Anna Traquair. We might think about this for a moment, if we move on 20 years or so to 1913 and look at Stanley Cursiter's painting of crossing Princes Street in Edinburgh.

ALAN: The key things are the movement, the velocity, and the speed of the whole place. Time is there with the clock; and, in a way, the painting is about what the experience of the modern does to time. The painting is about the perception of what the rhythm of human life is, or what the rhythm of a community might be in such a place as this city crossroads. The eye of the woman is there, centrally vivid, and the fact that she is a woman is very important too, when you think of the role of women in the modern movement – Joyce writing about Molly Bloom, sexuality as the main theme in D.H. Lawrence, MacDiarmid's exploration of sexual identity, or Lewis Grassic Gibbon (James Leslie Mitchell, 1901–1935), putting women at the centre of his novels – Chris Guthrie, pre-eminently at the centre of the *Scots Quair* trilogy, but also Thea Mayven in his first novel, *Stained Radiance*, or Gay Hunter in his science fiction novel of that name, or Rachel Gault, Mistress Menzies and Ellen Simpson in the great short stories, 'Clay', 'Smeddum' and 'Greenden'. The experiences of women are rising to take a central position, even in writing by men, in the modern movement. But look at that woman's eye in Cursiter's painting: how does she feel? And what about women writing or painting at this time? How did they feel?

SANDY: In Scotland, the odds were stacked against them. They were disenfranchised. In art schools, there was little or no encouragement for women to pursue careers as professional artists. Think of Anne Redpath, Joan Eardley – they really had to struggle to achieve what they did. It was very, very difficult for them and there's no question that female students were discriminated against at that time – there was a kind of misogyny in operation – not quite on the scale one finds even today in eastern Europe, especially Russia, but it did exist, right up at least until the 1970s. Things have changed for the better, quite dramatically, and now many of Scotland's leading artists are women. There's a long list, including Barbara Rae, Joyce Cairns, Sam Ainsley, Gwen Hardie, Alison Watt, Margaret Hunter, Christine Borland, Moyna Flannigan and many others, all currently pursuing successful international careers.

ALAN: That's a very significant development. And in writing, similarly, the most important breakthrough doesn't arrive till the 1970s with Liz Lochhead. There are exceptions to the rule of course. Violet Jacob and Marion Angus were important poets whose work MacDiarmid built on. And there are important novelists – Catherine Carswell, Nan Shepherd, Willa Muir, and the playwright Ena Lamont Stewart and others – but the rule pertains.

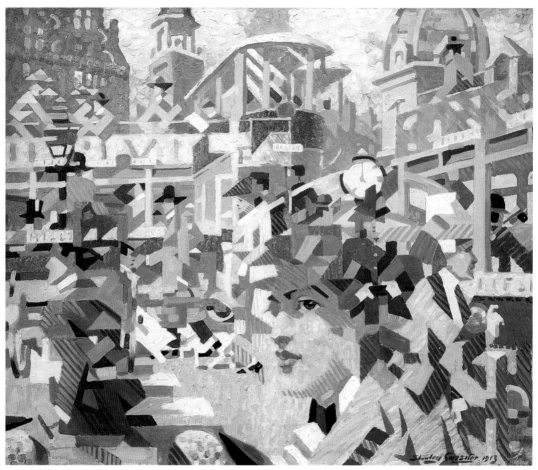

1.13 Stanley Cursiter 1887–1976 The Sensation of Crossing the Street, West End Edinburgh 1913

It's only relatively recently that scholarship has recovered these writers from obscurity and neglect.

LINDA: Where did MacDiarmid stand on these issues?

ALAN: Apart from writing the poetry itself, MacDiarmid did two other things of vital importance in the 1920s: he wrote reams of journalism, critical essays about Scotland's politics and the arts – all the arts of Scotland – many collected in the book *Contemporary Scottish Studies* in 1926, and many syndicated in newspapers and periodicals for sale all over the country; and he edited three anthologies of modern Scottish poetry called *Northern Numbers*. Now what he did there was very smart. He included in the first one established names like John Buchan and conservative poets writing fondly about rural Scotland. By the second, he was including a larger number of younger writers, just back from the war, writing poems about the unemployed, about out-of-work music-hall artistes or about prostitutes in the cities. And

in the third and final book in the series, he had 20 contributors – 10 men and 10 women. You couldn't get a more proto-feminist editorial policy! He understood that the experience of women needed to be written into poetry if Scottish literature was to become truly modern.

SANDY: But MacDiarmid wanted the sensual, natural world as well as intellectually and technologically advanced modernity. Other than Gillies and his Border landscapes, I think that the only two artists who were really close to MacDiarmid were William McCance (1894–1970) and William Johnstone (1897–1981). They were significantly more modern than Peploe and Fergusson and even Cursiter, much more committed to the whole idea of the modern in art. And you could actually relate this to the experiments in the visual arts, cinema, and so on, that were going on in the Soviet Union at that time – that would really appeal to MacDiarmid.

In his paintings of the 1920s, McCance shows the influence of Vorticism – bold colour, mechanical precision, and the simplification of form. His big idea, however, was that the future of painting could lie in a synthesis of Cubism and Expressionism, and that this might be done in Scotland, provided that the Scot could break through 'his narrow provincial barriers and gain a knowledge of what is actually taking place in the world around him'. This has great relevance to the New Image explosion which took place in the visual arts in Glasgow in the 1980s.

The Italian Futurists, the Russian Constructivists, wanted a combination of painting, sculpture, engineering and architecture. They embraced the machine as something that would take us to a social utopia. They really believed in that and their art was about that.

ALAN: Isn't that what MacDiarmid was on about when he was talking about the value of the machine in workers' lives, that it could save labour?

SANDY: Yes. And McCance was in tune with these ideas. He was personally very close to MacDiarmid; they were trying to paint and write and create a manifesto which would bring all of this together.

ALAN: It doesn't work, though. All labour-saving machines do is put folk out of work and give us lots more time to watch TV. None of it helps unless you have a sense of something worthwhile to fill your time with, a sense of shapeliness or rhythm that can inform you, help you to live.

SANDY: And maybe that's where nature comes in. The seasons, elemental rhythms, nature itself. And that's where William Johnstone comes in. He was a Borderer and a lyricist and his paintings of the landscape gradually became more and more abstract. MacDiarmid once said that William Johnstone was really the first abstract painter in Scotland.

ALAN: You can see that lyrical way of combining landscape, portraiture and the sense of the abstract running right through his career. It's there in his portrait of MacDiarmid's schoolteacher, the composer F.G. Scott.

SANDY: He was like MacDiarmid in this too: he never quite cut off that link with nature.

ALAN: William Johnstone's A Point in Time was painted from 1929 to 1937, in the period between the two world wars. What Johnstone is doing, I think, is describing a circumstance in which the forms are not secure. The consolations are not there. The fixed final assurances, of structure and human life in an organised society or a way in which people might feel comfortable – these things just aren't happening. The painting is full of these shapes, and some of them are organic, as if they are internal organs. It's a painting full of movement, but it's movement that's undefined. It's huge and looming and turbulent. A difficult work, I think, but it's an important work.

SANDY: Johnstone is a very different figure from McCance. In Paris, in 1925, he found all of the

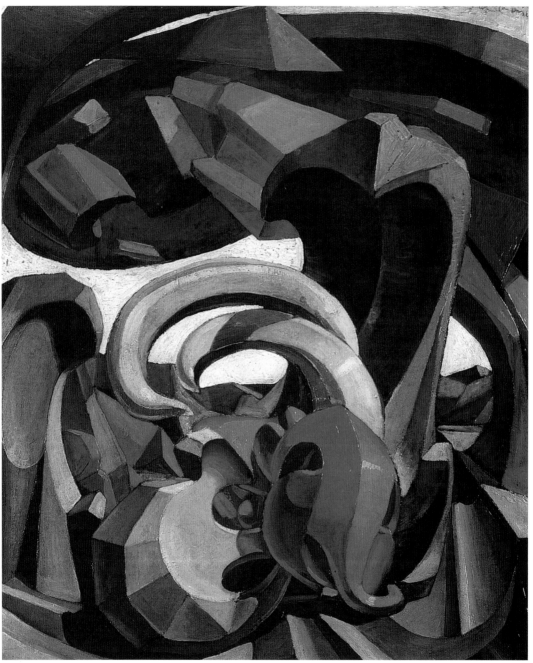

1.14 William McCance 1894–1970 Conflict 1922

influences – abstract painting, Cubism, Surrealism 'most valuable'. On returning to Scotland, his response was that there was no immediate tradition in Scottish art worth talking about. Turning to the collection of Pictish carved and incised stones in the National Museum of Antiquities, Johnstone felt he had discovered an earlier form of symbolism or surrealism. Johnstone said that his pictures were motivated from an inner being, the subconscious, and had no relation to the visible world as seen by the photographic eye.

ALAN: MacDiarmid has a poem that comments on this specifically. It's in a little book published in 1963 but dated 30 years earlier, *Poems to Paintings by William Johnstone 1933*. The poem's title is also that of one of Johnstone's paintings, 'Ode to the North Wind':

> *Our task is not to reproduce Nature*
> *But to create and enrich it*
> *By methods like musical notes, mathematical tables,*
> *geometry,*
> *Of which nature knows nothing,*
> *Artificially constructed by man*
> *For the manifestation of his knowledge*
> *And his creative will.*

MacDiarmid's poems 'Composition 1934' and 'Of William Johnstone's Art' and 'A Point in Time' are directly related to the painter's work; others, such as 'The Creative Instant' and 'Conception', express thoughts and ideas central to both poet and painter.

SANDY: Johnstone travelled in America in the late 1920s and then left Scotland for London in 1931, only returning in 1960 to resume the life of a farmer in the Borders. At that stage, very few people were aware of who he was or of his earlier achievements. Re-emerging in the 1970s, he produced an enormous amount of work and staged several exhibitions. These late works are of interest, as they show that Johnstone had assimilated both the linear art of the Celts and the

1.15 William Johnstone 1897–1981 Francis George Scott *c.*1933

gestural art of Japan and China. But what really mattered to him was the act of creation rather than the finished work.

ALAN: I think it is worth mentioning that William Johnstone and Francis George Scott were cousins, and that Scott hoped that they might combine with

1.16 William Johnstone 1897–1981 A Point in Time *c.*1929

conception I have reached the stage when questioning myself
Concerning the love of Scotland and turning inward
Upon my own spirit, there comes to me
The suggestion of something utterly unlike
All that is commonly meant by loving
One's country, one's brother man not altruism,
Not kindly feeling, not outward-looking sympathy,
But something different from all these,
Something almost awful in its range,
Its rage and fire, its scope and height and depth,
Something growing up, within my own
Separate and isolated lonely being,
Within the deep dark of my own consciousness,
Flowering in my own heart, my own self
(Not the Will to Power, but the Will to Flower!)
So that indeed I could not be myself
Without this strange, mysterious, awful finding
Of my people's very life within my own
— This terrible blinding discovery
Of Scotland in me, and I in Scotland,
Even as a man, loyal to a man's code and outlook,
Discovers within himself woman alive and eloquent,
Pulsing with her own emotion,
Looking out on the world with her own vision.

1.17 William Johnstone 1897–1981 and **Hugh MacDiarmid 1892–1978** Conception from Twenty Poems by Hugh MacDiarmid and Twenty Lithographs by William Johnstone 1977

MacDiarmid in producing work that would form the core of the Scottish Renaissance in painting, music and poetry. But by the 1930s, they were pretty isolated from each other geographically.

SANDY: Later, in 1977, Johnstone and MacDiarmid collaborated on a book entitled *Twenty Poems by Hugh MacDiarmid with Twenty Lithographs by William Johnstone*. The book was the result of many years of friendship and mutual respect between poet and painter and each thought of it as one of their most important works. Johnstone didn't set out to illustrate or interpret the poems: each poem and lithograph creates its own image and as MacDiarmid put it, there are 'profound affinities between poem and lithograph'. The lithographs were printed by my old friend Ken Duffy, who, during his time as director of the Edinburgh Printmakers' Workshop, did so much to enhance and promote the whole idea of printmaking in Scotland.

ALAN: But when MacDiarmid began to write his short lyric poems in Scots, in the 1920s, you also get a painter like William Crozier, looking back to

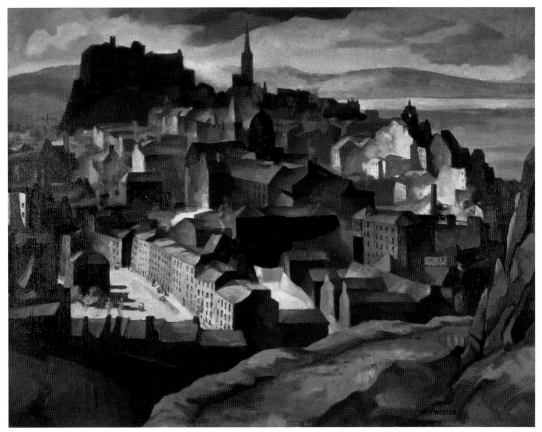

1.18 William Crozier 1893–1930 Edinburgh from Salisbury Crags c.1927

Edinburgh as an ancient city; going right back beyond the Union of the Parliaments, beyond the Union of the Crowns, beyond royalty, to the geological Edinburgh, a prehistoric scale of vision; and then coming back through into the present tense, with these tenement buildings.

You know that generation upon generation of people have lived here through different political systems in the past, so why not different political systems in the future? You know how the women in Picasso's *Demoiselles d'Avignon* are staring right back at you out of that painting? That's a key element in modern art: who's looking? Who do you think you

are? This painting is not merely for the delectation of the viewer, like a pretty landscape or – as with the Picasso – as if these women were merely objects for sale. No. They're looking into you, very uncomfortably. It's the same with Crozier's painting of Edinburgh, I think. The eye curves up and around the dark line, up towards the castle, and it's as if the castle itself and the volcanic rock on which it stands is looking back at you, asking you, what do you think you're looking at? What kind of Scotland do you want?

MacDiarmid and Language

LINDA: So that's a kind of affinity between these different artists in different locations?

ALAN: Aye. I think so. Crozier and his friend Gillies were painting in the 1920s and at the same time, MacDiarmid is writing these little lyrics in Scots, completely tight little poems. And F.G. Scott is setting them to music in fantastically memorable, deeply appropriate interpretations. Scott's song-settings really illuminate MacDiarmid's poems. They're doing the same thing, looking right back into Scotland's past and coming forward again to a contemporary artistic *avant garde* and pushing forward with all that pressure in their very language, their nuclear make-up. There's a recent CD of Scott's songs, *Moonstruck*, that's absolutely essential. Read MacDiarmid's early lyrics, listen to Scott's settings of them, and they flash open in front of your eyes. As soon as you start to unpack them, they explode in all directions. Illuminations. They're really about forms of resistance: the need to resist accepted things, whether it's the political status quo or the dominance of the English language.

LINDA: What happens to a MacDiarmid lyric in Scots if you translate it into English?

SANDY: Let's try it.

ALAN: Okay. There's a poem MacDiarmid published in the 1920s which derives from a German poet, Stefan George, and I think it catches the sense of the relation between spirit and form, brilliantly and memorably. And that relation between spirit and form is an inherent quality in language itself. The poem seems to be about something you can't grasp or understand or comprehend, something that changes its shape between one breath and another and might seem to disappear, perhaps at the moment of death, and yet at the end, MacDiarmid identifies this quality as the thing that gives you courage, the wild and eager kiss that is always burning into your soul,

something painful and yet inspiring and vital. Maybe this is what we're trying to approach in what art might possess and remind us of, something otherwise ineffable, unsayable, but you recognise it instantly. Opposite is MacDiarmid's Scots version alongside my translation of it into English.

SANDY: That's very revealing. The Scots version has a different kind of authenticity. The English is like a black-and-white photograph, clearly defined, which faithfully reproduces the scene. Everything's in place in the English version. There's nothing ungraspable. But the Scots is both present and somehow elusive, hard and real but also moving fast and emotionally quick. Your voice has to shift more quickly. It's a quality you could find in Van Gogh's paintings. It's not painting-by-numbers. It's not just colouring-in. It's a heightening. In a letter to Emile Bernard, Van Gogh wrote from the insane asylum as follows:

> Here's the description of a canvas in front of me at this moment. A view of the park of the asylum where I am: on the right, a grey walk, and a side of the building. Some flowerless rosebushes, on the left a stretch of the park, red ochre, the soil parched by the sun, covered with fallen pine needles. This edge of the park is planted with large pine trees, the trunks and branches being of red ochre, the foliage green, darkened by a tinge of black. These tall trees are outlined against an evening sky striped violet on yellow, which higher up shades off into pink and then into green... You will realise that this combination of red-ochre, green saddened by grey and the use of heavy black outlines produces something of the sensation of anguish, the so-called *noir rouge*, from which certain of my companions in misfortune frequently suffer...

R.B. Kitaj, who was a passionate admirer of Van Gogh, quotes Stephen Spender's comment on this passage: 'Here the painting not only becomes a poem: it is made to speak...' MacDiarmid's Scots speaks in the same way as Vincent's painting.

ALAN: You can feel it viscerally in so many of these early lyrics. It's as if it's an Expressionist language.

You Know Not Who I Am

After the German of Stefan George

Ye kenna wha I am – but this is fac'.
I ha'ena yet by ony word or ac'
Made mysel' human… an' sune I maun tak'
Anither guise to ony I've yet ta'en.
I'll cheenge: an' yet my ain true sel' I'll hain,
Tine only what ye ken as me. I' vain,
Ye'll seek to haud me, an' ye needna murn,
For to a form ye canna ken I'll turn
'Twixt ae braith an' the neist: an whan I'm gane
Ye'll ha'e o' me what ye ha'e haen o' a'
My kindred since licht on earth 'good da' –
The braith that gi'es ye courage, an' the fain
Wild kiss that aye into yer saul maun burn.

You Know Not Who I Am

After the German of Stefan George

You know not who I am – but this is fact.
I have not yet by any word or act
Made myself human… and soon I must take
Another guise to any I've yet taken.
I'll change: and yet my own true self I'll keep,
Losing only what you know as me. In vain
You'll try to hold me, and you need not mourn,
For to a form you cannot know I'll turn
Between one breath and the next: and when I'm gone
You'll have of me what you have had of all
My kindred since light on earth began to dawn –
The breath that gives you courage, and the eager
Wild kiss that always into your soul must burn.

There's a wonderful poem called 'The Sauchs in the Reuch Heuch Hauch' – 'Sauchs' are simply 'willow trees'. This is how it begins:

There's teuch sauchs growin' i' the Reuch Heuch
 Hauch
Like the sauls o' the damned are they,
And ilk ane yoked in a whirligig
Is birlin' the lee-lang day.

O we come doon frae oor stormiest moods,
And licht like a bird i' the haun',
But the teuch sauchs there i' the Ruech Heuch Hauch
As the deil's ain hert are thrawn.

Perpetual resistance! You know those great paintings of Constable where the big old oak trees look as though they've been there forever and always will be there? Well, these are the opposite of that, wizened, twisted, scrunty wee trees blown out of shape by prevailing winds and absolutely 'thrawn' – what a great Scots word that is – twisted, oppositional, resistant. He says that not even God could persuade them away from their 'amplefeyst' – their own 'amplitude of feistiness'! That's a key note, an essential component in MacDiarmid's make-up.

And it's a local poem: the 'Reuch Heuch Hauch' is the name of a field near Hawick, near where MacDiarmid was brought up. But it's also this great vocal throat-gargler with all its velar fricatives and tongue-twisting sound effects. Explosive. And then, *A Drunk Man Looks at the Thistle* – this great ironic title – he's not drunk and the thistle is by no means a single, simple image of Scotland; it's a multi-faceted thing. It's a deeply contradictory, wildly exciting, sometimes extremely dark and sometimes a very pessimistic poem, about post-war exhaustion, the waste land, the desert landscape, the barren field and the thistle. What signs of hope are there here? And there are no easy answers. At the end of it he says that he'll reserve the right to answer that question later: 'I'll tak' it to avizandum.'

SANDY: George Mackay Brown always thought the ending of *A Drunk Man Looks at the Thistle* was one of MacDiarmid's greatest achievements, where he returns to silence and the mystery of silence: 'Yet I ha'e Silence left, the croon o' a'…'

ALAN: He describes the kind of silence he's not talking about, the silence of perpetual snow in the mountains – beautiful but oppressive and ultimately sterile, or the silence of an eternal

midnight threatening to engulf all things that live in time, or the silence of death, or the silence of the God who never speaks, who, he says, might be as astonished to see humanity as humanity would be if it ever saw Him – all these kinds of silence he rejects, and then he seems to walk into a different kind of silence, and he spells it out, something that is beyond sterility, God, death, fear, loneliness – the silence of infinite resource, unspoken plenitude, all the experience of the past and all that's still to come. He says that it's the silence of someone who has '*deed owre often and…seen owre much…*'

LINDA: Those images are so haunting…

ALAN: That description of the silence of someone who has died too often and seen too much is like an inversion of the closing lines of *King Lear*, the very last lines. You remember at the end of Shakespeare's greatest play, Edgar – sometimes the lines are given to Albany, but it's one of the younger survivors of the play, and there aren't many left – the character says, 'we that are young / Shall never see so much, nor live so long.' MacDiarmid is saying that he knows this silence, the silence of the overwhelming reservoir of human potential. All that life has been. It has something of the sense of tragedy you feel when Lear asks you to look at Cordelia's dead lips, when all her words have gone into silence. Yet MacDiarmid sees this silence also as the source of all life to come…

LINDA: You can see why that would be so impressive to George Mackay Brown.

SANDY: When MacDiarmid first published these works, the early lyrics and *A Drunk Man*, I believe they were quickly recognised, by some people, as remarkable, revolutionary works.

ALAN: David Daiches said that they hit Scotland with all the shock of a childbirth in a church.

SANDY: So who were the people that immediately recognised the greatness of those poems and what they held for the future of Scottish writing? And

who were the young poets, writers and artists that were really fired up by the early 1930s, and became the next wave of the Renaissance?

ALAN: You're coming on to people like William Soutar (1898–1943), for example, who is also writing in Scots, and responding positively, and enthusiastically. There are prose writers too, Lewis Grassic Gibbon and Neil Gunn (1891–1973).

SANDY: Soutar didn't write in Scots until he met MacDiarmid, did he?

ALAN: That's right. And Grassic Gibbon transforms what the Scots language can do in terms of the narrative of prose fiction. If you think of it in very simple terms, the narrative language of the great Scottish novels, from Sir Walter Scott, right through, is English. The language of the 'omniscient narrator', the language you have to trust, the language in which the story is told, is English. A Scots type of English but, nevertheless, English. The characters speak Scots but that division is very closely observed. English is the language of the law and Scott of course was a lawyer. Selkirk folk called him the shirra' – the sheriff. So in 19th-century Scottish novels, by and large, narrative language and the language of the characters are different things. There are some exceptions but generally this is the case. The major breakthrough comes with Lewis Grassic Gibbon's trilogy of novels, *A Scots Quair*. Each of them, *Sunset Song*, *Cloud Howe* and *Grey Granite*, uses the Scots idiom for its entire narrative. They are not difficult to read but Gibbon uses Scots vocabulary and rhythm and he uses the voices of the characters that are in the book to construct the narrative. What he's doing is very much like MacDiarmid in poetry. He's taking a language that is entirely natural to his own upbringing and his childhood, to his youth; it's in his ears, it's in his head, he knows the sounds, he knows the meaning of the words, and he brings it into the light. At the same time, he's a literary artist, he's a complete

craftsman. He's articulating this language in art, for the widest possible readership, internationally. So that anybody might be able to read this, without compromising the idiom of the language, of the people that he's writing about. It's a matter of honesty, and balancing what you're talking about with who you're talking to.

SANDY: Isn't this the basis of the big disagreement MacDiarmid had with Edwin Muir in the 1930s?

ALAN: Aye, exactly. Grassic Gibbon and MacDiarmid were commissioning editors for a series of books published by Routledge called 'The Voice of Scotland' and they invited various eminent Scottish writers to contribute – well, really they were long essays, not fully-researched books. And you had some very fine writing there: Neil Gunn writing *Whisky and Scotland*, making the national drink into a kind of beautiful metaphor for distinctive national identity, so it's one kind of drink but full of so many different identities, single malts from different parts of the country; Compton Mackenzie writing *Catholicism and Scotland*, saying, basically, if the conventional idea of Scotland is of a Presbyterian or Protestant or Calvinist country, you have to remember that in fact, for most of our national history, Scotland was a Catholic country, and the great Scottish national heroes, especially Wallace and Bruce, were Catholics – so how does polite, patriotic, Protestant Scotland like them apples? Willa Muir writing *Mrs Grundy in Scotland*, a kind of quasi-feminist study of Scotland's astonishing sexual repressiveness. Anyway, Edwin Muir was invited to write about Scott and Scotland but he turned in a book which effectively attacked the achievement of writers who worked in the Scots language. MacDiarmid felt this was an attack not only on his own position, but also on all the great writers in Scots, going right back to Henryson and Dunbar. What Muir said was that the great Irish writers – Joyce and Yeats pre-eminently – had won international acclaim and achieved great literary

worth through writing in English and this was the way forward for Scottish writers too. More than that: he said it was the *only* way forward for Scottish writers. The line he wrote was, 'Scotland can only create a national literature by writing in English.' He asserted that the chief requirement for a national literature was a homogenous national language and that Scots was no use for that. Only English would do.

SANDY: And that got MacDiarmid's blood up!

ALAN: Well, MacDiarmid's whole point here remains valid, I think: there are many different languages in Scotland, different voices, and they all might find articulation in literature. And Scots, English and Gaelic are all languages of Scotland, and they all give voices to experiences which are part of the national identity of Scotland. Remember that phrase I quoted earlier? – 'From the Renaissance point of view, it is utterly wrong to make the term "Scottish" synonymous with any fixed literary forms or to attempt to confine it.' So he's out for greater variety and range of expression. So he responded to Muir by editing the ironically-entitled *Golden Treasury of Scottish Poetry* which includes poems translated not only from Gaelic but also from Latin, as well as poems in Scots and English – but nothing by Muir!

It wasn't only MacDiarmid who saw Muir's book as a betrayal. The composer F.G. Scott, who had set many of MacDiarmid's Scots lyrics to piano accompaniment but had also set poems by Burns, Dunbar and others – Scott too thought that Muir had betrayed the validity of the Scots language and that his book was misjudged. At that point, he had considered them all to be friends – MacDiarmid in poetry, Muir pre-eminently in criticism and revaluation of Scottish literature, William Johnstone in painting and himself, Scott, in music – Scott had thought they might be the kernel of this Scottish Renaissance and he thought of his own musical idiom as intrinsically Scots, distinctively a

musical equivalent of MacDiarmid's Scots-language poems. And Muir was heaping contempt on all that.

But maybe Muir had a point, you know? The Irish writers *do* have an international cachet – a readership, especially in English and American universities – which is usually denied the Scots writers.

LINDA: Maybe not so much these days. I'm thinking of James Kelman, who has taught in the American university system.

ALAN: Aye, but you do find that American and English and even Irish academics can sometimes be awfully lazy when it comes to this. 'Oh, the language is too difficult!' they complain. Even when it's easier – and a lot more fun – than most of what they do read. You can grasp a MacDiarmid word like 'thrawn' more quickly than the fancy vocabulary of T.S. Eliot – 'polyphiloprogenitive' indeed!

LINDA: Pardon?

ALAN: Eliot has a poem called 'Mr Eliot's Sunday Morning Service' that begins with the lines:

Polyphiloprogenitive

The sapient sutlers of the Lord

Drift across the window-panes.

In the beginning was the Word.

Now when you read the whole poem, you see that it's full of references and quotations and it's witty and smart and so on but it is unquestionably dictionary-dredging and showing off that you're clever. When MacDiarmid is using Scots words from the dictionary, you've always got the sense that the words got in there from the living language of Scots people. Eliot's language doesn't breathe like that. But it's MacDiarmid who gets criticised for taking words from the dictionary! The real problem is that so many academics and teachers of literature in English are simply ignorant of the work of MacDiarmid and his contemporaries. And this obscures any proper understanding of this period in Scottish literature. People are generally aware of J.M. Barrie and Robert Louis Stevenson but then of little else till you get to the commercial successes of Irvine Welsh and contemporary Scottish writing. We haven't exported our literary history very well.

And there's another reason. It's very clear in the novels of Neil Gunn. Gunn provides a comprehensive vision of Scotland. And we've noted this radical vision in Burns, Scott, MacDiarmid, Gibbon, Gunn and more recently, with Edwin Morgan. But it became all too easy to caricature Gunn's notions of 'race' and 'blood' and 'destiny' after World War Two. So 'racial identity' became a slippery term that went alongside 'national destiny' and after the Second World War, there's a very materialistic sense of disillusionment and the non-visionary in the work of many writers. But we'll come back to that a bit later.

SANDY: So you're saying that *A Scots Quair* and MacDiarmid's early lyrics and *A Drunk Man Looks at the Thistle* are equally key works in the arrival of a new modern Scottish literature?

ALAN: Aye. And the cycle of Neil Gunn's novels too. They are all to do with the need and the search for self-possession, self-confidence and self-determination. All these works of the 1920s and 1930s deal with the end of a world. To Gibbon and MacDiarmid, most especially, the First World War was the end of the story of empire, of Victorian Scotland and the Victorian empire. But for these guys two things are happening of equal importance: first there was the Easter Rising in Ireland in 1916 and then there was the Soviet Revolution in Russia in 1917. Now these are significant events for anyone concerned with Scottish culture and nationalism in that era.

In the 1920s and 1930s, MacDiarmid was trying to explore his own past and possible futures. Looking at his boyhood, when he was living in Langholm, he wrote a sequence of poems called 'Clan Alban' – which means, 'The Children of

Scotland'. The past that he comes from, the future that he might be looking forward into, unfinished, unresolved, what's going to happen? – we don't know. We're in this state of uncertainty. It's like William Johnstone's painting, 'A Point in Time'. Even the very languages of Scotland are uncertain. MacDiarmid is now writing in Scots, but also writing in English, and he's aware of writing in Gaelic, beginning to come into this scene, but it's a very uncertain time.

SANDY: There's that wonderful polemic in *Lucky Poet* where he pins his flag to the mast and says he wants to cut himself off from all the compromisers, the middle-earth people:

> The poetry I want turns its back contemptuously on all the cowardly and brainless staples of Anglo-Scottish literature – the whole base business of people who do not act but are merely acted upon – people whose 'unexamined lives' are indeed 'not worth having', though they include every irresponsible who occupies a 'responsible position' in Scotland today, practically all our Professors, all our M.P.s, and certainly all our 'Divines', all our peers and great landlords and big business men, the teaching profession almost without exception, almost all our writers – 'half glow-worms and half newts'.

> My work represents a complete break with all these people – with all they have and are and believe and desire. My aim all along has been (in Ezra Pound's term) the most drastic *desuetisation* of Scottish life and letters, and, in particular, getting rid of the whole gang of high mucky-mucks, famous fatheads, old wives of both sexes, stuffed shirts, hollow men with headpieces stuffed with straw, bird-wits, lookers-under-beds, trained seals, creeping Jesuses, Scots Wha Ha'evers, village idiots, policemen, leaders of white mouse factions and noted connoisseurs of bread and butter, glorified gangsters, and what 'Billy' Phelps calls Medlar Novelists (the medlar being a fruit that becomes rotten before it is ripe), Commercial Calvinists, makers of 'noises like a turnip', and all the touts and toadies and lickspittles of the English Ascendancy, and their infernal women-folk, and all their skunkoil skulduggery.

ALAN: He made a lot of enemies.

SANDY: So in the 1930s, he is in a state of isolation within Scotland, away up in the Shetland archipelago.

ALAN: Aye. There are those who think of MacDiarmid as a kind of authoritarian figure who has the rule over a whole cultural scene. hat's completely misguided. What happens in this era is that he begins in the 1920s as a totally committed activist, a catalyst, trying to bring out the full cultural potential of Scotland. Politically radical, he wants a break with the past, he wants to make it new. He's at the centre of all these activities, journalistic, literary, cultural and political. He's a founding member of the National Party of Scotland in 1928. But he's not in any sense a cultural commissar. At this time, he's trying to bring about the revolution, not hold it in check. Then by the mid-1930s, the establishment has had its revenge. MacDiarmid is now in the most isolated position you could think of. He's away up on the island of Whalsay, which is a beautiful place, and a place of terrific, profound regeneration for him, in all sorts of ways. But imagine: his first marriage has broken up, his first wife has taken his children away. And now, with his second wife Valda and their young son Michael, he is right there on his own and their life is extremely precarious. It's right on the edge, in so many ways.

SANDY: There's a marvellous Shetland painting by John Quinton Pringle simply showing a window from a croft that suggests that lonely act of looking, looking out. It's called *The Window* and it's in the Tate Gallery in London.

ALAN: This quality of being on the edge of things shows in MacDiarmid's later poetry: both a profound loneliness and a completely miraculous sense of regeneration building out of that. You look at the central poem of his whole poetic career, 'On a Raised Beach', which he wrote in the Shetland Islands in 1934, and you see this utterly lonely figure trying to make sense of an almost

impenetrable world. That's the meaning of that great opening, which must have put many weak-willed people right off.

> All is lithogenesis – or lochia,
> Carpolite fruit of the forbidden tree,
> Stones blacker than any in the Caaba,
> Cream-coloured Caen stone, chatoyant pieces,
> Celadon and corbeau, bistre and beige…

And so on. Now, you can go to the glossary and check all the words but the point here is that they're difficult, almost impenetrable words – just like the stones he's looking at and touching – and if you look into that sentence as it unfolds through the verse-paragraph that follows, you'll see a scattering of simple words and they give you the sense of what's actually going on in the paragraph: 'Stones… I study you… and like a blind man run / My fingers over you… stones.' He begins the poem in this lonely, isolated place, lying on this stony beach:

> Nothing has stirred
> Since I lay down this morning an eternity ago
> But one bird…

And then the poem enters into this quite magnificent contemplation about the worth of human striving to achieve something valuable, and how would you measure its value against the scale of geological time? By the end of the poem, that first person singular has become the first person plural and he's seeing himself in the company of people once again.

SANDY: The later poetry carries this further, doesn't it?

ALAN: Yes. The later work, *The Kind of Poetry I Want* and *In Memoriam James Joyce* for example, are enormous catalogues and assemblages of quotations, examples, anecdotes, illustrations, all combining into an epic vision of what language in all its varieties might be capable of, and what art, or all the different arts, can do to heighten and sharpen

and focus those languages, simply to give life its full range and capacity, and to make it more shapely. This is the political focus of the later work, the idea that imperialism is essentially the imposition of order and limitation upon an energy in language that requires controlled or focused expression but also the freedom without which expression is impossible. That's the meaning of that poem we looked at a moment ago, 'Ye kenna wha I am' – it's about the spirit, the energy, something that moves. 'All dreams of imperialism must be exorcised,' he says, 'including linguistic imperialism, which sums up all the rest.' Domination as dictated by absolutist imperialism is political foreclosure, fixity. And we're opposed to that. So you see, he can be direct and lucid as well as dense and obscure, and some of the later poetry is beautifully straightforward.

LINDA: So MacDiarmid's defining moment, if you like, is in the 1920s – and it's found in that value of Scots as an expressive language – and in the later decades his example continues to be unique and inspiring but increasingly singular. And nobody else writes stuff like this. It's influential because it shows that work of such magnitude can be done but it isn't the foundation of a school of writing or a group of people trying to write in a similar way, is it?

SANDY: It's as if, in the 1920s, he suddenly allowed for independent thought, thinking that was grounded in Scotland, in all its variousness, and not channelled through a uniform imperial idea of Anglocentric Britain.

ALAN: In 2006, the BBC Reith lectures were given by the pianist and conductor Daniel Barenboim, who made a very cogent statement about this sort of thing:

> In times of totalitarian or autocratic rule, music, indeed culture in general, is often the only avenue of independent thought. It is the only way people can meet as equals, and exchange ideas. Culture then becomes primarily the voice of the oppressed, and it takes over from politics as a driving force for change.

Think of how often, in societies suffering from political oppression, or from a vacuum in leadership, culture took a dynamic lead. We have many extraordinary examples of this phenomenon. Some is that writings in the former Eastern Bloc, South African poetry and drama under apartheid, and of course Palestinian literature amidst so much conflict... Culture brings contact between people, or, shall we say, culture can bring contact between people, it can bring people closer together, and it can encourage understanding.

SANDY: That's exactly what MacDiarmid was proposing, first on a national, then on an international scale.

Language and Art

SANDY: There's an article by James Campbell from *The Guardian* of 27 June 2005 that makes this point:

> In 1977, Seamus Heaney visited Hugh MacDiarmid at his home in the Scottish Borders, when the great poet and controversialist was in the final phase of life. MacDiarmid had been overlooked by the curators of English literature... Heaney, who has always felt at home with Scots vernacular takes a different line. 'I always said that when I met MacDiarmid, I had met a great poet who said "Och". I felt confirmed. You can draw a line from maybe Dundalk across England, north of which you say "Och", south of which you say "Well, dearie me". In that monosyllable, there's a world view, nearly.'

LINDA: The point here, I think, has to do with language, in two different but overlapping ways. It's to do with the language people speak, generally. And it's to do with the language of literature. Is there anything equivalent happening in the world of painting at this time? What's going on there?

SANDY: What MacDiarmid was doing with the Scots language at that time was essentially a form of resistance. But there was no real equivalent language of resistance in the visual arts. David Donaldson once said to me that it was easy for the poets – they had this language – but he too wanted to find a way of *painting in Scots*. How could

that be done? J.D. Fergusson and McCance might have been imagining a Scots language for the visual arts which might strengthen their resistance to the ways in which cultural ideas and tastes are imposed by an imperialist authority. We shouldn't have our own standards set somewhere else. We should set them for ourselves, as did the 'Fathers' of Scottish painting, David Wilkie and Henry Raeburn. You could ascribe certain characteristics to Scottish artists, from Wilkie and Raeburn and McTaggart onwards, through the Colourists, on to the present day, which would show them to be very different from their English contemporaries. Wilkie, for example, was firstly influenced by Dutch painting and towards the end of his life 'discovered' Velasquez (long before Manet and Renoir), while his large history paintings made an impact on Delacroix – he was clearly part of a larger European tradition.

Are there any English portrait painters who combine supreme painterliness with human insight as much as did Raeburn?

ALAN: Compare these two portraits by Raeburn and Sir Thomas Lawrence and you can see it clearly. Raeburn's portrait gives you a real woman, a living person with a character and time and her own

1.19 Sir David Wilkie 1785–1841 Study for The Defence of Saragossa 1828

story. But Lawrence's painting delivers a female model in a pose, a posture, and not much more than that. It's an advertisement, and so basically heartless, false, a fabrication.

SANDY: I checked my old Penguin *Dictionary of Art and Artists* which I got as a schoolboy in the late 1950s, and it refers to the 'empty flashiness' of Lawrence's portraits!

ALAN: That's it, exactly!

SANDY: And moving forward in the 19th century, William Dyce's vision developed after making contact with 'The Nazarenes' – a group of German painters – in Rome and it differs from that of the Pre-Raphaelites. His masterpiece, though, is *Pegwell Bay: A Recollection of October 5th 1858*. That title itself is interesting because it draws your attention emphatically to the matter of time, both the time depicted in the work and the moment of its composition and creation.

There's an essay by Marcia Pointon, 'The Representation of Time in Painting' which is a study of this painting, where we read this: 'In his insistence on recollection Dyce was at variance with the practice of the Pre-Raphaelite artists who spent hours ensuring complete visual accuracy. Dyce succeeds in rendering a landscape with extraordinary clarity and an air of exactitude but his main concern is with the intellectual response to this particular environment. *Pegwell Bay* is a painting about time, explored through an image of a particular moment in time.' She also makes an emphatic distinction in this regard between Dyce and other English landscape painters: Dyce's inclusion of a date in the title does not spring from a desire to record accurately and scientifically weather conditions on a particular day. That may have motivated Constable, but for Dyce, maybe partly because of the friendships he made with

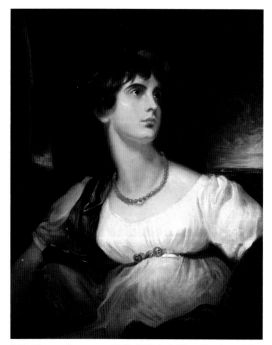

1.20 Thomas Lawrence 1769–1830 Lady Maria Hamilton 1802

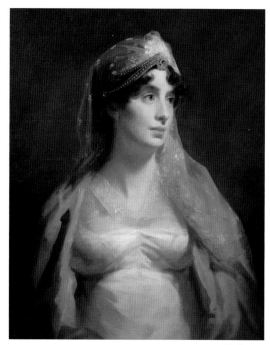

1.21 Henry Raeburn 1756–1823 Grace Purves, Lady Milne *c.*1817

German artists in Rome, there is a depth of philosophical seriousness like that which you find in Caspar David Friedrich.

Similarly, there is no one like McTaggart in English painting. The Colourists are certainly a hell of a lot more painterly than the Vorticists and there is no equivalent of Expressionism in English painting. But let's also point out that there's no-one like Blake or Hogarth or Constable or Turner or, for that matter, Hockney, in Scottish painting. The differences between all of these Scottish artists and their English counterparts are significant. You have to see all of them within a proper historical context to get an overview of a Scottish tradition or a totally distinctive language for Scottish art. And you can do that. It is possible.

ALAN: But it has not been done yet, not fully. We normally see these Scottish artists as isolated individuals, never coherently discussed as part of a national tradition. How are they exhibited in our National Galleries?

SANDY: Well, there isn't as yet a National Museum of Scottish art and there's a continuing tendency to see all of these artists as British. Only a handful of art historians have insisted that they be seen in a Scottish context, pre-eminently Duncan Macmillan, Murdo Macdonald and Tom Normand. They have made a tremendously important contribution simply by showing that there is something called Scottish art.

ALAN: Aye. But they're badly outnumbered by those historians who speak as if they're talking about the whole of Britain when they're not. Macmillan and Macdonald and Normand are pioneers in a world where most critics still adhere to the old Anglo-British line.

SANDY: In 2007, the Museum of Fine Arts in

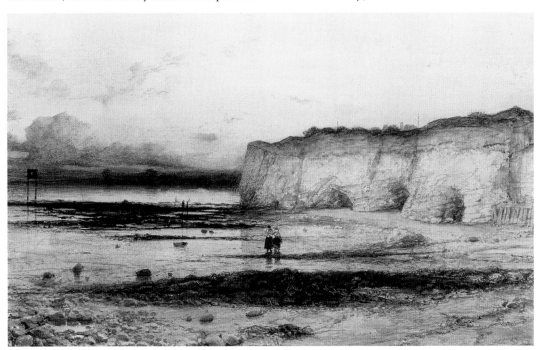

1.22 William Dyce 1806–64 Pegwell Bay: A Recollection of October 5th 1859 [1859–60]

Ghent staged a huge survey exhibition of British art, entitled 'British Vision: Observation and Imagination in British Art, 1750–1950'. Epic in scale, with over 300 works, it was described as a 'far-reaching interpretation of Britain's visual culture'. There were, I believe, only three or four paintings by Scottish artists. I was talking to one of the exhibition's curators, Timothy Hyman, and he simply said, 'Scottish art is much too European'. If he meant, 'More European than British', well, that would be fine by me.

LINDA: Can we get back to the modern movement?

SANDY: By the middle of the First World War, Mackintosh is drinking heavily, leaves Glasgow, carries out no more large-scale commissions, and by the mid-1920s the Colourists seem to step back from the radicalism of their early period in Paris.

ALAN: It's something you can see even in the original frames of the Colourists' paintings. Peploe, Cadell, even Hornel, a little earlier, if you look at the frames they chose for their paintings, they are very plain, cream or off-white, big, bold, but not ornate or gilded or rich. The very plainness of those frames was a modernist statement. Later on, their paintings were bought up by collectors and surrounded by heavily decorated gold frames, and covered by glass. They were no longer an active intervention. They'd become mere property.

SANDY: McCance gives up painting seriously in 1930. And Johnstone, after his pioneering abstract work, becomes an art school administrator in London. Very few of those major artists actually lived in Scotland. Why couldn't they live and work in Scotland? Was it because there was no real market, no real public appreciation, no education system that would encourage that public appreciation, combined with a Presbyterian suspicion of art and beauty?

ALAN: Some of that is still pretty much with us.

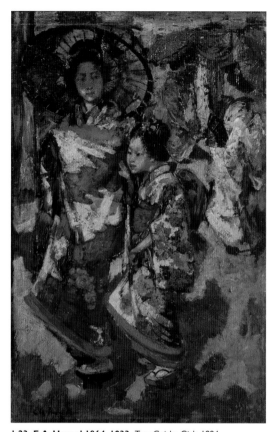

1.23 E.A. Hornel 1864–1933 Two Geisha Girls 1894

In Scottish schools, there is a real struggle to get Scottish history and literature to a more central place on the curriculum and where does that leave Scottish artists or composers? How are children supposed to encounter them? The question applies in terms of how children read and look at and listen to literature and art and music, and write and paint and sculpt and compose and play instruments themselves, if they come to that. It also applies in terms of how they understand the history of our literature and arts and cultural production generally. How is it taught? There was a famous disagreement a few years ago between the composer James MacMillan and Edwin Morgan.

MacMillan had left Scotland, saying that it was such a philistine country no artist could live and work there effectively. Morgan had replied in a newspaper, saying that Scotland had come a long way and it was quite possible to live here without being overwhelmed by national philistinism; that in many ways, Scotland's is a sophisticated modern culture and you could build on that, live here, work for the good. This is an old debate, though. MacDiarmid had it both ways. On the one hand, he didn't go to Paris after World War One, as all the artists and writers were doing – he went to Montrose, worked as a reporter on the local paper and was a local Justice of the Peace and town councilor. He was very much of small-town Scotland, trying to make that a more habitable world. But by the time he's in Shetland, in the 1930s, he's writing this:

> Nae man, nae spiritual force, can live
>
> In Scotland lang. For God's sake leave it tae
>
> Mak' a warld o' your ain like me, and if
>
> 'Idiot' or 'lunatic' the Scots folk say
>
> At least you'll ken – owre weel to argue back –
>
> You'd be better that than lackin' a' they lack!

SANDY: For most politicians, I would imagine golf is far more important than poetry. Both Peploe and Fergusson were really in despair about what was happening in Scotland, that absence of colour in Scottish life. They were trying to do something about that. And we owe them a hell of a lot for that, we really do owe them.

William Crozier died a very young man in 1930. So much had been hoped for him. But his close friend Gillies continues his dialogue with modern French art: Bonnard, Braque and Matisse were all great influences but with Gillies these influences are restricted to the still life and landscape. The full-blown erotic sensuality of Matisse or Bonnard is not on his agenda. The intellectual authority of Braque is, however, and if we care to study the series of still-life paintings he produced from the late 1920s right up until his death in 1971, we will see just how rigorous and inventive he could be. These are paintings of real stature. Perhaps it all seems a bit sanitised by the time it gets to Edinburgh. The wildness has been removed. But in saying this, it would be foolish to underestimate Gillies's achievement as a painter. In the mid-1930s, he too was capable of breaking out, his *Edinburgh Abstract* (1935), based on a drawing of Princes Street and perhaps a riposte to Cursiter's futurism, is a violent Expressionist vision of the capital's main boulevard. It remains unfinished and unresolved and is as far as he will go down the road to abstraction. This reflects the debates which raged within European Modernism and his subsequent return to landscape based on direct observation places him alongside many of the great individualists of 20th-century painting: Carra, Morandi, Beckmann, Matisse and Picasso – all of whom rejected abstraction in favour of a humanist exploration of the visible world.

Sometimes the paintings are too 'nice' but there's a darker side to him. He shared certain things with Bonnard – not only his felicity of touch but also some of Bonnard's abysses. His subject matter may be limited but in composition and deployment of colour he was a master. A more realised and greater artist than any of the Scottish Colourists! In fact, I would say that William Gillies is the best Scottish painter in the first half of the 20th century. His work preserves not just the look of Scotland but the deeper urge to make the accomplishment – of really getting Scotland onto the canvas – tangible and exact.

ALAN: There's an essay by George Scott-Moncrieff in Karl Miller's book, *Memoirs of a Modern Scotland*, where Scott-Moncrieff says this:

> In painting, Gillies was to me what MacDiarmid was in poetry: re-interpreting some part of the Scottish scene for me, making me more aware of, and so enriching, the life around me... Gillies brought an

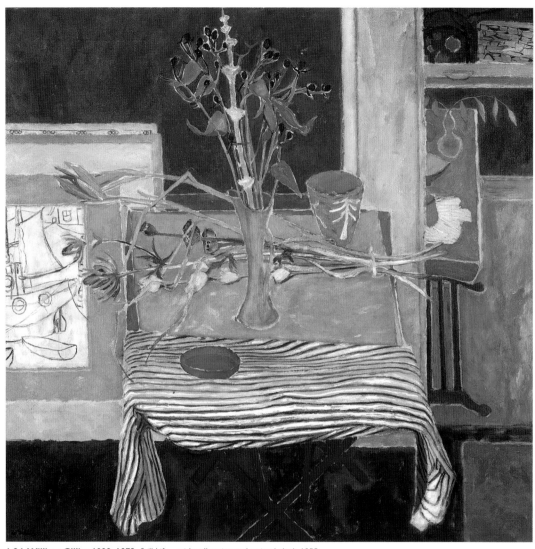

1.24 William Gillies 1898–1973 Still Life – with yellow jug and striped cloth 1955

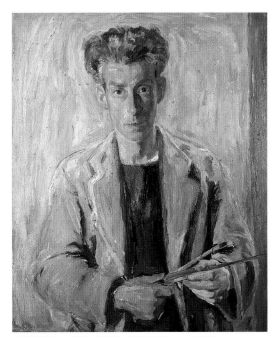

1.25 William Gillies 1898–1973 Self-Portrait 1940

1.26 William Gillies 1898–1973 Edinburgh Abstract 1935

innocent eye – quickened but not betrayed by French influence – to both the Highland and Lowland scenes.

SANDY: And we shouldn't forget that the young William Gillies was bowled over by the work of the great Norwegian artist Edward Munch. There's a story about the Society of Scottish Artists bringing over 15 canvases of Munch in 1932 to a show in Edinburgh and when this opened in the Royal Scottish Academy, only 10 of the canvases were hanging. Five canvases of female nudes were deemed inappropriate for Scottish public taste. I think they did actually fear a puritan backlash that the exhibition would be closed by the police and that they would have ended up in court. And that, sadly, set the parameters for Scottish art that remained in place till the 1960s, when I enrolled at Edinburgh College of Art.

LINDA: What was that like?

SANDY: There were no classes in life drawing or life painting until I entered my third year. That would not have been the case in any other European country. Even in Norway, which is pretty similar, art students didn't have this hugely censorious Presbyterian ethos looming over them. It seems that Munch was greatly amused when he heard that some of his paintings – the nudes – hadn't been shown in Edinburgh. He would regale his old pals when they came round for a drink, exclaiming, 'The Scots are afraid of naked women!'

One other consideration is that no major Scottish artist – after Mackintosh – was really able to connect with central Europe, with what was happening in Berlin, Vienna, Prague and so on – Expressionism, the *neue sauchlichkeit* movement, the Bauhaus, the meshing of art and politics during the Weimar Republic. That was pretty much unknown in Scotland. Paris and France still remained the first port-of-call for Scottish artists venturing abroad, although by the mid-1920s, Berlin had become the centre for Modernist music (both composition and performance), for Expressionist art, theatre and film.

When Hitler came to power, most of the leading German artists and intellectuals emigrated to the USA, where they became hugely influential in the reshaping of the western art world after the Second World War. Because of its newly acquired

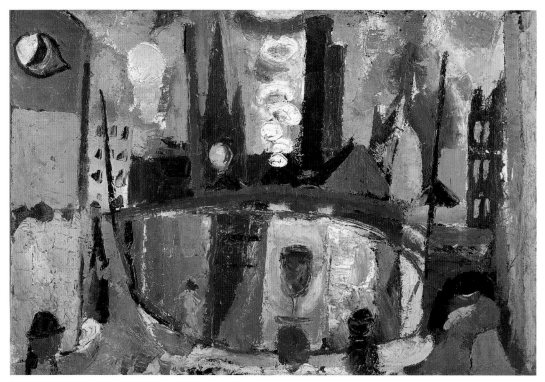

1.27 William Gillies 1898–1973 Edinburgh Abstract 1935–6

superpower status, American cultural values dominated above all else. Those German émigrés based in the USA – Gropius, Schoenberg, Bruno Walter, Beckmann, Albers, Thomas Mann, Adorno, Kurt Weill, Billy Wilder, Fritz Lang – all assumed leading roles within this cultural hegemony, paradoxically bringing about what was in effect the triumph of German Modernism. We in Scotland missed out on all of that. And it took me years, after I started at Art School, to find out about it.

LINDA: So nothing of that was visible here in Scotland?

ALAN: Well, I wonder. I wonder if we missed out entirely. I'm thinking of some of the more brutal and violent episodes in Lewis Grassic Gibbon's writing, for example. In his first book, *Stained*

Radiance, there's a horrific account of a woman having an abortion in London and her suffering and slow recovery, and there are a number of very violent episodes in *A Scots Quair* that are close to the gross social disfunction you find in a novel like Alfred Doblin's *Berlin Alexanderplatz* (1929) or Odon von Horvath's great play, *Tales from the Vienna Woods* (1931). And again, there's MacDiarmid's 'Ode to All Rebels' with that astonishing challenge to his readers to think of the unthinkable horrors that are going on all around us, every day.

> There are buildings in ilka toon where daily
> 　　Unthinkable horrors tak' place.
> I am the woman in cancer's toils,
> 　　The man without a face...

You may thank God for good health

 And be proud to be pure

In body and mind – unlike some.

 I am not so sure.

Strangely enough, MacDiarmid visited Vienna in the immediate pre-Hitler years. In his 1943 autobiography *Lucky Poet*, he says that it was 'the most beautiful and romantic and theatrical city' he had ever been to:

> Vienna, full of memories of Johann Strauss and Offenbach, Freud, Kraft-Ebbing, Gustav Mahler, Hugo von Hoffmansthal – the spirit that is celebrated in Berta Szeps's memoirs, a spirit neither of surface gaiety and indolent acceptance, nor of rigid nationalism and partisanship, but a civilized sense of values, free kinships of the mind, tolerance and a patriotism not so much concerned with domination and glory and aggrandisement, but mindful of man's individual worth and liberty – the spirit that is today in eclipse over much of the earth's surface, and has now been extinguished in Vienna itself, where so many of the able and delightful people I met while I was there have now been murdered or tortured or ruined and obscenely put upon.

Edinburgh, he says, might be bracketed with Vienna in some ways, but Edinburgh never had 'what made Vienna a city unique among cities – its indescribable blend of depth and solidity and substance happily wedded to light-heartedness and the ecstasy of life for life's sake.'

LINDA: He clearly knew what was going on.

SANDY: And then after the war, there's another generation of Scottish writers who begin to see these connections. The next exhibition of Munch in Scotland was in the 1950s, and that had a major impact on the young Alasdair Gray, so there is progress at last! Gray says this:

> Norwegian Munch was the first great modern artist whose paintings I saw on their original canvases. He died in 1944 when I was nine, and about ten years later a great exhibition of his life's work filled at least three upstairs galleries of Kelvingrove Museum. I was then at Whitehill Secondary School and seeing all the great Munchs at exactly the right time.

LINDA: So Alasdair Gray encounters this way of seeing the world as an adolescent and it changes everything for him.

> How wonderful to discover the works of a Norwegian artist who had lived in the industrial, capital city of a modern nation smaller than Scotland – who painted it as an area of loneliness and sexual tension and disease, yet saw it as grand and tragic – not boring or trivial, which was almost the worst thing I feared life could become.

ALAN: That's a great point, isn't it? That's how art can save your life!

MacDiarmid in the 1960s

LINDA: European art had an important effect on you, Sandy, when you started to think about the traditions you wanted to draw on when you began painting in the 1960s, didn't it?

SANDY: The question of which visual language to use preoccupied John Bellany and myself during our student years in the early 1960s. There was the big issue – abstraction or figuration? And you could say that question also meant a choice of allegiance: the USA or Europe? After experimenting with abstraction under the influence of Alan Davie, we decided the best way forward was to look backwards. I remember arguing that after Kandinsky, after Matisse, after Pollock there was no way back, but as soon as we began to admit to certain figurative possibilities for our own painting, we realised that a new set of models would be required. In theory we were intent on forging a figurative language which would not only be a synthesis of the old and the new, but would contain subject matter particular to modern Scotland. We closely allied ourselves to what we regarded as a specific Northern tradition of European Art. There was Breughel, Bosch, Grunëwald and Rembrandt. Goya was included – Spanish and Northern European art have much in common, including a special feeling for Expressionism.

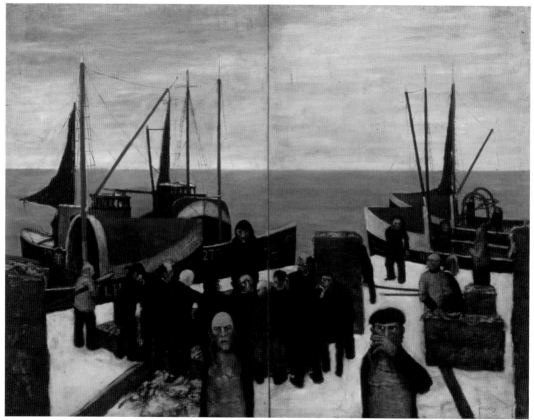

1.28 John Bellany *b.*1942 Fishers in the Snow 1966

But you have to remember that in the late 1950s and early 1960s American culture, jazz, the Beat generation, Abstract Expressionism – these things were all persuasive. Scotland couldn't compare. Not only did it seem provincial, it also appeared incapable of change. It was at this moment, in the summer of 1962, that MacDiarmid re-emerged, on the occasion of his 70th birthday. I managed to get a copy of the *Collected Poems* which Macmillan's of New York had brought out. MacDiarmid showed us that art mattered, that it could change the world, but only if artists aspire towards greater horizons than were commonly accepted. MacDiarmid also showed us that Scottish artists were included in

this, if they so wished. And that Scotland has a unique culture and history which could be used and developed by modern artists. This is what we had been waiting for.

John Bellany and I travelled to Paris in 1963 and embarked on a survey of French painting since the Revolution. With MacDiarmid's plea for 'giantism in the arts' in mind, the great 'machines' of David, Géricault, Delacroix and Courbet left an indelible impression.

Now was the time to look again at the Scottish tradition – a Scottish tradition which could be seen to have a distinct identity as part of the larger European tradition – Ramsay, Raeburn, Wilkie and

McTaggart loomed large in our thinking. The question was how to connect the past to the present. John Berger argued that 'the function of the original artist is to renew the tradition to which he belongs', so as a result of reading Berger we began to examine the relationship between Picasso and Goya and Velasquez. Picasso, the greatest innovator in 20th-century art, had maintained a life-long dialogue with his great creative predecessors – he was both 'modern' and 'anti-modern'. *Les Demoiselles d'Avignon* and *Guernica* are violent and aggressive images but both construct meanings from a fusion of form and content, not simply from an exploration of formal experimentation.

By the early 1960s, MacDiarmid, too, would seem 'anti-modern' to many, but for us, his blend of communism and nationalism and his battle against timidity and mediocrity and parochialism proved inspirational. It seemed that MacDiarmid and the poets who followed him, their ideas, their horizons, were far in advance of anything in Scottish painting. Something had happened in poetry which hadn't happened in painting: poetry seemed to matter, while painting merely aimed at the petit-bourgeois living-room with pretty still lifes and landscapes.

Alan Bold's manifesto – that is, his introduction to our 1964 Edinburgh Festival exhibition puts it like this:

> There is evidence now that Scotland is experiencing a second Renaissance in the arts. Hugh MacDiarmid was virtually the sum-total of the first 20th-century revival in Scotland and the reason why it has taken so long for Scotland to produce more artists of serious intention is partly in fact that MacDiarmid had to work so much in isolation. There were no writers near his stature: and there were no painters.

Alan Bold played an important role – he was more than capable of writing manifestos and stirring up controversy, and with *Rocket* he produced a thoroughly polemical little magazine. It has to be said that in the early 1960s his 'theorising' was

unashamedly Marxist – quoting John Berger, Ernst Fischer and MacDiarmid with regularity. His support was invaluable and he wasted no opportunity to champion our work curating important exhibitions such as *Scottish Realism* (1971) and *Four Painters* (1975), where he promoted our ideas about painting and cultural renewal in Scotland. Sadly, Bold died in 1998. His huge contribution as a poet, critic, painter, has yet to be fully recognised.

In 1967 Bold, Bellany and I travelled to Germany for the first time, thanks to our great friend and colleague, the composer Ronald Stevenson. Prior to our visit, our knowledge of German art was limited to the Expressionists and Max Beckmann. German art and culture was still under a cloud in the UK, so to discover what had been going on from the beginning of the 19th century onwards – from Caspar David Friedrich to the Weimar

1.29 Gustave Courbet 1819–77 The Beggar 1867–68

1.30 John Bellany b.1942 Kinlochbervie 1966

republic period – was a revelation. We also experienced the seriousness with which art was viewed and discussed and the sheer quality of the museums and galleries. All of this was to have a deep effect on our thinking and practice. Bellany was to return to this theme in his opening address on the occasion of his exhibition, *Eine Schottische Odyssee (A Scottish Odyssey)* at the Citadel in Berlin in 2007, in which he reflected upon the enduring influence of German culture with regard to his own practice. He's always been impressed by the serious place art has in German life.

ALAN: That's Port Seton for you!

SANDY: The small-village world of either frivolity or solemnity had little room for that seriousness. But the seriousness was there in the actual lives of people – the fishing people, for example. Their lives had that quality but no art represented it until Bellany.

LINDA: You're talking about a deep relationship between politics and art. Did this go beyond painting and poetry, to the other arts as well?

SANDY: Yes, indeed. The composer Ronald Stevenson's importance for both myself, Alan Bold and John Bellany cannot be over-estimated.

Like MacDiarmid, Stevenson's work involved a

dialogue between art and politics, between art and philosophy, between art and philosophy, between music and literature and between music and the visual arts. Stevenson showed us that music could, to paraphrase Mahler, include the world. His *Passacaglia on DSCH* contains passages such as 'The Pibroch: Lament for the Children', 'War Visions' and 'The Pedal Point: To Emergent Africa'. Pasted throughout the manuscript score are newspaper cuttings, photographs, postcards and so on, serving to remind us how he composes – in many ways, just like a painter, transforming so-called 'extra-musical' material into purely musical ideas of great emotional power.

ALAN: Stevenson told me that when he presented this work to Shostakovich at the Edinburgh Festival in 1964, Hugh MacDiarmid acted as the Master of Ceremonies at the event. He told me that although there was a film taken by a European TV crew, I think, nevertheless there were no UK or Scottish press photographers there to record the moment. He said he suspected that they had been told not to give it air-time or space in the newspapers because it would have been a serious endorsement of MacDiarmid's political credibility in Scotland to show him with Shostakovich in this way. In the press he was represented as a sort of eccentric character in a kilt. So the message was effectively blocked in the mass-media but if you knew what was going on, there was great strength and encouragement to draw from that occasion.

SANDY: We were to benefit too from Stevenson's intellectual presence. It became possible to discuss the theories of Marx and Nietzsche, the operas of Brecht and Weill, the symphonies of Shostakovich and Nielsen, the differences between Bartòk and Janacek in their uses of folk-music, and so on. All of this would lead us back to our ongoing debate about Scottish art and culture, past, present and future.

And you have to remember, too, that the 1960s

1.31 Alexander Moffat b.1943 Alan Bold 1969

was also the decade in which Scotland began to establish some of the necessary cultural institutions which could help foreground a national idea of self-determined cultural representation. There was the creation of the Scottish Arts Council in 1968, but before that, Scottish Opera and the Scottish National Gallery of Modern Art, both in 1962.

LINDA: So what was going on in the world of Scottish poetry in the 1960s and 1970s?

ALAN: It's increasingly recognised that the key figure, in Scottish poetry in the 1960s, is Edwin Morgan. He was known at the time as a playful, experimental poet, very much Glasgow-based but open to many different influences, unlike his contemporaries, who were perhaps thought of as more securely grounded in particular locations. But now it's that openness that seems the key

characteristic of his importance. He knew what was going on in the Beat movement in the USA, arising in the 1950s, and with concrete poetry in South America – Morgan and Ian Hamilton Finlay were key figures there – but Morgan's openness to the east as well is a really enabling example – his early translations into Scots of the great Russian revolutionary poet Mayakovsky – his translations from eastern European poets – and his interest in scientific subject-matter – all these qualities are there. And at the heart of it, there is a compassionate figurative human sensibility in poems that tell stories and give you pictures of people and places: 'In the snack-bar' or 'At Central Station'. Morgan's poetry presents all this and foregrounds the component parts of language in sound poems too. It's also related to play, visualisation, comprehensible meaning – never merely realist nor merely abstract. So there are those component parts of sensuality and intellectual appetite, and increasingly after 1979, through the 1980s, a national agenda too. And of course, in the 1960s, that great generation of Scottish poets really began writing in earnest – not only Morgan but George Mackay Brown, Norman MacCaig, Sydney Goodsir Smith, Robert Garioch, Iain Crichton Smith, and others.

MacDiarmid's Politics

LINDA: But MacDiarmid was contemporary with this generation too. How did his explicit political commitments and his extremism compare with the politics of the younger generation? He came out of a much more radical political world, in the early decades of the 20th century, didn't he? And was well-known as a political extremist...

ALAN: In 1931 he was actually ejected from the Communist Party, twice. The paradox was that he was the victim of a Stalinist witch-hunt. Can you imagine MacDiarmid as a victim of a Stalinist witch-hunt? He was saying things about Scottish Nationalism that the British CP didn't like at all.

And they really didn't like him making anti-English remarks. He was reinstated, then thrown out a second time; and he re-entered the party in the 1950s.

SANDY: At that stage, he had just been expelled from the embryonic Scottish National Party, hadn't he?

ALAN: Yes, he was a founder member of the National Party of Scotland in 1928, along with fellow-writers R.B. Cunninghame Graham and Compton Mackenzie. All of this has to do with a kind of aggressive idealism. It has to do with real social engagement and thinking about what might be done. Between the two world wars there was a period of radical uncertainty. And that can be very scary indeed. Perhaps the sense of commitment that the political parties maintained gave him a kind of security, something to drive for.

SANDY: The main thing about MacDiarmid and the poets we'll speak of a bit later on, like Sorley MacLean, Iain Crichton Smith and George Mackay Brown, is that they were actually dealing with what it was like to be living in some particular place, on an island, or in other parts of Scotland. And that's the big difference between them and many visual artists. That's one of the things that attracted the young John Bellany and myself to the poets. We'd say. 'Look, they really are dealing with what it's like to live in Scotland, at this moment, in time, and in those places.' And meanwhile there were the painters who were still just painting pretty pictures. That's not good enough. And that's why MacDiarmid's whole war cry, for engagement, for social engagement, was really attractive. Because it just wasn't there in the visual arts. I think that's why we took so much from these poets and asked the question: 'Why? Why don't we paint reality?' For example, there are very few paintings of the industrial city, in Scottish art, and we thought, we have one of the greatest industrial cities in the world, with all kinds of social problems.

ALAN: And who writes about that?

SANDY: The poets.

ALAN: Well, there are a few. In the late 19th century, there were James Young Geddes and John Davidson but then it's not until well into the 20th century that you come to Edwin Morgan in the 1960s and you find a Scottish poet who inhabits the industrial city familiarly. The key thing, I think, is that the vast majority of the Scottish population in the early 19th century is rural and living in the country. With the industrial revolution, four-fifths of the population moved into the cities very, very quickly, especially to Glasgow. So you had rural ideas of community, of supportive social circumstances, dispositions about neighbourliness, or an ideal way of behaving and a sense of right behaviour, of right support – a democratic idea, if you like – coming into an industrial world and being confronted by extremes of poverty and squalor, and class exploitation, in a way that had not existed before. So there was a major clash between social ideals and social practices, and the artists had to take some time to come to terms with this. MacDiarmid was onto it earlier than most. He produced a fantastically chilling poem adapted from a rather limp English version of Rudolf Leonhardt's 'The Dead Liebknecht'. Liebknecht was the German revolutionary who, along with Rosa Luxembourg, was trying to get the German Communist party together. Lenin in fact said that he'd hold back the revolution in Russia if Germany could take the lead. But Liebknecht was killed. MacDiarmid's poem has this terribly ambiguous sense of the human cost of sacrifice. You know Christopher Marlowe's play *Doctor Faustus*, where Faustus cries out that he sees Christ's blood streaming in the firmament? He's crying out for redemption, he wants to be saved. But of course, Marlowe isn't having any of that and Faustus is torn to bits. It's like that. MacDiarmid shows you Liebknecht's blood metaphorically turning the skies crimson – a red dawn or a bloody sunset? The skull's smile under the earth – is that a promise

of liberty to come, or a *memento mori* that all human effort is vain and the struggle itself is a kind of martyrdom? The poem seems to end with a question.

> *The factory horns begin to blaw*
> *Thro' a' the city, blare on blare,*
> *The lowsin' time o' workers a',*
> *Like emmits skailin' everywhere.*
>
> *And wi' his white teeth shinin' yet*
> *The corpse lies smilin' underfit.*

SANDY: After the end of the Second World War, with the defeat of Fascism, and with the onset of the cold war, MacDiarmid suffered from the fact that he was a Communist. All art produced in conjunction with Marxist ideology was judged to be contaminated at that time. There was a huge reaction against political art covertly supported by US foreign policy, and by implication, against figurative painting, because a type of figuration had been the official style of the Nazis and the Stalinists. I remember when I was a student and had discovered MacDiarmid and would talk to older artists about him, they would say, 'Aw, MacDiarmid – he's a Communist.' End of story.

ALAN: But he was a *practising* Communist. He worked in the real world. In 1964, he stood as a Communist Party candidate against the then Conservative Prime Minister, Sir Alec Douglas Home, in the constituency of Kinross and West Perthshire – one of the most conservative areas of Scotland!

SANDY: That's a signal of the kind of political man MacDiarmid was. Could you imagine Philip Larkin or T.S. Eliot standing as a political candidate? Maybe Eliot could have stood to be elected as a Church of England bishop...

ALAN: There's a great story that when the results came in, Douglas Home polled 16,659 votes and MacDiarmid came bottom of the poll with a total of 127 votes – and he demanded a recount! And when

his election agent told him to forget it, that he'd lost, he replied that it wasn't that – 'It's just that it's hard to believe that there are 127 good socialists in Kinross and West Perthshire!'

SANDY: But that's not the end of the story, is it?

ALAN: No. The Communist Party then took Douglas Home to court, on the grounds that he had received far more air-time broadcasting to the public than had been given to the smaller political parties.

LINDA: What happened?

SANDY: They lost. But the case got a good airing and there was a general sense that justice was on their side.

ALAN: And since then, you have a much greater equity about party political broadcasts on TV and radio, that allow for minority parties as well as the big Westminster parties – so maybe there was a real change brought about there…

SANDY: It was another watershed moment…

LINDA: How do MacDiarmid's politics square with his poetry?

ALAN: It's true that he wrote poetry that was explicitly political, poems in praise of Communism – as did Bertolt Brecht, as did other great writers. Think of Pablo Neruda, Paul Eluard, Nazim Hikmet or more recently, Ernesto Cardenal. Then in the 1950s, MacDiarmid published *In Memoriam James Joyce*, which is the most radical, postmodern, book-length poem. The first editions carried illustrations by J.D. Fergusson, so that the book as an artistic production itself connects right back to the era of the Scottish Colourists. There's a continuity and an overlap between their lives, biographically, and also between their art and the commerce between their art, in producing this book. But again, this is a new opening into the future. MacDiarmid was writing this poem through the 1930s and 1940s, right into the 1950s. It was not published until 1955, after T.S. Eliot had kept it and turned it down, saying

that his publishers' board at Faber and Faber had not been disposed to take it. You know, I wonder if Eliot may have felt a little bit frightened or intimidated by MacDiarmid's magnitude in this work. Because it is huge poem in praise of the variety of the languages of the world. In the end it's a rejection of anything that has to do with a singular lyrical voice that's purely, aesthetically, self-contained. It's a rejection of imperial authority and religious certainty or dogma. It's an assertion of openness, to the variety of languages, and arts, and forms of self-expression, that might be found, as far as you can see, as far as you can reach. It's an experimental poem and in some ways it fails. Maybe it's not an aesthetically coherent poem, as you might say *Paradise Lost* is, or Joyce's *Ulysses* is satisfying, aesthetically. But maybe it's appropriate that *In Memoriam James Joyce* isn't like that. It's a constantly unsettling work of great magnitude. And it's exhilarating and it's invigorating and you can't pin it down. You can't say it's any sort of flag-waving poem, it's not Scottish Nationalist authoritarian, it's not Communist authoritarian, it's about being open to the experiences and the resources of the whole world.

LINDA: So did MacDiarmid develop into a 'grand old man'?

ALAN: Not exactly. He was always contentious. One of the last things he published was an article in the *Radio Times* describing the Edinburgh Military Tattoo as 'a disgraceful spectacle perpetrated by an army of occupation upon a nation of sheep'! Now that's spunky and steely and frivolous in a serious way; but he was like Picasso, I guess, always concerned with world-politics and change. In the 1960s he began to gain international critical recognition and his own pronouncements were listened to. And I think people liked him because he did combine those qualities of passion and frivolity, substance and lightheartedness, that he mentioned as characteristic of Vienna. I guess you

could describe him as a figure of philosophical leadership. There are very few people like that in the English-speaking world in the 21st century. There were some American writers who used to have that role in the 20th century, but hardly anyone on the world stage, now. The great Nigerian writer Wole Soyinka is an exception that proves the rule. Maybe Barack Obama can change that climate in America. Anyway, in Scotland in the 1960s, one other figure came to have that status. This was George Elder Davie, whose book, *The Democratic Intellect* (1961), was ostensibly a study of the Scottish universities and Scotland's tertiary education system in the 19th century, but it came to have the status of a political and mythic legend, just around the same time as MacDiarmid was celebrating the publication of his *Collected Poems* (in 1962) and his 70th birthday and gaining wider critical recognition.

SANDY: At the memorial gathering for George Davie at Edinburgh University in July 2007, I recollect Paul Scott saying that he thought *The Democratic Intellect* was probably the most important book to be published in Scotland in the last hundred years.

ALAN: But isn't this also to do with the idea of the epic? What 'the democratic intellect' suggests is a national epic myth, a kind of egalitarian ideal at the heart of Scottish education, and what MacDiarmid stands for is a comprehensive vision of people and society and the arts, and artists who are engaged by that vision.

SANDY: And we've noted that he has his precursors in Geddes and Mackintosh...

ALAN: MacDiarmid was seeing Scotland whole, from the Borders to Shetland. For him, it was not a place of factions but a multi-faceted unity. You know, forget this Glasgow-Edinburgh rivalry and all the other little parochial things that diminish our sense of comprehensive, multi-faceted complexity –

SANDY: For a lot of Glasgow artists, Glasgow is

1.32 Alexander Moffat b.1943 George Davie 1999

bigger than Scotland! And maybe it's not just Glasgow artists – it's Glasgow people as well! As a result, many of them lack an overview of Scotland. It's not something they think about. Rangers and Celtic fans evidently have no interest in supporting Scotland. Maybe Calum Colvin's *The Twa Dogs* is an ironic comment on this, both looking away from each other, neither of them aware of the condition they're in together.

ALAN: Isn't this a general problem though? I mean, if you take the newspapers – *The Herald*, *The Scotsman*, the *Aberdeen Press and Journal*, the *Dundee Courier* – they each speak for their own city constituency and its hinterland, and each has an international section, but none of them fully

addresses itself to national self-representation.
MacDiarmid once talked about his removal to the
Shetland islands as a kind of quest to discover
whether or not he could find an identity you could
call Scotland that embraced all the differences.
And he said that there *was* this, it did exist, he
found it, it was there. And maybe that's the
difference between Scotland and other nations:
there's no uniformity. Our distinction is in our
sense of our own multiplicity – in languages,
voices, geographies, and so on. And anyone who
lives here or comes here should have equal access
to all these different ways of understanding.
If that's our foundational myth in Scotland, maybe

it's a good one, one worth keeping. It's certainly
preferable to a lot of the other national myths you
see around today. It's not 'ourselves alone are
single and superior'. It's open. It's not about
clearing people out or dominating other people.
It's not a myth of imperial superiorism. And it
allows for the dynamics of society. It acknowledges
that people will change and are full of differences.
Maybe that's also MacDiarmid's lesson.

SANDY: It's idealistic.

ALAN: It's a myth. Of course there is racism.
Of course you can indicate examples of
nationalistic chauvinism and anti-English hatred.

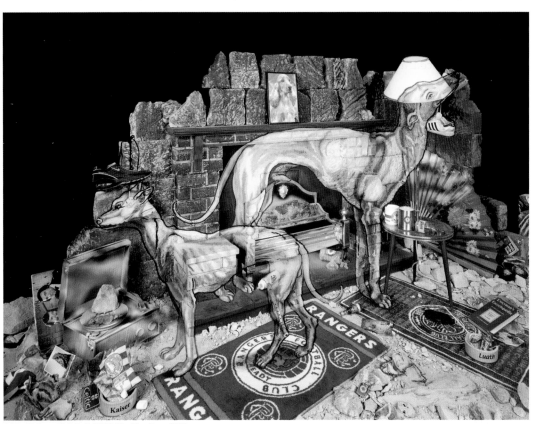

1.33 Calum Colvin *b.1961* The Twa Dogs 2002

Of course there is religious sectarianism and bigotry. These things are here in Scotland today. And you know as well as I do where such horrifying things can be encountered most keenly and how and why they have come about. I don't think they're any worse than examples you could point to in England or Ireland or America or elsewhere. They have their own histories and their own locations, where people have grown up encouraged to think in certain ways, believe in certain things. The myth I'm talking about doesn't whitewash the horrific things people do to each other. It reveals them. If the great dream of humanity is to bring about some kind of social justice and real egalitarianism, then a myth that configures that desire can be enabling, rather than restrictive, and it is one of the strongest things in all the arts that have come out of Scotland. There is nothing feeble about it.

LINDA: A lot of people would be cynical about that dream.

ALAN: Aye. Cynicism is on the side of the opposition. Listen. This is important. The American novelist Robert Penn Warren has a poem called 'Brother to Dragons' in which he spells out the need we all have to keep belief in virtue despite all opposition:

... despite all naturalistic considerations

Or in the end because of naturalistic considerations,

We must believe in virtue. There is no

Escape. No inland path around that rocky

And spume-nagged promontory. There is no

Escape: dead-fall on trail, noose on track, bear-trap

Under the carefully rearranged twigs. There is no

Escape, for virtue is

More dogged than Pinkerton, more scientific than
* the FBI,*

And that is why you wake sweating towards dawn.

So what I'm saying is, deny the dream at your peril. And if the very fact that Scotland's people speak different languages, live in such a varied terrain, co-exist in families across different economic strata, speak to each other throughout and beyond Scotland, across the world in fact, then I think there's a lot of potential good in that situation and we haven't even begun to make the best use of that yet. There's nothing self-congratulatory or smug about it. You don't rest easy with it. You wake up sweating towards dawn.

LINDA: There's something of that multiplicity of perspectives and of the potential for change for the better, in your portrait of MacDiarmid, Sandy, There are different landscapes and different moments in time...

SANDY: My portrait of MacDiarmid – subtitled, 'Hymn to Lenin' – could be described as an 'extended' portrait where I've constructed an environment in which to place the poet, who is set against a background of the Border hills and the Shetland islands, and a foreground of images from the Russian revolution. John Maclean, the Scottish revolutionary socialist, also makes an appearance. I was attempting to reflect MacDiarmid's commitment to the ideals of the Russian revolution, and likewise to the creation of a socialist state in Scotland. But I also hoped to suggest that MacDiarmid was a poet who ultimately soared beyond the confines of political thought and action.

The context I wanted to reveal in the portrait was that of seeing Scotland whole. I made the initial drawings, sketches for the portrait in the summer of 1978, a few months before he died. I remember on the occasion of his 85th birthday, in August 1977, at a concert organised by the STUC in the Assembly Rooms in Edinburgh, MacDiarmid stood up on stage and called for an end to the monarchy and English rule and the establishment of a Scottish Republic. What had been said from the

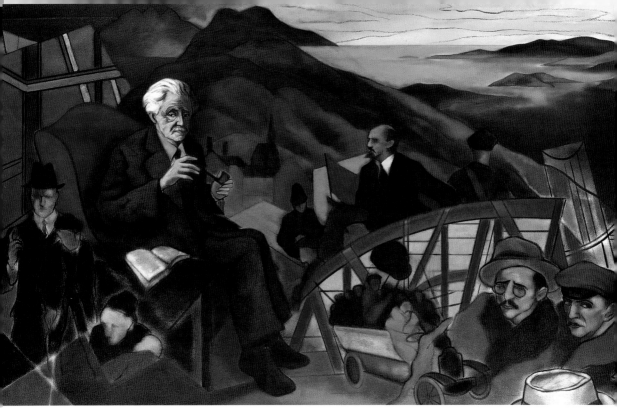

1.34 Alexander Moffat b.1943 Hugh MacDiarmid: Hymn to Lenin 1979

podium up to that point was pretty unexciting. Suddenly this happened and everyone was utterly stunned. The audience were just blown away. It was one of the most electrifying moments I have ever experienced. All of this had a big influence on my approach to the portrait.

ALAN: And you could think of the difference this way. Scotland's leading poet from the 1920s right through the 30s, 40s, 50s, 60s and 70s is a rabble-rousing Communist – what's the equivalent in England? John Osborne, Kingsley Amis, Philip Larkin? No wonder MI6 intercepted his letters in the 1930s. The report on him said, 'The man is a menace!' Look at the correspondence of Larkin and Amis. Look at how they talk about him! MacDiarmid was just too hot for them to handle. Larkin writes to Dan Davin at Oxford University Press on 2 April 1971, explaining his wish to omit MacDiarmid altogether from his

Oxford anthology: 'I am so averse from his work that I can hardly bring my eyes to the page, but I agree a lot of people will expect to find him there (assuming, of course, that he will consent to be included in a work whose title includes the word English) and if you like I will make another effort to find some stretch of his verbiage that seems to me a trifle less arid, pretentious, morally repugnant and aesthetically null than the rest.' Five of MacDiarmid's poems were included and at the launch for the book MacDiarmid asked why Larkin had omitted the greatest poet then writing in English, David Jones. No wonder Larkin hated him.

LINDA: And Kingsley Amis hated him too?

ALAN: Aye, MacDiarmid chose his enemies well. Amis writes to the poet Robert Conquest on 28 October 1976, saying he'd been writing TV reviews for *The Observer* newspaper, in which he'd described MacDiarmid's appearance on an episode of the

Tonight programme: 'vole-faced, red-shirted Hugh MacDiarmid, arguably (as one tribute has it) the greatest Scottish poet since William McGonagall, inferior to him only in sense of irony.' In the letter to Conquest, Amis remarks: 'He was actually worse than I had room to say, saying he didn't like being called greatest since Burns because B wasn't much good; greatest since Dunbar would be more like it. Off his head, of course.'

LINDA: Pretty dismissive!

ALAN: It's not simply that Amis and Larkin were politically opposed to MacDiarmid, or that their preferred kind of writing – or even the sort of things they liked reading and doing in their lives – was so different from MacDiarmid. That's perfectly normal. But what you get in those comments implicitly is an utter denigration of a different national context. There is no attempt at all to see MacDiarmid from anything other than their own perspective. And that brings out how narrow their perspective is.

SANDY: But then – think of so many other countries throwing up politically engaged writers – Nazim Hikmet in Turkey, Günter Grass in Germany, Sartre and the student revolution in France, Pablo Neruda working right up to the 1970s

ALAN: There was also Ernesto Cardenal, especially in the 1970s and 80s, in Nicaragua, and Yevtushenko and Voznesensky in the USSR. It was Ronald Stevenson, in fact, who introduced MacDiarmid to Cardenal's poetry in the 1970s and MacDiarmid responded by saying that he thought Cardenal was better than Pound in some respects – an astonishing compliment to come from him near the end of his life!

LINDA: He recognised the political affinity as well as the poetic authority of the work.

ALAN: Exactly. And in the USA, like England, many poets had become politically disengaged in immediate terms, but you've got Ed Dorn and Amiri Baraka, poetry associating itself with social justice, black rights, feminist poetics, Adrienne Rich, and so on. The era of Ezra Pound is receding and Bob Dylan and popular protest song is loud and clear but of course that's also compromised by the commercial imperative. It's popular and it's money-making. So MacDiarmid in this company was a slightly younger contemporary of Pound but he comes forward and is clearly in a coincidence of temperament with Neruda, Sartre, Yevtushenko and the South African 'Freedom Poets' of Barry Feinberg's 1974 anthology, for which MacDiarmid wrote a Foreword – he's very much a man of the left and completely out of sympathy with Osborne, Amis, Larkin, let alone Auden. In *Who's Who* he listed 'Anglophobia' as his recreation and a lot of rather mealy-mouthed people nowadays are keen to say he was an anti-English racist but the point is he *was* anti-English, in his poetics, his language, his whole sensibility. There's a big difference between that and ignorant racism. In fact, you might wonder whether there wasn't an element of 'Scotophobia' in those remarks of Larkin and Amis. But the most important thing is that MacDiarmid put forward the idea that Scotland could rightfully take its place on the world stage, where all nations could be equal, a comity.

SANDY: The egalitarian ideal, with a vengeance!

LINDA: And his English contemporaries couldn't quite sympathise with that.

ALAN: The challenge was to make it worth being, to make it worthwhile. The English writers had no interest in that. Their political world was essentially different. Edwin Morgan gets that distinctively Scottish spirit exactly in his poem for the opening of the resumed Scottish Parliament...

SANDY: We'll come to that later. But I guess we need to try to sum up MacDiarmid's legacy, don't we? To a certain extent his achievement had begun to be seriously recognised towards the end of his life. In 1973, MacDiarmid took part, alongside

Josef Beuys and Tadeusz Kantor, in a conference called 'Edinburgh Arts', organised by Richard Demarco. Demarco also presented a conference marking the tenth anniversary of MacDiarmid's death in 1988. In the latter years of his life, MacDiarmid was appointed Professor of Literature by the Royal Scottish Academy.

ALAN: Trying to sum up the achievement is next to impossible though. There's a verse that comes to mind, from a poem called 'The War with England':

> I was better with the sounds of the sea
>> Than with the voices of men
> And in desolate and desert places
>> I found myself again.
> For the whole of the world came from these
> And he who returns to the source
> May gauge the worth of the outcome
> And approve and perhaps reinforce
> Or disapprove and perhaps change its course.

Poets' Pub

SANDY: Soon after I started painting the individual portraits of the poets, the idea of a large group painting began to formulate in my mind. In the spring of 1980, I suggested to George Mackay Brown that I had an idea for a big painting of all of the poets together in Milne's Bar. He was very enthusiastic and I immediately knew that it had to be done. There was another reason why such a task became important to me. In the aftermath of the failed referendum on Scottish devolution in 1979, it seemed imperative to make a positive statement about Scotland and Scottish culture. A large painting of these great poets would be such a statement. In *Poets' Pub*, I've tried to evoke the romance of Edinburgh's bohemian life of the late 1950s and early 1960s. At that time there was a thriving intellectual life centred on the Rose Street pubs where poets, painters, musicians, actors, publishers, lawyers, politicians and students would congregate nightly. As Karl Miller puts it in *Memoirs of a Modern Scotland*, 'It bred this tradition of conviviality and talk. The passion in the Rose Street pubs had to be heard to be believed.'

As a young student, I haunted the Rose Street bars with my closest friends, keeping company with the poets Hugh MacDiarmid, Norman MacCaig, Sydney Goodsir Smith, George Mackay Brown, George Campbell Hay and Tom Scott, the composer Ronald Stevenson, the art critic John Tonge and many other characters and raconteurs too numerous to mention. In the painting, the poets are placed together in a space resembling a combination of Milne's, the Abbotsford and the Café Royal – the so-called 'poets' pubs'. The main figure is that of Sydney Goodsir Smith, who died in 1975, a few years before I embarked on the portraits. I think all of the others would have wanted Sydney to be central. He was that sort of character, the life and soul of the proceedings. The moment he entered a room, the company just charged up. He wrote many fine verses about Edinburgh pub life, including *Kynd Kittock's Land* (1965), in which he describes the poets MacDiarmid, Robert Garioch, MacCaig, Mackay Brown, Alexander Scott and Albert Mackie, who was also a journalist, all in one of these pubs:

> Grieve and Garioch aye tuim their pints,
> Mackie wheezes, Scott aye propheseezes
> Frae his lofty riggin tree
> While lean MacCaig stauns snuffin the Western seas
> And Brown leads wi his Viking chin
> And winna be rebukit.
>> Name the names, O Auk
> As tributaries o' the Muse.
> And spurn the mean, lang-heidit pencil-nebs
> Like terriers yapping at their shades
> – Nae man kens why; it could be envy, shairly,
> But wha wad envy sic penurious scribes?
> – Search me, nuncle, I ken nocht aboot it.

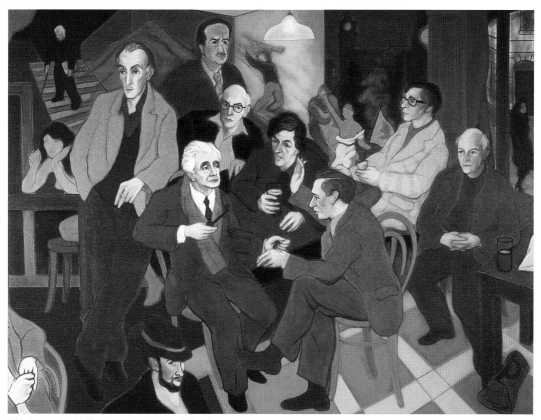

1.35 **Alexander Moffat b.1943** Poets' Pub 1980–82

Edwin Muir once quipped that the Milne's Bar drinkers were 'Men of Sorrows, afflicted by Grieve' – but Milne's Bar was also visited by Sean O'Casey, Dylan Thomas, the Indian poet Dom Moraes and T.S. Eliot, among others.

ALAN: And in the previous verse in Goodsir Smith's poem, he refers to Edinburgh's Canongate murmuring the names of 'lang deid bards' who might have been found in such a company – Allan Ramsay, Robert Fergusson, Burns himself and James Hogg – 'the Electric Shepherd / (As they cry him)', who 'Still hauds up his boozie snoot for nourishment...'

SANDY: I should say something more about John Tonge, who I've depicted coming down the stairs

in the top left-hand corner of the painting, with his walking-stick in his hand. As a student at St Andrews University in the late 1920s, Tonge had embraced MacDiarmid's ideas about the Scottish Renaissance. Alan Bold said that 'St Andrews in 1935 could claim to be the cultural centre of the Scottish Renaissance'. Since 1931, F.G. Scott had taken his annual summer holiday there and Edwin and Willa Muir had settled there in 1935. Douglas Young was at the university and was very well-known as a poet, translator, polymath and polemicist, and stalwart of the Scottish National Party. He was a conscientious objector during the Second World War and the significance of this was

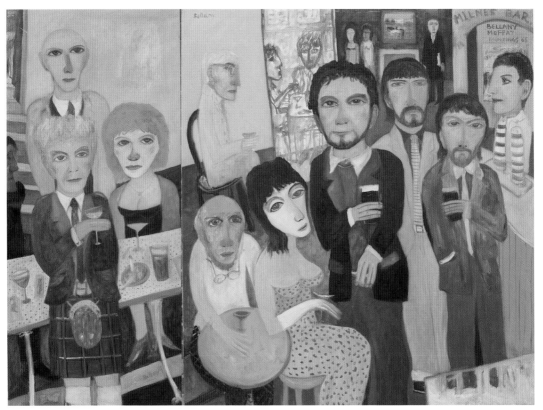

1.36 John Bellany *b.*1942 Milne's Bar 2007

very widely recognised. For many of the writers, the literary energy of St Andrews was largely due to the activities of the wealthy American owner of the handsomely-designed Modernist periodical, *The Modern Scot*, James H. Whyte, who established the Abbey Bookshop in 1931 and also opened an art gallery. 'On a Raised Beach' is dedicated to Whyte and John Tonge. MacDiarmid would later include them both among the dedicatees of *In Memoriam James Joyce*.

ALAN: John Tonge was the author of a book called *The Arts of Scotland* published in 1938.

SANDY: That book was written to accompany a major exhibition of Scottish Art at Burlington House, and at that time, Sir William Llewellyn, the President of the Royal Academy, said that he had no idea there was such a rich and distinctive tradition of Scottish painting. It was an eye-opener for those London types, as it would be today. For a long time afterwards, that book remained one of the few overviews of the history of Scottish art. During the Second World War, in which he served in the RAF and was based in the south of England, Tonge befriended Robert Colquhoun and Robert MacBryde and helped them build their careers in London. By the early 1960s, he worked for the *Press and Journal* in Aberdeen but still managed to write occasionally about contemporary art. He was a highly cultivated man whose sophistication in all

matters had a telling influence on both John Bellany and myself. But my main aim in painting *Poets' Pub* was to celebrate Scottish cultural achievement by means of depicting this unique generation of poets.

ALAN: Sandy's painting brings that great generation of Scottish poets together and MacDiarmid's life spans through all these other lives. To a greater or lesser degree, all of them were friendly with him. Iain Crichton Smith said that MacDiarmid was the most tremendous influence and example, not in the sense that he wrote anything that might be imitated, but that he was an influence, absolutely, in that he showed that it could be done, that it was possible to have deep commitment and radicalism and to express yourself fully in literature or in any of the arts. Never content with being second best, or think that Scotland was something to be ashamed about, but to begin with the sense that writing should be a public thing, engaged with the way people are, as an art.

We could draw to an end with two quotations that show that continuity. First, Naomi Mitchison's 'The Scottish Renaissance in Glasgow: 1935':

> Somewhere up grim stairs, steep streets of fog-greased cobbles,
>
> In harsh, empty closes with only a dog or a child sobbing,
>
> Somewhere among unrythmic, shattering noises of tram-ways
>
> Or by crane and dock-yards, steel clanging and slamming,
>
> Somewhere without colour, without beauty, without sunlight,
>
> Amongst cautious people, some unhappy and some hungry,
>
> There is a thing being born as it was born once in Florence:
>
> So that a man, fearful, may find his mind fixed on tomorrow.

Now put that alongside Seamus Heaney, writing in 1995. Heaney says this:

> There is a demonstrable link between MacDiarmid's act of cultural resistance in Scotland in the 1920s and the literary self-possession of writers like Alasdair Gray, Tom Leonard, Liz Lochhead, and James Kelman in the 1980s and 90s. MacDiarmid prepared the ground for a Scottish literature that would be self-critical and experimental in relation to its own inherited forms and idioms, and that would also be stimulated by developments elsewhere in world literature.

SANDY: So the legacy is that it's still a matter of contemporaneity. It's a matter of recognising that nothing in art is easily confined to a historical position only, if it works as art at all. You mentioned earlier that phrase MacDiarmid came out with, 'It's not tradition that matters, it's precedents' – the things you can take, for your own use, to help make it work. And it doesn't matter where they come from.

ALAN: It's what you do with them that counts.

Part Two
Poets of the Highlands and Islands

The Highlands and Islands

ALAN: We began with the idea of 'Time' and how the arts – poetry and painting especially – were connected, from the 1890s to the 1930s and 1940s. Now we'd like to look more closely at the artists and poets working predominantly during and after the Second World War, and their link to their land and surroundings in the Highlands and Islands of Scotland. This is a particular story, not a universal one – it's distinctive to Scotland, Scottish history and the terrain of the country, the tidal, returning, haunted landscapes and seascapes of Scotland.

LINDA: So is there a particular history and geography from which the work of these artists and poets arises?

ALAN: Yes – and yet, you have to qualify that a little. There is and there isn't. I mean, yes, certainly, there are particular aspects of the history and terrain that are unquestionably pertinent to their work and lastingly so – but these are artists and poets we're talking about – the specifics of history and locality are not limitations or finally defining things. Let's see – how can I describe this? Since the Jacobite rising of 1745 and Culloden in 1746, the Highlands and Islands of Scotland have had a kind of double history: in fact and in fiction, or in history and in myth. And literature – especially poetry – has a lot to do with moving between these two areas. Maybe that's something only literature or art can do anyway – the truths that it tells aren't documentary data, proven facts like the basic material of history; neither are they the big, unexamined myths that so many people take for granted so much of the time, belief systems they just accept. The arts are between these extremes, they move beyond mere data and they ask questions about what people take for granted. The truths of art are essentially of the imagination. That's what they're about, that's what they're for.

In his autobiography, *Theme and Variations*, the conductor Bruno Walter (1876–1962) defines this:

History! Can we learn a people's character through its history, a history formerly made by princes and statesmen with an utter disregard of, frequently even in opposition to, its interests? Is not its nature disclosed rather by its poetry, by its general habits of life, by its landscape, and by its idiom? Are we not able more deeply to penetrate into a nation's soul through its music, provided that it has actually grown on its soil?

Is anyone entitled to speak with authority of the Russians who has not become familiar with Pushkin, Lermontov, Gogol, Dostoyevsky, Tolstoy, and Gorky, and has not listened to the music of Mussorgsky, Borodin, and Tchaikovsky?

I have preserved the unshakable conviction that man's spiritual accomplishments are vastly more important than his political and historical achievements. For the works of the creative spirit last, they are essentially imperishable, while the world-stirring historical activities of even the most eminent men are circumscribed by time. Napoleon is dead – but Beethoven lives.

SANDY: Let's get back to Scotland. After Bonnie Prince Charlie escaped to France, reprisal was immediate and the assault on Gaelic Scotland was violent, to say the least. Now that's a familiar image – the iconic picture of BPC and his doomed rising and the bloodshed that followed. History or myth? And how does art figure it?

ALAN: Looking back from the 21st century over that whole story, you can see something very strange happening culturally. The Gaelic language, playing the bagpipes and the wearing of the kilt – traditional, or simply normal, things, clothes, music, language – they were all intensely suppressed. And after that happens those things take on a strange power. They become symbols, if you like. But they become symbols *of themselves*. They stand, symbolically, for Highland culture as a whole, but they are actual representations of the potency of their own existence. That's a phenomenal thing. Gaelic becomes a symbol for itself, a language, and all that a language means by

way of negotiating between people and the place they live in, its climate, resources, economy, requirements. And bagpipe music was significant in itself as a kind of resistance. MacDiarmid has a lovely poem called 'Bagpipe Music' with these lines:

> The bagpipes – they are screaming and they are sorrowful.
>
> There is a wail in their merriment, and cruelty in their triumph.

He says they're like the human voice but then he corrects himself and says no, for the human voice lies and so, 'They are like human life that flows under the words.' That's a terrifically powerful idea. Another form of resistance. And the whole story of Gaelic poetry and Highland culture from the late 18th century right up till now is a way forward from that watershed.

LINDA: Did you feel that had a particular personal effect on you, when you were growing up?

ALAN: I was aware that my name, Riach, is a Gaelic word. Sorley MacLean himself once gave me a full reading of its meaning and history, but I don't speak Gaelic, my father has no Gaelic and he has no recollection of his father ever speaking Gaelic, so you'd be going back four or more generations in our family before you'd get to someone who could speak the language of our name. That's part of Scotland's story too.

LINDA: And you, Sandy?

SANDY: Growing up in Lowland Scotland in the 1950s, I had a rather vague awareness of the Highlands. Certainly there was bagpipe music, but it was pipe bands and marches on miners' gala days and strathspeys and reels at the dances afterwards – there was nothing to convey any knowledge of pibroch, the classical music of the pipes with those huge sequences of variations that are so intense and piercing. Although we might have heard something about the Clearances, there

was no overview, no sense of what the Highlands and Islands were in Scotland's history and how their people were connected to us. And as to the literary significance of Gaelic, we knew almost nothing about that.

ALAN: In the 18th century there were three major literary traditions in Scotland and each had its own language: Gaelic, Scots and English. Now, there was overlap and complexity and some people in each tradition knew about other people in the other traditions but there was no organic, uniting political or cultural force there. In fact, the separation of those three traditions or contexts of cultural production for a long time meant that Scottish literature could be dismissed, or at least relegated to insignificance, because it wasn't an organic, unified thing. The idea of an organic national culture is very much a post-Romantic, Victorian to Modern, basically imperial idea. It's T.S. Eliot displacing Matthew Arnold as the central cultural judge. The implication is that in the English-speaking world there's one central culture, one language and so on. You can see this idea debased and degenerated in these idiot politicians trying to tell you that you have to speak English and play cricket to be a proper British citizen. It's as if they don't know about the indigenous languages of their own country, or want to liquidate them altogether. Anyway, the legacy for Scotland is evident enough now. You have a long tradition of Gaelic poetry. That tradition encompasses song, oral tradition, and written forms. For example, think of the work collected in *The Book of the Dean of Lismore*, a manuscript which dates from 1512, published in 1862, that included praise poems, satires, love lyrics, Christian poems, mild obscenities and Ossianic heroic ballads, so the connections with Ireland are clear. You have the vernacular tradition in Ramsay, Fergusson and Burns, who are all both urban and rural, spontaneous and learned, very much of their time but also drawing from and connecting with the earlier Scots poets of the 15th and 16th centuries. And you have the English-language writers, the Enlightenment philosophers and literati, the critics and journalists – and because these guys are the arbiters of taste, their language and all its implicit attitudes has prevailed. This is the legacy that came down to us through generations of anglified teachers and an education system that always privileged English. The key moment is Dr Johnson, sanctifying English and denigrating both Scots and Gaelic.

SANDY: Johnson was only one of a great number of visitors – wealthy tourists, really – who came to Scotland to enjoy it as a Romantic landscape. Mendelssohn is the most famous but there are native Scots who go on tours of the north as well – Smollett, Burt, Pennant, not to mention Burns, Scott and Hogg – so the Highlands comes to have a kind of kind of sheen, a veneer of fiction. It's an exotic place to visit rather than a local habitation with a name and an economy of its own.

ALAN: One moment I do pause and listen to is when Boswell and Johnson are walking across Culloden field. Johnson is silent. They must have felt something there, something real. Like visiting a desolate First World War battlefield in 1920, say.

SANDY: The historian Bruce Lenman notes this sensitivity in Johnson and Boswell:

> In 1773 Dr Samuel Johnson and his friend James Boswell were touring the Highlands during a summer full of the bustle and talk of emigration. Neither man approved of it. On Skye Boswell deplored the forcing out of tacksmen on the grounds that men of substance could withstand bad years better than a poor rack-rented tenantry, while on Coll Dr Johnson remarked, crushingly, that 'the Lairds, instead of improving their country, diminished their people'.

And that diminishment went hand-in-hand with the stereotyping of images associated with the Highlands. The Victorian image of the Highlands and the sentimentality that became attached to Highland landscapes, or else the image of the

Highland people as 'teuchters' – big strong men, bumbling buffoons, was firmly established throughout the 19th and early 20th centuries. There's a long persistent history of this idea.

Allan Massie sums it up: 'Scotland has never been monocultural,' he says. 'For much of our history, there was a sharp divide between the Gaelic-speaking north and west, and the Scots-speaking south and east.' He continues:

> Back in the fourteenth century, the chronicler John of Fordun distinguished between the two cultures: 'The people of the seaboard and the plains are of domestic and civilised habits, trusty, patient and urbane, decent in their attire, affable and peaceful, devout in divine worship, yet always ready to resist a wrong at the hands of their enemies.
>
> 'The highlanders and people of the islands on the other hand are a savage and untamed nation, rude and independent, given to rapine, easy-living, of a docile and warm disposition, comely in person but unsightly in dress, hostile to the English people and language, and owing to the diversity of speech, even to their own nation, and exceedingly cruel.'

Massie agrees with the historian T.C. Smout that this was the attitude towards Highland Gaelic society which persisted in the Lowlands for nearly six centuries. When Boswell and Johnson tour the Highlands, Boswell, son of an Ayrshire laird, considers that he is visiting a culture 'almost totally different' from his own. And about a hundred years later, Robert Louis Stevenson writes that 'the division of races is more marked within the borders of Scotland itself' than between Scotland and England but he goes on to say that 'Galloway and Buchan, Lothian and Lochaber, are like foreign parts; yet you may choose a man from any of them and, 10 to one, he shall prove to have the headmark of a Scot.'

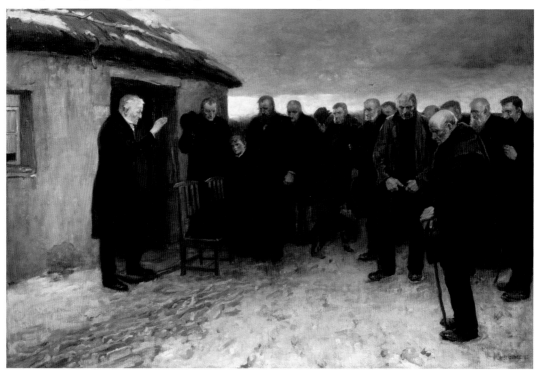

2.1 James Guthrie 1858–1930 Highland Funeral 1882

ALAN: We suggested earlier that maybe in itself this is the distinctive characteristic of Scottish identity. Think of Norman MacCaig, for example, a most urbane man writing in precisely modulated English. And yet his concerns are very deeply rooted in the culture and language of the Highlands of Scotland. His politics, even if they are normally implicit, are very clear. He doesn't use language as political rhetoric but his politics can be seen in his treatment of the national tragedy of the Highland Clearances in his longest, most explicit poem, 'A Man in Assynt' (from *A Man in My Position*, 1969), where he begins with the geological prehistory of north-west Scotland but rapidly moves to the question of ownership, the vexed relation between property and love:

Who owns this landscape?

The millionaire who bought it or

the poacher staggering downhill in the early
* morning*

with a deer on his back?

The pragmatic urgencies of politics (crofters' rights, the evils of absentee landlords) are set against elemental and almost abstract ideas:

Who possesses this landscape?

The man who bought it or

I who am possessed by it?

Yet MacCaig admits that these are 'False questions' because 'this landscape is / masterless' – docile 'only to the weather'. But the questions don't go away: they return throughout the poem, haunting the poet as he walks through this land, by the seashore, asking, where have the people gone? And who does the sea belong to, governments or guillemots, fish for city-folk to eat, or the locals? He asks if the landscape itself does not belong to the dead, to those

whose loyalty

was so great it accepted their own betrayal

by their own chiefs and whose descendants now
are kept in their place
by English businessmen and the indifference
of a remote and ignorant government.

SANDY: One other thing I remember people, especially Norman MacCaig, speaking about when I was a student: land rights, the whole business of absentee landlords, investors from London or Germany or just about anywhere except Scotland, who owned all that land for their huntin' an' shootin'...

ALAN: There's one politician who should be noted here, Tom Johnston, Secretary of State for Scotland in Churchill's wartime coalition government. Johnston really did help to bring about change in the Highlands and Islands. He was determined to benefit the people who lived there. In the 1940s and 1950s, with the development of the Hydro Board, Johnston confronted people with vested interests who thought all the energy that could come from those parts of Scotland should be directed towards industry. Johnston said no, the first loyalty and responsibility should be to the people who live there. That was a very important choice. So the more isolated communities got electricity. That wouldn't have happened if Johnston hadn't confronted and opposed those interests.

SANDY: But in the popular perception of the Highlands and Islands, nobody really got to grips with the situation until John Prebble at the beginning of the 1960s. Prebble was Canadian and his books, *Culloden, Glencoe, The Highland Clearances* and *Mutiny,* were all immediately accessible and well-reviewed. They all became best-sellers and had a huge impact. There was also the Englishman Peter Watkins, whose film *Culloden* was commissioned by BBC television in 1964 and then I think was shown once and never broadcast again for a quarter of a century. Too violent, they said – but that was an excuse. The real reason was that it

was a political hot potato. Watkins left Britain in despair over the banning of his work and he moved to Sweden, where he continued to make films, war, or rather anti-war films, but not only that – he made a film about Munch which I think is the finest film ever made about an artist.

ALAN: A far cry from David Niven in *Bonnie Prince Charlie* in the 1948 Hollywood movie.

SANDY: As children we went to the cinema to see westerns and in these, the Indians were the Highlanders, the indigenous peoples, wild and savage, who had to be civilised in the name of progress.

LINDA: Or simply killed off…

ALAN: There wasn't even a sense of dignity – you might have great Indian chiefs like Geronimo but Bonnie Prince Charlie was a Frenchified fop or an Italianate ninny, wine-drinking, effeminate, effete, and so hardly even a worthy enemy! But then you come to 7:84's play, *The Cheviot, the Stag and the Black Black Oil* – in the early 1970s.

One of the most important things about that play is that it tells the historical story of the places it was performed in. The people from those places had never before experienced their own story being told to them in that way. That's an uncanny thought. John McGrath and 7:84 made that history contemporary, immediate.

SANDY: And just at the time when Sorley MacLean and Iain Crichton Smith were becoming a lot more prominent. MacLean's *Selected Poems* appeared from Canongate in 1977 – the first major selection of his work to be published. The sheer power of his poetry

2.2 John Byrne *b.*1940 Set-design for the Cheviot, the Stag and the Black, Black Oil 1972

combined with a growing understanding of the overall story of the Highlands brought widespread realisation of what an important figure MacLean was. When he was teaching in Mull and Plockton and became headmaster there, he really threw his energies into putting Gaelic back into the school curriculum. Most people then would have thought he was wasting his time. By the late 1970s, the opposite was true – it was seen as a battle well worth fighting for. By the end of the 1970s, I think we had a much more complete view of Scotland, a sense that the diversity of the nation was important. Whereas the old imperial, Darwinian notion would have been that minority languages would just fade out and become extinct, and that that wouldn't be such a bad thing. The survival of the fittest, and all that. If MacLean was alive today, what would he make of the fact that at Holyrood, at the Parliament building, all the major signage is in both English and Gaelic? Not English and Scots, but English and Gaelic!

LINDA: So there is a major reappraisal going on here?

ALAN: Yes. I'm sure that's right.

SANDY: There's been major reappraisal of the culture of Gaeldom over the past 25 years or so. Think of Gaelic broadcasting, for example, or the new galleries that have been set up in Stornoway and Portree and Stromness. Then when you think of William McTaggart, one begins to reappraise his entire life's work. It's only in this new context that we begin to understand the significance of the fact that he's a Highlander himself; that he was painting about the Clearances, and not just rosy-cheeked children playing on the beaches at Machrihanish. And that's about the whole idea of time as well, because most of the great upheavals in history were consigned to a kind of safety zone – you know, Wallace, Bruce, Mary Queen of Scots, and so on – they were all securely of the past. But if you really looked at the situation in the Highlands, it was a running sore. McTaggart's painting is in the present tense. Angus Calder summed this up when he said that the tragedy of Gaeldom 'persists in consciousness as almost the universal prototype of clearance everywhere'.

ALAN: In fact, the Clearances are part of history but the term also to applies to the way in which the artists of the Highlands and Islands have been neglected. It's only recently that the significance of Highland art has begun to be properly valued.

SANDY: There's no doubt that the visual arts in a Gaelic context have been undervalued but this is now being addressed by Murdo Macdonald, Professor of History of Scottish Art at Dundee University. He is leading a major project entitled 'Window to the West: Towards a Redefinition of the Visual within Gaelic Scotland', in conjunction with Duncan of Jordanstone College of Art and Design and Sabhal Mòr Ostaig, the Gaelic College in Skye. A little book was published in 2008 by the Royal Scottish Academy drawing on the research already achieved by Murdo Macdonald, Joanna Soden, Will MacLean and Arthur Watson, with the title, *Highland Art*.

The Visualisation of the Highlands

SANDY: Romanticism was the big new movement towards the end of the 18th and the beginning of the 19th centuries. Its central subject in painting was landscape and the representation of the sublime. Before Romanticism, there's hardly any trace of the Highlands as a subject in the history of art. But in terms of the British Isles, apart from north Wales, I guess, the Highlands is the ideal terrain. It supplies in abundance what the Romantic artist was looking for. And the greatest of all Romantic artists was Turner, who made a total of six trips to Scotland between 1797 and 1834. He considered Scotland 'a more picturesque country to study than Wales', because 'the lines of the mountains are finer and the rocks of larger masses'.

Turner set the standard and the example. But these artists are all tourists, they go up there into

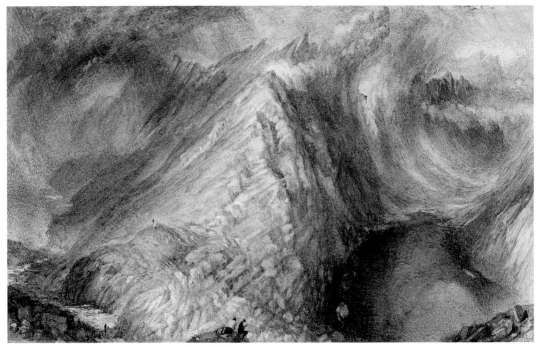

2.3 J.M.W. Turner 1775–1851 Loch Coruisk, Skye *c.*1831

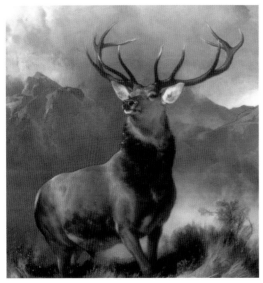

2.4 Edwin Landseer 1802–73 The Monarch of the Glen 1851

the Scottish Highlands to seek inspiration from the wilderness but then they go back to their studios in London to paint up what they've made notes and sketches about. So in that respect they're the equivalent of Boswell and Johnson. By the mid-19th century, though, Romanticism had atrophied into a kind of Victorian sentimentalism. The works of Landseer are prime examples of this. The imagery of Landseer's paintings is pervasive to this day. Millais was also part of this story – he was one of the huntin' and shootin' set – that was his Scotland, really. Claims that his late landscape paintings of Perthshire show him moving towards a kind of Impressionism or proto-Modernism are completely bogus. They're as sentimental as Landseer. He never really saw further than that.

ALAN: Most people would question Landseer's imagery now. There's been a big change in critical

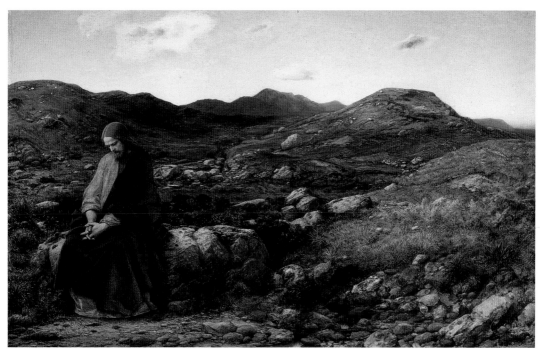

2.5 William Dyce 1806–64 Man of Sorrows c.1860

understanding of the work and its context. But aye, it was certainly a major source for international images of Scottishness. When an extensive exhibition of Landseer's paintings was put on in the National Galleries of Scotland in 2005, there was considerable controversy in the press about how little his work was contextualised by the exhibition curators. It was put on as a grand spectacle for the tourists and it was envisaged as a blockbuster exhibition but it ended up as a damp squib. It could no longer be seen simply as a straightforward representation of the Highlands because everyone could see through the superficiality of the images. It's bad art but it was very effective propaganda in its time.

SANDY: Luckily, that time is over!

Compare Landseer's work with the painting by William Dyce of Christ in the wilderness, an intensely-perceived vision of a Highland landscape related to the religious theme. For Landseer, the landscape is basically a stage set but for Dyce, it's a specific location with its own special character. By placing Christ in this landscape, Dyce creates a painting that demonstrates a kind of relevance that really passes Landseer by entirely. This is one of the great Highland landscapes, perhaps because of the depth of feeling and commitment Dyce's painting transmits to the viewer.

ALAN: If you look at Landseer, the message is essentially making a sentimental package out of the landscape. It's the same point we made about Thomas Laurence as opposed to Raeburn. Landseer's paintings seem cold and merely commercial, when you compare them to this work of Dyce.

SANDY: And there's one glaring exception to the

bogus Landseer view of the Highlands: William McTaggart. The ideal of the Romantic landscape does not provide for the human element, human society – society is somewhere else. With McTaggart, you're always conscious of the fact that people actually live in the Highlands. These are inhabited landscapes. It's not in the foreground as Millet or Courbet would depict peasant society in France, but it's there all right. He was deeply aware of the social history of Scotland and he remains the only painter of his time who really understood that beyond the façade of grandeur there were real human beings living and working there. McTaggart came from a Gaelic-speaking crofting and fishing family in Kintyre, so when he painted a coastal scene he understood what he was painting from a socially engaged perspective. He thus integrated

his Highland background into his work, making no distinction between his modern self as an artist and the traditions of his folk. McTaggart's engagement with his subject matter is at its height in a series in which he draws directly on his youthful memories of the Highland Clearances: the 'Emigrant Ship' paintings. They're not obviously political propaganda and that's part of their greatness. As the art historian Lindsay Errington has said, 'these compositions were never intended as a news-style record of any one emigrant group's departure but rather as an emotionally-charged reflection or recollection of Scottish Highland emigration as a whole.'

ALAN: The Romantic movement's radical break with tradition was to overturn classicism, order and pattern with that individualistic aspiration towards

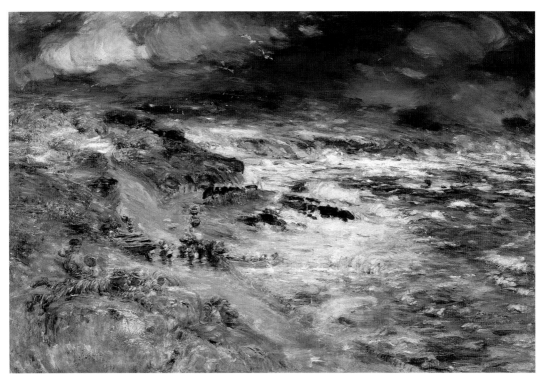

2.6 **William McTaggart 1835–1910** The Storm 1890

the sublime, that soaring leap of individuality. By that token, Romanticism glorifies the individual and neglects the social dimension. But McTaggart keeps it in mind.

SANDY: Aye, exactly. And because of that, there is a direct link with the work of Sorley MacLean, Iain Crichton Smith and George Mackay Brown – who come later but equally have this sense of their own social world and that of their families and ancestors.

ALAN: There's another distinction here, too. The preoccupations of the early Modernists reflected a cosmopolitan outlook and an urban context. Modernism is city-based – all the major artists were centred in Paris, Berlin or New York, or even London. Rural issues were not part of the avant-garde thing.

SANDY: The city was the home of sophisticated, cosmopolitan artists. Such artists might go to remote places – to project a Cézanne-ist vision, for instance, upon the landscape, rather than to represent anything of the history or sensibility of the lives of the people who lived in it. To the arbiters of taste in the cities, even in culturally enlightened countries like Germany, Bartòk out in Hungary and Sibelius up in the Finnish woods were country bumpkins. How could they be great composers like Reger or Pfitzner? And if we look at what the London critics said of Jack Butler Yeats, we find the same lack of understanding. Patrick Heron reviewed the

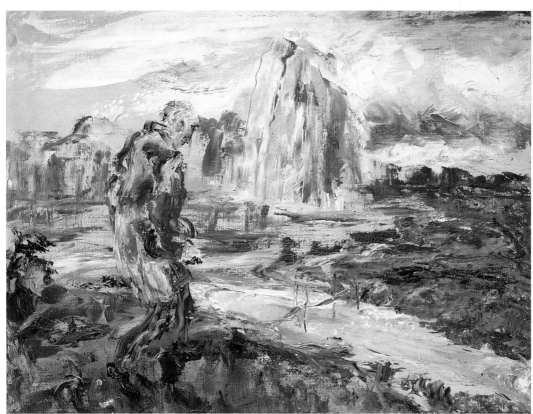

2.7 Jack B. Yeats 1871–1957 On Through the Silent Lands 1951

2.8 David Forrester Wilson 1873–1950 An Islay Woman 1931

Tate Gallery show in 1948 in these terms: 'One cannot possibly feel that the majority of paintings in this exhibition are anything but tentative in their suggestion of solid objects in space.'

ALAN: Of all the great artists of the early 20th century, he's my favourite, Ireland's greatest painter, I think. Brother of the more famous W.B. – you know their father once remarked, 'One day I shall be known as the father of a great poet – and the poet is Jack!' He was a fascinating writer as well, a novelist and a playwright, the author of wonderful plays for the miniature theatre. He is the link between the experienced world of a writer like John Masefield, a man of the sea whose writings deal with the experience of sailors and ships, and an eagle-eyed, shrewd and politically keen-minded aesthete like Samuel Beckett.

SANDY: Jack Yeats was a Sligo man. He knew the people he painted, he was familiar with their ways of life and the landscapes, weather, climate, the terrain of their lives, and he put all these things into his paintings. Here's part of a 'Eulogy' for Jack Yeats by the influential Dutch museum director Rudi Fuchs:

> While the artistic revolution was breaking out on the European mainland, Jack B. Yeats worked in Devon after 1897 and later in Ireland, from 1910 onwards, first in County Wicklow and then, after 1917, in Dublin where he continued to live for the rest of his life. He was a contemporary of Picasso, Munch and Matisse but never took part in the explosive stylistic debate of the 20th century. Literally and physically, he kept a distance from this so as to remain undisturbed in the melancholy music of his own fairylike, imaginative world. He travelled seldom but looked a great deal at his surroundings: horse races, country fairs, travelling circuses, the streets of Dublin – in Ireland, that enchanting island, his imagination found its home. His attitude was that of a Romantic: rather than organising the world and art according to lucid principles of style, as the Modernists did, he allowed himself to be carried away by what he saw – and from there into his memory which, in masterful paintings merged with his observation. 'No one creates,' he told a friend, 'the artist assembles memories.' His self-imposed detachment allowed him to go his own slow, atmospheric way and find the broad imaginative space for his mysterious paintings.

There are affinities, of course, between Jack Yeats and William McTaggart. If you look at what they do with the material, the paint itself, you can see that there are astonishing similarities there. The way they mix colour, brush it on, their way of seeing, how they combine and merge figures and landscapes.

ALAN: It's as if you can hear the sounds of the landscape, the wind in the grass and the trees, in McTaggart's paintings; or sense the warmth of the fire in the hearth or the taste of a drink in a pub, the strength of a jockey or a circus performer in a Jack Yeats painting. These are lived experiences. That's very different from what you see in Millais or Landseer.

SANDY: To think that both McTaggart and Yeats were written off by some critics as mere 'daubers' who couldn't finish a painting! That's the thing. There's nothing fixed in their paintings. They understood that in nature, everything is continually changing. That's what makes their paintings so moving – life coming and going, Yeats's meetings on the road, occasional moments, McTaggart's waves, tides, clouds, wind. These are the ungraspable things fools suppose cannot be painted.

ALAN: In Scotland, there is probably no equivalent of Jack Yeats in the 20th century, but the spirit of the character being described there is very close to that of Sorley MacLean, Iain Crichton Smith and George Mackay Brown.

SANDY: There is a forgotten figure named David Forrester Wilson (1873–1950), who was born in Glasgow and studied in Italy, Belgium, Paris and London. He was invited by Fra Newbery, director of the Glasgow School of Art, to join the staff just before the First World War and he was Head of Painting from 1931 to 1938. In 1911, he was commissioned to produce the mural decorations in the banqueting hall in Glasgow City Chambers. What's interesting is that he was actually out in Islay in the 1920s and 1930s, painting the people who lived there. *An Islay Woman* is one of the best portraits of any woman in all of the 20th century. It's wonderfully sympathetic, based in the knowledge and experience of what her life was like. This is not sentimentalism or portraiture as advertising. Another of his paintings, *The Young Shepherd*, pre-echoes European socialist realism. There's nothing quite like it in Scottish art of this time.

LINDA: There must be dozens of paintings by this man. Where are they? Has his life ever been fully researched?

ALAN: There's a very serious point here. Isn't there an enormous gulf between the work and dedication of this artist and the management priorities of Scotland's major art galleries? The work of artists

2.9 David Forrester Wilson 1873–1950 The Young Shepherd c.1929

like David Forrester Wilson doesn't fit in with the fashion. David Forrester Wilson must have been most concerned with doing the best job he could as an artist. For that, you have to preserve and protect your privacy, your imagination and your insight. The important point of connection with Jack Yeats is that sense of a major artist not taking part in big public debates about art, as Picasso and Stravinsky and Schoenberg and Eliot and Pound all did, but simply getting on with the job in such a way that an honest response from the viewer must recognise its quality and its uniqueness, its difference – as Richard Strauss did when he said of Sibelius, 'I can do more – but he is the greater!' So the responsibility to the work of such artists must lie with the educationalists and the managers of the art galleries and institutions. The priorities of the artists command a respect they have not always had.

SANDY: Very few important artists visited Scotland in the 20th century but in the years just after the Second World War, two significant figures came to work in Scotland: the photographer Paul Strand (1890–1976) and the artist Josef Herman (1911–2000). Strand was originally from New York, where he made his reputation as a Modernist in the 1920s. In the early 1950s he set out for the Scottish Hebrides with the intention to photograph the people, communities and landscapes of that world. Richard Hough, in *The Hebridean Photographs of Paul Strand*, writes that: 'Rural communities drew his attention. Man's relationship to the place he lives in became the theme of Strand's work. Landscape, common, natural and man-made objects and man himself, heroic by nature, became the subject of his photographs.' In 1962, Strand's photographs of the Hebrides were published as a book, *Tir A Mhurain – The Land of Bent Grass*. In his introduction, Basil Davidson says, 'down the centuries, these people in their islands on the heaving seas have made a community whose values and whose standards are very much their own, proud and vigorous, demanding a great deal of themselves and others. With the rain and wind and rock and shallow soil of their land, they have woven a strong individuality, a

2.10 Paul Strand 1890–1976 Tir A' Mhurain, South Uist, Hebrides 1954

strong determination to resist and to survive. As no other photographs have ever done, those of Paul Strand illumine the life and character this interweaving has created.' Strand shared with Jack Yeats an honesty of vision which meant having a real respect for the things in front of them.

LINDA: And Josef Herman...

SANDY: Herman was born in Warsaw in 1911. He left Poland in 1938 for Belgium but with the outbreak of war he had to escape. He arrived in Glasgow in June 1940 where he lived for the next three years, associating with Benno Schotz, J.D. Fergusson and his fellow Polish painter Jankel Adler. He became close to MacDiarmid, describing him as the only real genius he ever met. There's a story Herman told me, that when the terrible news came that his family had been entirely wiped out by the Nazis, he lapsed into a state of deep depression. One night, in a pub in Byres Road in Glasgow, MacDiarmid came in and saw that he was looking low and asked him what was the matter. When Herman told him, MacDiarmid immediately responded by saying, 'That's absolutely nothing compared to what the Scots have suffered at the hands of the English!' What Herman wanted to emphasise when he told me this story was that MacDiarmid's comment was so magnificently absurd that it had the effect of shifting him out of his gloom. Nobody but MacDiarmid could have got away with that.

LINDA: What about Herman's art in Scotland?

SANDY: While he was in Glasgow, the sculptor Benno Schotz introduced him to a number of friends and acquaintances who recognised that he wasn't well-off and offered him various forms of employment. He responded angrily, saying, 'I already have a job! I am an artist!' He never compromised that ideal. During his time in Glasgow, he met and married Catriona MacLeod from Skye, and there followed numerous visits to Skye and other western islands. He was an old-fashioned socialist who believed in the dignity of the labouring man and his work. No half measures. In a note for his 1984 exhibition of drawings from the Highlands, he wrote: 'A group of fishermen in yellow or black oilskins standing on shore, sitting in the boat or moving about their tasks. A dream-like tranquillity. A planet all its own. In the atmosphere of this planet one forgets the distant hustle and one is reminded of more durable rhythms. Each figure self-contained in a grand form... Each group telling the simple tale of human bondage... And all this happening in slightly moist, soft Highland light.'

Neither Herman nor Strand were interested in Romantic scenery. They were instead interested in the people who lived and worked in great hardship in these remote islands.

ALAN: So let's try and sum up what we've been saying. Maybe there are four major areas of representation of the Highlands: the Romantic sublime of Turner, the sentimentalised vision of Landseer which is the view of the ruling classes, really, the deer-hunting and fishing set, an atrophied version of the sublime. Then there is the whole range of popular art-forms, postcards, sweetie-tins or shortbread-tins, calendars, Harry Lauder music-hall style Scottishness, films like *Brigadoon* or *Bonnie Prince Charlie*. They trade in a debased currency. And then there are the artists who set out to consciously respond to the places and the people who lived in them – and McTaggart, Jack Yeats and Paul Strand and Josef Herman would be among these.

SANDY: And Norman MacCaig, Sorley MacLean, Iain Crichton Smith and George Mackay Brown.

Sorley MacLean (1911–1998)

LINDA: What is really characteristic of Sorley MacLean's poetry?

ALAN: Places – Raasay, Skye, the Cuillin. Major abstractions – love, loss, tragedy and haunting, guilt, moral responsibility. World events, the

2.11 Josef Herman 1911–2000 West Highland Fisherman c. 1940s

Second World War, the situation in Ireland – in poems like 'At Yeats's Grave' and 'In the National Museum of Ireland' – and the terrible fact of the nuclear age, in a poem like 'Screapadal'. But when I think over MacLean's entire body of work, landscapes come most to my mind. One of the most perceptive things I've read about landscape and MacLean's poetry was written by the poet Meg Bateman. She says this:

> Sorley MacLean's poetry concerns itself with the starkest of questions about self-worth and the nature of time. It would be painfully abstract if it was not for his use of landscape as symbol. It is the landscape that gives form and sensuousness to his ideas and that lets him communicate them as emotion.

That's a great insight into how MacLean's poetry works. She goes on:

> He circles between the abstract and the specific. He is at once himself and everyman. Skye is recognisably itself and a terrible roller-coaster of self-loathing, exhilaration, tenderness and despair. Reading his poetry can feel like a physical work-out. To separate MacLean's art from the landscape would be to separate form and content.

So she sees MacLean wrestling with himself, 'in the most exposed and elemental settings, on the bare rock of the Cuillin, by the ocean or below the stars. They represent the lonesomeness of the individual, the blankness of life and the perspective of eternity'. She says, 'The landscape is also the

landscape of the mind. It is both majestic and broken, where his poems run like mad wolves in pursuit of beauty and where art, "a flower to windward", grows on the bare rock.' He describes this pursuit in his poem 'Dogs and Wolves':

Across eternity, across its snows

I see my unwritten poems,

I see the spoor of their paws dappling

the untroubled whiteness of the snow:

bristles raging, bloody-tongued,

lean greyhounds and wolves...

He imagines them running 'through the forests without veering, / over the mountain tops without sheering...' searching for an unattainable beauty:

beauty of soul and face,

a white deer over hills and plains,

the deer of your gentle beloved beauty,

a hunt without halt, without respite.

That's MacLean, a personal vision. But he is also a supremely social poet. His poems speak about others. For example there is that unremittingly bitter poem, 'A Highland Woman' which begins by addressing Christ directly and challenging the Christian vision, when all compassion seems extracted from the scene. The anger is intense. The poem opens with this astonishing rhetorical question: 'Hast Thou seen her, great Jew, / who art called the One Son of God?' Then MacLean describes the woman:

The load of fruits on her back,

a bitter sweat on brow and cheek,

and the clay basin heavy on the back

of her bent poor wretched head.

The load of fruits is a bitter, ironic image. He says that for decades she has been carrying 'cold seaweed / for her children's food and the castle's reward.' What has God to say about this?

And Thy gentle church has spoken

about the lost state of her miserable soul,

and the unremitting toil has lowered

her body to a black peace in a grave.

And her time has gone like a black sludge

seeping through the thatch of a poor dwelling:

the hard Black Labour was her inheritance;

grey is her sleep tonight.

SANDY: When I think of Sorley MacLean's poems, 'Dogs and Wolves' or 'A Highland Woman' for example, I think of those painters who present an unflinching view of the human condition – Picasso, Munch, Goya...

LINDA: What was MacLean's response to the Spanish Civil War?

ALAN: MacLean would have gone to fight Fascism during the Spanish Civil War. He endured considerable personal anguish because he could not go due to his commitments to his family. This was a source of great anguish to him. He was committed to the anti-Fascist cause and knew that he was courageous enough to have fought, but had to hold himself back. During the Second World War, however, he served in North Africa and was badly wounded at El Alamein.

SANDY: In fact, he was one of a number of major Scottish poets who fought in the desert at that time. George Campbell Hay, Hamish Henderson, G.S. Fraser, Edwin Morgan were all there.

ALAN: And Morgan has a poem from the Sonnets from Scotland sequence, which names them, these Scottish poets who went to the desert: MacLean 'at the Ruweisat Ridge', Henderson travelling 'west through tank-strewn dune and strafed-out village', George Cambell Hay watching Bizerta burn, Robert Garioch taken prisoner at Tobruk, G.S. Fraser taking memoranda and Morgan himself serving in the Medical Corps, watching as 'gangrened limbs' were 'dropped in the pail'.

LINDA: But MacLean's fight was in the context of a social vision, wasn't it? It wasn't simply a matter of military service...

ALAN: That's right. He deeply believed that Fascism and Nazism had to be opposed and fought against, literally. He was not a pacifist in that sense but he certainly held to the idea that the struggle against Fascism was a great cause, a way of building towards a better society. That's partly what links him with Goya, I think. Goya's paintings and etchings of war are also part of a great social vision – they reach way beyond the personal lyric response or the idea of 'despatches home' from a singular observer. They have a much more comprehensive meaning.

LINDA: What was MacLean's personal background and upbringing?

ALAN: Sorley MacLean was born in 1911 on the island of Raasay. He went to school in Portree on the Isle of Skye, then on to Edinburgh University. He was writing poems through the 1930s and Douglas Young helped to see his first major collection of poems into print, the *Dàin do Eimhir agus Dàin Eile | Poems to Eimhir and Other Poems*, which was published in 1943 (though his very first publication was a combined effort of selected poems by himself and Robert Garioch, *17 Poems for Sixpence* – that appeared in 1940). The *Dàin do Eimhir* consists of 48 love poems addressing the idea of love, a man's relationship with a woman. These are poems of loss and wounding, weakness and vulnerability – but there is also a sharp, political and Modernist edge to them. There are poems describing the context of war and the landscapes of his islands and the tidal, ebbing, returning, solitary landscape recurs in their imagery. There are poems that bring together the social context of war with the lonely personal circumstance of broken love or martyrdom, loss and rejection. There are thunderous poems about social inequality and injustice. And there are beautifully poignant,

touching poems based in the abstractions of haunting and memory. There are tangible qualities of introspection and reflection and subjectivity in them. This book was a major breakthrough for Gaelic poetry. Here was a truly contemporary, deeply moving and unforgettably powerful voice. MacLean had been in correspondence with MacDiarmid since the 1930s and MacDiarmid was delighted to see poems like these – he welcomed them with total enthusiasm!

SANDY: The themes we're exploring – language, the past, how artists respond to these things – make me wonder: do you think MacLean's decision to write in Gaelic was the equivalent of MacDiarmid's decision to write in Scots?

ALAN: Yes and no. MacLean was a native Gaelic-speaker, as MacDiarmid was in Scots, so when both chose to make modern poetry in the languages they knew as children, yes, both of them were estranging the language of their work from the globalised imperium of English. And both were very self-conscious about the artifice of the written poem and brought together a naturalness and fluency in language which they were familiar with from childhood alongside a crafted sense of the made thing, the object in language which is decidedly unnatural. Poems are different from other written things, they have a special status. So I think you could say yes, both were trying to bring their native languages into the adult, modern world of the 20th century in ways that had not been attempted before. Both were originators. Yet there remains a difference as well. MacDiarmid thought the Gaelic ground of Scotland's literary and cultural identity was fundamental. I think he genuinely regretted not being fluent in the language. He told me he could read it with a dictionary and Grant Taylor, who worked with him as a typist and secretary in Shetland in the 1930s, told me they would translate from German and French poems in literary magazines that were sent

to him, Taylor thumbing through the dictionary while MacDiarmid directed him to look up a word he didn't know, but that very often MacDiarmid had caught the precise meaning of the word before Taylor found it. He had an unfailing intuitive grasp of vocabulary – how language works. So I think he regretted not being a native Gaelic-speaker.

SANDY: MacLean's critical writings as well as his professional work were informed by the desire to see Gaelic restored to a central place in the Scottish linguistic and literary sensibility. He was also one of the great oral historians of the Western Islands. He could talk for hours about the way Highlanders have been ruthlessly exploited over the past 200 years or so and trace the individual involvement of families, fathers, grandfathers and great-grandfathers in historical events, as if he had personally met them all and heard their stories at first hand. Again, that's the antithesis of the Modernist point of view – the idea of the impersonality of the artist. In doing what he does though, MacLean creates an alternative Modernism, a different sense of modernity – one that does not exclude the family or the social context of responsibility.

ALAN: There's a Welsh poet named David Gwenallt Jones (1899–1968), whom people refer to simply as Gwenallt, almost exactly contemporary with MacDiarmid. I wonder how many readers of Scottish poetry know his work? Very few of his poems have ever been translated and I only know a few from *The Penguin Book of Welsh Verse*, translated by Anthony Conran, but I would say he is a great poet even on the strength of one poem, 'Rhydcymerau'. In that poem, it's as if everything you could learn about hard, clean, sculpted verse can be seen, but it's absolutely freighted with the authority of responsibility for family, people, places, a language and a culture. 'Rhydcymerau' seems to be a place-name but it also means 'the ford where the waters meet'. I don't know, but the

word also has the suggestion to me of another meaning: 'the crossing-over place of the Welsh people' – the ford of the Cymru. He talks about the forestry plantations of trees and the imposition of imperial financial power onto the place he came from. He talks of his grandparents, an uncle and cousin, and the place where they lived. This is how the poem ends:

And by this time there's nothing there but trees.
Impertinent roots suck dry the old soil:
Trees where neighbourhood was,
And a forest that was once farmland.
Where was verse-writing and scripture is the south's
 bastardised English.
The fox barks where once cried lambs and children,
And there, in the dark midst,
Is the den of the English minotaur;
And on the trees, as if on crosses,
The bones of poets, deacons, ministers, and teachers
 of Sunday School
Bleach in the sun,
And the rain washes them, and the winds lick them
 dry.

SANDY: That's the Welsh parallel of the Highland Clearances, isn't it?

ALAN: And the artist is not 'refined out of existence' but bears the weight of conscious connection with his or her society, family, language – national history. All these things are pre-eminently present in MacLean's work. Now, you might say something similar about Joyce – he does write about himself, his family and of course about Ireland. But there is an aesthetic priority which he shares with Eliot and Pound where, to be blunt, form or structure is in the ascendant. If that's arguable in *A Portrait of the Artist as a Young Man* and *Ulysses*, surely it's evident in *Finnegans Wake*. What you have in MacLean's work is differently insistent on the urgency of communicated material –

perhaps that's a responsibility of writing in Gaelic, as with Gwenallt, writing in Welsh. MacLean's readership must have been very small, even compared to Joyce!

SANDY: You can see this in terms of how widely these people are read even now.

ALAN: Aye. It's to do with your feeling for home or belonging. There's a very fine poet named Andrew McNeillie who has a poem called 'Cynefin *Glossed*'. Now, 'Cynefin' I'm told means precisely that, a sense of belonging, at-homeness. And Andrew has his own mixed loyalties – his father was a very fine novelist from Galloway in Scotland but he moved south and Andrew grew up in Wales but also lived in Ireland for a long time, so his own experience leads him exactly to what this poem is asking us to consider.

Cynefin Glossed

What is another language? Not just words
and rules you don't know, but concepts too
for feelings and ideas you never knew,
or thought, to name; like a poem that floods
its lines with light, as in the fabled
origin of life, escaping paraphrase.
So living in that country always was
mysterious and never to be equalled.

For example, tell me in a word how
you'd express a sense of being that
embraces belonging here and now,
in the landscape of your birth and death,
its light and air, and past, at once, and what
cause you might have to give it breath?

SANDY: '...in a word...'

LINDA: Bring us back to Sorley MacLean...

ALAN: I think the central poem, the key poem of his entire career, is 'Hallaig' – a haunting evocation of a cleared township on Raasay. The central line in

that poem delivers a sense of resistance – no, not just resistance, but defiance, defiance in the face of what must have seemed like the proximate possibility of complete extinction: 'The dead have been seen alive.' The poem names places and depicts a particular historical time. And it depicts 'time' itself, the thing that causes all things to pass into oblivion, the world's invisible erosion. The epigraph – 'Time, the deer, is in the wood of Hallaig' – gives us an image that the last lines of the poem will destroy: 'a vehement bullet will come from the gun of Love', MacLean says:

and will strike the deer that goes dizzily,
sniffing at the grass-grown ruined homes;
his eye will freeze in the wood,
his blood will not be traced while I live.

So the poem itself kills the deer, kills time, brings the dead back to life, speaks with their voice while we read it. The poem works against time. That's what it tells us it's setting out to do, to commemorate and allow a presence to be carried in the mortal memory, to stand in resistance against, in defiance of, time and time's erosion. MacLean's deeply personal poems of loss and despair and tragedy were also contemporary with the time of war. So these are simultaneously universal and very specific poems. For example, in 'Hallaig' there's a fusion of two kinds of sensibility, the Romantic view of the exalted status of Nature and natural beauty, and the Gaelic view of a natural landscape inhabited by the people who live in it – or lived in it at one time, populated it with their society and voices and meals, daily rhythms of life, and songs. As the Gaelic scholar John MacInnes says, 'Through his genius, both the Gaelic sense of landscape, idealised in terms of society, and the Romantic sense of communion with Nature, merge in a single vision, a unified sensibility.'

SANDY: In the 1930s, there was a huge economic slump resulting in massive unemployment. They

were lean years. MacDiarmid was nearly starving up in the Shetlands. And MacLean faced difficult times, having to take a job as a schoolteacher to support his extended family. The war gave everyone a new impetus. MacLean told me that when war was declared in September 1939, he was the first schoolteacher in Edinburgh to volunteer: 'I wanted to have a crack at the Nazis.' Disappointed with his failure to fight in the Spanish Civil War, this time he was utterly determined to fight Fascism. So this was a moral crusade that began for him there and then. But the way he puts it is interesting: 'It wasn't as if we were fighting to make the world a better place but we were certainly fighting so it wouldn't become any worse than it already was.'

ALAN: I think he's actually formulating a socialist vision at this point. He was writing a lot of letters to MacDiarmid, pretty much agreeing with the MacDiarmid communist republican point-of-view, endorsing that. His long poem, 'The Cuillin', uses the image of that mountain-range as a permanent symbol of aspiration, of trying to get higher, beyond all the degradations and squalor and horror and wasted potential of modern life, to rise 'on the other side of sorrow...'

SANDY: For Sorley MacLean, socialism included his reaction to the Spanish Civil War, the defeat of Nazism, the discovery of the concentration camps – and all of these things, in his view, can be linked to the Highland Clearances. For Sorley, the Clearances became a 'universal prototype' and that takes us back to William McTaggart.

ALAN: In McTaggart's painting, *The Sailing of the Emigrant Ship*, we see the ship, out on the horizon, which bisects the canvas right at its centre. Drawn up on the foreshore, there are these empty boats, and a dog, looking off, its head exactly in line, pointing towards the distant ship that is taking his master away. A man, a shepherd with his crook, and his wife with her snood or bonnet are visible in the foreground but they're like hollow figures, like

T.S. Eliot's 'Hollow Men', you can literally see through them. The whole painting has a sense of potential being lost, potency departing. It gives you that sense of a story opening out without closure. This is unfinished business.

Maybe it's also a reflection of what we were saying earlier. There is a history of the Highland Clearances and there's a mythology of the Highland Clearances. The mythology carries the heart of the event while the history holds the facts. The myth of the Clearances had a very heavy impact and was a powerful force, for artists and poets, and that impact continued to have its effect for generations, literally for hundreds of years.

SANDY: What you're seeing here I think is the landscape of mankind. McTaggart was a political painter, although that's not widely grasped, even now. Most people think of his snowy landscapes or the cheery children. But Lindsay Errington refers to the comments of a Canadian visitor to McTaggart's studio when he was working on 'The Emigrants' series: 'Mr McTaggart sat and described what he meant to represent. The huge canvas was covered with a confused maze of black and white markings.

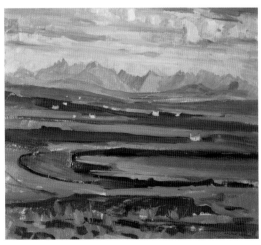

2.12 **John Cunningham 1926–98** The Cuillin, Evening 1964

2.13 William McTaggart 1835–1910 The Sailing of the Emigrant Ship 1895

When he mentioned that there was a piper and that he was playing "Lochaber No More" I looked for this figure in vain and it struck me as extremely odd that the artist should not only know about the piper but also what tune he was playing.'

This is an extraordinary statement. For McTaggart, the painting's meaning is bound together with the music of a lament. In fact, the painting itself is a lament, a pibroch.

ALAN: You can hear it.

SANDY: And Sorley MacLean's work is carved by these events also, the legacy of the Clearances, just as he would talk about his ancestors as if they were still alive, just there in the next room.

ALAN: History was never elsewhere for him. It was always present tense. In terms of landscape, it might be worthwhile to go back and look at what MacDiarmid had to say about this, in *Lucky Poet*: 'I share the Chinese belief in the essential function of geography as a training of the mind in visual-

isation, in the making of mental pictures of forms and forces – landforms and climatic forces – that are beyond the horizon, a belief the importance of which lies in the fact that Chinese painting developed as an art based on visualisation and not on vision, on a mental picture and not on a Nature study, even when the subject was a landscape.'

LINDA: It's often said that MacLean's poetry was radically new in the tradition of Gaelic poetry. Could you tell us something about that?

ALAN: Well, essentially, Scottish Gaelic poetry was closely linked with Irish Gaelic poetry and the social system in which there was an assigned place for the professional bards. This went on until the 17th century, when that system started to break down. Scottish Gaelic poetry flourished roughly from 1740 to the beginning of the 19th century, with poets such as Alasdair MacMhaighstir Alasdair (Alexander MacDonald, c.1695–c.1770), Rob Donn (1714–1778), Donnchadh Ban Mac-an-t-Saoir (Duncan Ban MacIntyre, 1724–1812) and Uilleam Ros (William Ross, 1762–c.1791). The second major period of efflorescence in Scottish Gaelic poetry was initiated by MacLean in 1943, with the publication of his book *Dàin do Eimhir*. Others who followed then included George Campbell Hay (1915–1985), Derick Thomson (b.1921), Iain Crichton Smith and Donald MacAulay (b.1930).

But while these poets were producing great original work, they were building on a foundation that reached back into oral traditions, poems and stories from a Celtic past that included a commerce of travel between Ireland and Scotland that contemporary political designations don't help you to imagine. The Red Branch cycle of stories, for example, include an episode where the great hero Cuchulainn travels to the Isle of Skye and is trained in the arts of war by the woman-warrior Skathach at the Castle of Dunskiath near Tarskavaig. You can still go there – I've visited that castle – you have to cross over to it on its rocky promontory by using your fingers and toes because the bridge is no longer there, only its stone frame. And there's the tragic love story of Deirdre and Naoise, whose happiest years are spent in Scotland before they return to Ireland and meet their destiny. Deirdre's farewell to Scotland is one of the most beautiful songs, naming the mountains and rivers and valleys she knows she'll never see again. And later of course, the Fenian cycle of stories gives us Finn MacCool and his son the bard Ossian, who is taken away to the land of the ever-young and returns to find a Christianised country and all the great heroes of the age of the Fenians have gone. Alexander Runciman (1736–85) was the first painter to depict the Ossianic stories in a series of paintings commissioned by the composer Sir James Clerk of Penicuik. The etchings that survive of Runciman's work are astonishing, proto-

2.14 Alexander Runciman 1736–85 Cormar attacking the Spirit of the Waters *c.*1772

2.15 Alexander Runciman 1736–85 Cath-loda *c.*1772

Expressionist, gestural, dynamic. In some ways they are archetypal Romantic images, but this is decades before Romanticism.

SANDY: Of course, the theme of Ossian persists right through to the 21st century. Recent work by Calum Colvin revisits these myths. They remain a potent source. They never go away entirely.

ALAN: Alongside these myths and stories there are a great number of poems, lyrics and songs in praise of Nature, which were adapted from the pre-Christian era into the Latin writers of a later time. So Gaelic poetry in Scotland has all this to draw on, as well as immediate experience of the Jacobite risings in the 18th century. There's a powerful realism at work, for example in Duncan Ban MacIntyre's poem in praise of the great mountain Ben Dorain, where he describes the thrill of the chase of the hunt for deer, but then goes on to describe how the deer should be shot, gralloched

2.16 Calum Colvin b.1961 Blind Ossian 2001

and cut up for the pot – it's a natural progression that shows respect for the animal and for the necessity of killing it simply to eat.

Now, what MacLean did decisively was to produce a poetry – predominantly tragic and anguished love poetry in his first book but also great war poems from his time in North Africa – that was filtered through his own sensibility, which had been trained at Edinburgh University. There, in the early 1930s, he had studied English under Herbert Grierson. The major poets he read there included John Donne and the Metaphysical poets of the 17th century, and then T.S. Eliot, Ezra Pound and W.B. Yeats. There was a rigorous and highly-charged Modernist intellectual aspect to his writing that was fused with a realistic, yet intensely passionate and indeed Romantic sensibility coming from 18th- and early 19th-century Gaelic poetry and Yeats (and Blake). But he could still refer easily and confidently to Deirdre and Naoise, to historical as well as mythical characters, to Patrick Pearse and W.B. Yeats or Hitler or Lenin, as well as Cuchulainn. Where earlier Gaelic poetry was literally sung and normally associated with song and a musical idiom, MacLean initiated a poetry that was intended to be read and thought through intellectually, even while it could have a mesmerising power if you heard him read it himself. I remember a reading I organised at Cambridge University in the 1970s, where MacLean read to some of the English Faculty. They'd never heard anything like it. It blew them away! It was simply tuned in as if it had arrived from another world – which of course it had!

SANDY: Here's an excerpt from the *West Highland Free Press* 'Tribute for Sorley MacLean':

Seamus Heaney, Nobel Prize winner, said in his Memorial Lecture for MacLean: 'Sorley MacLean stuck to his guns in all sorts of ways...' then added, 'not least in his determination to let his poetry stand as the pure thing in Gaelic, and not to attempt anything in his translation other than a faithful account of the

2.17 Alexander Moffat *b.*1943
Sorley MacLean 1979

meaning in an almost word-for-word way.' Then in reference to MacLean's love of Gaelic and the Highlands, he said, 'politically, linguistically and artistically, he was prepared to go a certain distance toward the horizon but he was not prepared to leave behind the landscapes and seascapes, where the navigation markers of his spirit were located.

ALAN: That's it exactly.

Iain Crichton Smith (1928–1998)

ALAN: The first time I met Sorley MacLean he looked deep and straight into my eyes and said 'Have you read Iain Crichton Smith?' and when I answered him that I had read Crichton Smith's poetry and some of his stories and novels, MacLean continued to look at me and it seemed even more intensely he said in a dramatically emphatic voice, 'He is a very – [long pause] – good – poet – *and* – a very – good – man!'

LINDA: What are the main preoccupations in Crichton Smith's work?

SANDY: Lewis – the Church – human dignity and worth, mortality, what you might call a kind of Outer Hebridean sense of winter and the terrible silences, the gales and storms, raging, actually and metaphorically –

ALAN: But there's also a stark, bare, reduced or reductive quality that is a repudiation of the 'Romantic Sublime'. He says in 'Deer on the High Hills' that the stone is stony, it is itself, no more than itself, the deer is inhuman, a living creature no more than itself. The ethos of his work is to lay bare the mysterious, numinous idea of the sublime, the idea that there's some greater spirit inhabiting things: it's materialist, bleak, although full of passion and anger.

SANDY: And there's also an openness to modern media. He wrote plays for radio, poems about the Gaelic language and the advent of the TV – one for every household! He told me once that – 'Apart from MacDiarmid, the one most important man in Scotland was Jock Stein!' Now, that might seem frivolous – the great poet and the football manager, but the thing is Iain saw Jock Stein's achievement as truly important in cultural terms. When he was a young man, Stein went off to Italy to study football tactics – he was rising to the challenge at a European level – and for Iain, he was this local man who had gathered a local team around him and brought them successfully onto the global stage. To this day, Stein's Celtic remain the only team consisting of eleven native-born players to have won the European cup. For Iain, this was what Scotland had to do, to raise the bar. In that way, linking Stein and MacDiarmid makes a lot of sense. These were the examples other poets and artists might take inspiration from.

ALAN: That's right. Poetry and popular culture together. He had a flair for writing poems on any occasion, ephemeral poems I guess, sometimes about the films he'd just seen – the cowboy film *Shane* or the science fiction horror film, *Alien*. Many of these poems were published in magazines and are probably still uncollected. There are poems that take real risks with their own fluency and facility. In one of his last poems, he's looking back over his life and you get the line: 'I run through the toilets of my childhood'. I mean, you have to read that twice, with astonishment! You know what he means, this dreamlike running through all the school toilets with their white tiled walls but the line simply could not be permitted in a poem by anyone else. Ted Hughes? He'd have scored it out at once. Larkin? Larkin couldn't have written it, because it has a quality of fluent joy, a natural impulse, that sense of the child running. But Iain's poem carries it through. It's a small example. But deeper than these, there are the poems centrally about his mother, the 'Old Woman' poems. Taken together along with some of the fiction, they are an extended study of the relationship he experienced between the austere and utterly limited reality of her world and the rich,

teeming world of literature and the arts to which he somehow opened his own door. I think he was a major poet of the 20th century.

LINDA: These are themes about people, relationships, art and ideas. What about the landscape of his poems, their sense of place?

SANDY: You could say that all art is derived from a sense of place. And Iain Crichton Smith's favoured place was utterly distinctive: the Isle of Lewis. The standing stones of Callanish might seem a numinous, spiritual presence but in Crichton Smith's poems there's a hard, materialist sense that the stones are simply stones. He's not caught up in the romantic idea, but his resources are entirely to do with the human landscape. His poetry came from a deep understanding of people, as well as place. He broke out of the conservative or oppressive aspect of that world, into a unique kind of poetry, that became an inspiration, not only to other writers, but to artists like myself. Crichton Smith may have been born in Glasgow, but he has always been associated with the Isle of Lewis. And no matter how uncompromising and bare that landscape, obviously he could still see the neon and glitz of the cities and the world beyond, from the corner of his eye.

LINDA: Sketch his life-story for me, could you?

ALAN: Iain Crichton Smith was born in Glasgow

2.18 The Standing Stones of Callanish, Lewis

but he and his parents moved two years later to the Isle of Lewis where he spent his young life. Not long after the move, his father died and he and his brothers were raised by their mother in a Gaelic-speaking crofting community called Bayble. His first introduction to English was when he entered school and it became his second language. He was educated at the Nicolson Institute in Stornoway, then went on to Aberdeen University, where he studied English. It was when he travelled to Aberdeen that he saw a train for the first time. That was the world he was moving into, the new world he was encountering for the first time. He became a schoolteacher and taught in Clydebank, Dumbarton and finally in Oban, until 1977, when he retired from teaching to write full-time. He told me that being a teacher and a writer at the same time was like trying to ride two stampeding horses, so he had to choose to stay with one.

He lived most of this time with his mother. Later on, he met the woman who was to become his wife, Donalda, and their marriage was generally very happy and full of laughter, though he suffered from continuing bouts of depression and broke down pretty seriously in the 1980s. There had always been a quality of intensity and it came to a real crisis. It's reflected in the novel *In the Middle of the Wood* (1987). Donalda helped him through that and by this time there were also a number of good friends, who were immediately responsive. His latter years were very productive, full of travel, new writing, encouragement of younger writers, and an increasing demand for him at public readings and festivals.

My father and he were contemporaries at the Nicolson Institute, but Iain was a boy from the village and spoke Gaelic whereas my father was the postmaster's son from the town and spoke English, so they didn't really know each other then. But years later I had the chance to introduce them to each other and it was just glorious. When they

met, on the doorstep of Iain and Donalda's house in Taynuilt, they eyed each other a bit and when we went in and were all sitting down, their conversation started out slow and a bit awkward. And then they went through the, 'Were you there when...' sort of questions, 'Do you remember that teacher who...' and all at once they came to the realisation that they remembered the same teacher who had given them both the belt, strapped them, probably with a leather 'tawse' – 'What a sadistic bastard!' they both agreed and started laughing and suddenly all that shared history became a source of humour and recognition and delight for them, and the conversation became rich and easy between them.

LINDA: Sandy, how well did you know Iain yourself?

SANDY: I met him at a conference at Aberdeen University, maybe around 1970; that was the first time I met Sorley MacLean as well. It was a real 'gathering of the clans', which had been organized by *Scottish International*, a very important magazine. Like all Scottish magazines it had a limited lifespan, from 1968 until 1977 or 1978, but it did a lot of good work, and they organised the occasional conference on Scottish culture.

ALAN: *Scottish International* was edited by Robert Garioch, Edwin Morgan and Robert Tait and it opened up very wide-ranging discussions on all sorts of topics in art and culture and politics. There were articles about Scottish opera in Europe, the BBC in Scotland, the use of the Scots language, art schools in Scotland, as well as translations from Eastern European poetry, new Scottish writing and reviews and essays on political developments. The last sentences of the first editorial from issue number 1 January 1968, read as follows:

> Everyone is aware to a greater or lesser extent of how cultures other than Scottish impinge upon us through publishing and the mass media. It is important that this awareness should be sharpened and extended critically so that more opportunity can be given to compare Scottish work with work done elsewhere.

> To define ourselves we believe it is necessary to define many other things for that is the nature of the world we live in.

I think we could still do with that today, an international cultural exchange office where artists and writers in every genre and teachers could find out about what their counterparts are doing in other countries.

SANDY: *Scottish International* reflected the fact that Scotland was waking up, culturally and politically. It had taken a long time to wake up from its subservient state.

LINDA: Why had it taken so long?

SANDY: I think the rise of the British empire encouraged Scots – especially the ruling class and the professional class – because they bought into that in a big way – to go off to London, India, Africa, China, the West Indies, to make fortunes and take up positions of power. The industrialisation of Scotland meant that many came down from the Highlands and up from the Borders into the cities. And there, they could no longer recognise Scotland – the Scotland of the cities bore no relation to the places they were born in. They'd look out of the windows and see grimness and soot, a hell upon earth.

They no longer saw Scotland clearly. This in turn left a damaged Scotland, a terrible defeatism and a lack of self-belief. That's why I think that the Scots emigrants could still see Scotland more clearly than many of the Scots who stayed were able to.

LINDA: That's also the matter of how they preserved the language they took with them, isn't it? Aren't there more Gaelic-speakers in Canada than there are in Scotland?

ALAN: Very possibly. Perhaps that shows us again how time doesn't move at the same speed for every society. Certainly, the language situation was crucial for MacDiarmid and MacLean, as we've seen, and for Crichton Smith too.

SANDY: Being bilingual was a very important part

of his work. Probably the first poetry of Sorley MacLean I ever read was in Iain Crichton Smith's translation. In his own writing, he was clearly multifaceted and very popular, with his short stories, novels and radio plays. His poetry has this uncanny quality of fluent intensity. You can see intense frustration and rage alongside a sense of the absurd and comic, in the opening of 'The White Air of March'. The opening line is, 'This is the land God gave to Andy Stewart'. Stewart, who was a very popular Scottish singer, always dressed in kilt and sporran, in the Harry Lauder tradition but aiming for popularity with the television-viewing public. For Smith, he was simply the epitome of the degradation of Highland culture. In the poem, Smith talks about 'our inheritance' in terms of hunting for golf balls, little children piously performing Gaelic songs and dances, the wholesale reduction of a culture to the tartan tourist clichés, and then he evokes the image of the white streams screaming through the moonlight on the Cuillins – a permanent scream of protest against all the trivialisation of our history that has been foisted upon us!

LINDA: He had some pretty severe opinions about Presbyterianism, didn't he?

ALAN: He once said that whenever he saw a priest or a minister walking down the road, he had to physically restrain himself from running over and belting them on the head with a big book and saying 'Wake up!'

SANDY: That quality is in the stories that were gathered in the *Murdo* books, isn't it?

ALAN: Aye. Murdo was a fabulously comic character Iain invented. In the 1980s, some of the Murdo stories were published in the magazine *Cencrastus*, an important magazine very much of its time, as *Scottish International* had been of its time. In one of them, Murdo goes to a local library on Lewis and asks for a copy of *War and Peace* by Hugh MacLeod and when the librarian looks at him

rather puzzled, he elaborates this great, thousand-page novel set in Napoleonic times on Lewis, a total fiction based on a work of fiction, and he tells her that MacLeod was a great Scottish writer of the time. The irony is, he says, if he was a Russian author, he'd definitely be in the library, but because he was from Lewis nobody's ever heard of him!

LINDA: That's wild.

ALAN: The thing is, it's working on various levels of irony, bitterness and comedy, and the questions are unanswered. Later on, Murdo became an auto-biographical figure, an ironic self-portrait that allowed Iain to raise such questions, intensely and seriously yet always with a sharp, probing sense of absurdity and injustice. The earlier self-representations are more austere. In his poem, 'Self-Portrait' he begins by balefully looking into the mirror, asking 'Whose is this Free Church face?' – identifying himself with the culture he wants to extract himself from. And that austere self-questioning led him towards the breakdown he suffered in the 1980s. But he saved himself I think, by becoming quizzical. Humour enters his world and his laughter seriously subverts any pretensions of solemnity. You can see that development if you look over the whole trajectory of his work, including the fiction, the novels and short stories, the radio plays – comic, farrago work – I remember accidentally turning on the radio one Sunday afternoon and listening to this utterly surreal play with a Wild West cowboy setting but all somehow taking place on Lewis!

SANDY: And the links are clear, from that fine short novel *Consider the Lilies*, where the Highland Clearances are central, to the poems of Sorley MacLean and to the paintings of William McTaggart – not only the 'Emigrant' paintings but also the series of paintings called 'Consider the Lilies', where you have a group of small children dancing in a circle, the symbolism of innocence beautifully realised.

ALAN: It's that social world of childhood innocence or perhaps 'grace' would be a better word. There's a wonderful play by Iain Crichton Smith, I think still unpublished, about Columba, in which that tone can be heard very clearly.

SANDY: And Columba, of course, was another major figure for McTaggart.

For McTaggart, *The Coming of St Columba* is not merely a seascape with a little boat, it's a history painting with a major subject and theme.

ALAN: Many of Crichton Smith's books have a doubleness in their titles that draws your attention to the conflict between these two aspects of the world: *The Raging and the Grace, Love Songs and Elegies, The Black and the Red.* Black and red are the colours of the Devil of course, and in Gaelic there is a word that evokes those brindled colours and it's an adjective that means 'devilish' – but it's ambiguous: it's not necessarily evil or bad, it might be mischievous or trickstery. In the Caribbean there's a trickster god called Anancy. It's a similar figure. Always up to something. That's an aspect of his character too.

SANDY: And yet, it's the personal poems, especially the 'Old Woman' poems, that speak about the pain at the heart of his work.

ALAN: Edwin Morgan once noted that Iain's favourite writers were Auden, Kierkegaard, Robert Lowell and Dostoevsky – quite a quartet!

2.19 William McTaggart 1835–1910 The Coming of St Columba 1895

SANDY: They're all dark figures.

ALAN: Some of the most obsessive aspects of Iain's writing remind me of them. There's the excess of words in Auden, although they're always too cleverly arranged in show-off versification; there's the reliance upon mind, the abstract mind, in Kierkegaard and his sense of 'Eros'; there's the confessional self-centredness and paranoia of Lowell and the dark social vision of Dostoevsky, the murderous backstreets and shadowy small Russian towns, awaiting the revolution. And yet, Iain transforms all these things – his language is more free in its movement, looser, with the risks that implies, but more generous and more capacious than Auden's; his recourse to mind and the world of the imagination never entirely loses touch with the sense of living bodily in a physical world; he is never so self-centred or simply selfish and bullying as Lowell; and his Scotland offers its own consolations which he endorses with kindness – he lacks the nastiness of Dostoevsky. Through all of his work the ancient and the contemporary co-exist without the sentimental sense of a 'Golden Age' or any false grandeur of vision. He's as close to the reductive potential in the domestic location as Larkin, but there's a lot more laughter there, thank goodness!

SANDY: But it's not always there – the austerity is plain to see.

Poem of Lewis

Here they have no time for the fine graces
of poetry, unless it freely grows
in deep compulsion, like water in the well,
woven into the texture of the soil
in a strong pattern. They have no rhymes
to tailor the material of thought
and snap the thread quickly on the tooth.
One would have thought that this black north
was used to lightning, crossing the sky like fish
swift in their element. One would have thought

the barren rock would give a value to
the bursting flower. The two extremes,
mourning and gaiety, meet like north and south
in the one breast, milked by knuckled time,
till dryness spreads across each ageing bone.
They have no place for the fine graces
of poetry. The great forgiving spirit of the word
fanning its rainbow wing, like a shot bird
falls from the windy sky. The sea heaves
in visionless anger over the cramped graves
and the early daffodil, purer than a soul,
is gathered into the terrible mouth of the gale.

That poem registers something about the sheer struggle for survival most folk had to endure for generations and a lot of Iain's poems are about the bleakness of the Protestantism that persists in that place – nobody was encouraging artists to make colourful paintings for the interiors of their kirks! There is clearly a literary and poetic tradition that runs right through the centuries in Gaeldom, and there is evidently a strong musical tradition, especially in piping and with the fiddle – though both were frowned upon or even outlawed at times – nevertheless, by contrast, painting is particularly vulnerable here.

ALAN: If you take these simply as forms of human self-expression – poetry, painting, music – languages of different but related kinds – isn't that a terrible kind of self-inflicted poverty?

SANDY: It is self-inflicted, isn't it? Nobody was

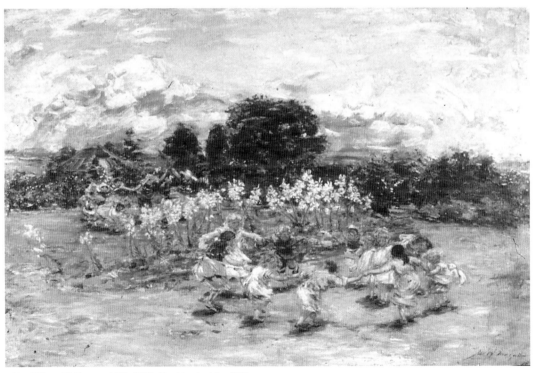

2.20 William McTaggart 1835–1910 Consider the Lilies 1898

forcing these people not to enjoy painting except the Church – the Church they all subscribed to.

ALAN: But something has changed since Iain was writing those poems in the 1950s and 1960s. Now, in the 21st century, you have an artist like Will MacLean working in a way that would have been inconceivable in the 1950s.

SANDY: Will MacLean was born in Inverness in 1941 but his family roots go back to the fishing villages of the north-west coast. He was a merchant seaman for two years before becoming an artist and his preoccupation with myth and symbol, realised not only in painting but in carved constructions and painted reliefs, owes much to a respect for the elemental spirit of the sea and its importance in the lives of fishing folk. On a personal and political level, MacLean has responded imaginatively to the Clearances and to the awful hardships endured by many Highlanders. His explorations of the past have been turned into elegiac icons capable of rendering the unspeakable presence of a tormented land.

In the early 1990s, MacLean designed three large memorial cairns on the Isle of Lewis, each commemorating an episode in the struggle between crofters and landlords in the 19th and early 20th centuries. These cairns used building forms derived from the black-houses and brochs. These are major works, marking the political history of the Hebrides; they signal how important issues of Highland culture and identity had become in the late 20th century. Like the poetry of Iain Crichton Smith, these works are about the human history in these places, yet they also connect with the imagery of the standing stones and link right back to human habitation from prehistoric times.

Will MacLean has also made a major contribution in rediscovering and bringing to our attention a number of very significant artists from the Highlands and Islands from the 18th century onwards. He challenges the commonly held view

that little of any value emerged from Gaelic Scotland. The list of Highland painters and sculptors who were born in the Gaeltacht between 1745 and 1910 is indeed impressive and includes James Alves (1736–1808), who studied in Paris and Rome and was a friend of Boswell's; his contemporary James Clerk (1745–1800), who also studied in Rome; Samuel Mackenzie (1785–1847), a sculptor and painter who was in close contact with Raeburn and Sir Walter Scott; Kenneth MacLeay (1802–1878), who by 1830 was acknowledged as the leading Scottish miniaturist; Robert Ranald McIan (1803–1856) and his wife Fanny McIan (1814–1897), whose great work, *The Clans of the Scottish Highlands*, is a classic record of Highland life and tradition; and the sculptor Alexander Munro (1825–1871), who played a prominent role in the pre-Raphaelite movement in mid-19th-century London. MacLean also points out that J.D. Fergusson was a Gaelic speaker who wrote a series of articles 'Towards a Celtic Front' advocating the revival of Celtic tradition and the Gaelic language. J.D. Fergusson himself insisted (in issue number 1 of *Scottish Art and Letters*, in an essay called 'Art and Atavism') that 'Old Toshy [Charles Rennie Mackintosh] was of course a Highlander...'

ALAN: Perhaps there is the language issue again here. Iain's first language was Gaelic but his first book and much – probably most – of his writing is in English.

SANDY: Is it the case of Iain moving into English to defamiliarise himself, just as MacDiarmid moved into Scots, and MacLean chose Gaelic?

ALAN: It's all about that balance between the familiar and the strange. Just as Joseph Conrad enters into the English language and changes it, refashions it for different kinds of experience, these poets use their languages in ways that change their capacity. It is as if a mask were being inhabited by a new spirit: this can create different capacities for expression. Reading their work,

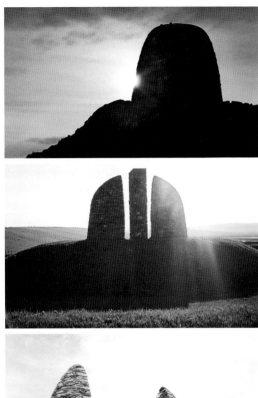

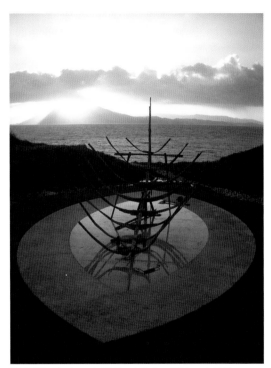

2.24 Will MacLean *b.*1941 and **Arthur Watson** *b.*1951
Crannghal 2006

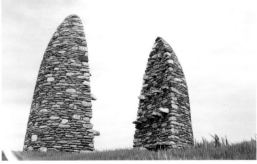

2.21–2.23 Will MacLean *b.*1941 Land-raid Memorials, Isle of
Lewis 1994–96, **2.21** Ballalan Cairn 1994 **2.22** Gress Cairn 1996
2.23 Aignish Cairn 1996

we begin to see through different lenses. Which is
literally what Paul Strand was doing, coming to
Hebridean landscapes with his camera and a
fresh eye.

One of the things I find remarkable is the sense
that the people and the land itself are both contem-
porary, however ancient or aged they seem. Just as

Iain writes his poems about an anonymous 'Old
Woman', Paul Strand will give you a photographic
portrait of an old man or old woman, which calls
up all sorts of questions about our relation to
people across time; how we think of age and
experience, what informs the experience of these
people. So there's no disturbance, really, in turning
from an Outer Hebridean landscape to something
that seems utterly intrusive – the television, for
example. Both have this contemporary presence,
an urgency, an unanswered question. Two of Iain's
most poignant, quirky poems, are the melancholy
refrain, 'Shall Gaelic Die?' and the oblique,
observational poem, 'The TV'. In 'Shall Gaelic
Die?', he discusses the ways in which language
shapes the way you see the world, meaning that the
death of a language is the death of an entire way of

2.25 Alexander Moffat b.1943 Iain Crichton Smith 1980

seeing the world. In 'The TV', which is unexpectedly funny, he shows how this happens in the new medium of television, how nothing seems real until it's seen on the TV. These are frightening, sober, grim poems. The laughter is like barbed wire.

SANDY: We saw that when we were in China, Alan, in 2004. When we were in Xin Pin, in the Guanxi Province, there was a whole peasant economy all around us, people working as they had done for millennia, and at the same time, television and computer technology were there in sheds or houses in the main street of the town...

ALAN: And there was the photographer who took a snap as we were disembarking from the river trip; he had wired the computers up from the back of

his van to the local electricity supply, the telegraph pole by the roadside, so that he could print out the picture in a few minutes. It's that concurrence of technologies, the ancient economy and the ultra-contemporary, that you witness in a place like that. And in Lewis too. So those contemporary references in Iain's writing are characteristic. He was writing about contemporary reality. Except for the novels *Consider the Lilies* and *An Honourable Death* and some poems, most of his writing is set in his own time. And even those novels and poems seem elastic in their sense of time, as if the historical locations are connected to whatever's going on now.

SANDY: I think the point is that there's enough

here, in contemporary reality, to make poems and novels about – you don't have to go back into history for major events. Most people want history and modernity separated out. They would prefer them compartmentalised. But they're both with us all the time. I suspect a lot of people wouldn't think that's the case. And yet, as we've seen, both Iain Crichton Smith and Sorley MacLean demonstrate this in their writing. History is present tense for them.

ALAN: That reminds me of MacDiarmid's famous poem, 'Scotland Small?' You remember how it begins: 'Scotland small? Our infinite, our multiform Scotland, *small*?' He answers his own question with this intricate description of 'a patch of hillside' which might appear to be 'a cliché corner / To a fool who cries "Nothing but heather!"' but which, if you look at it closely, can be seen to be abundant with varieties of plant life: heather, blueberries, bog-myrtle, tormentil, milkwort, sundew, butterwort and sphagnum moss, and little Blackface sheep, blue butterflies and 'neglected peat-hags, not worked / Within living memory...' That poem might be read as a sentimental assertion of Scotland's national identity, you know: 'Scotland... *small*?' – only a fool would call Scotland 'small'! And yet those references tell you that he's talking about a historically-specific, contemporary, cleared landscape: very bleak, very empty, very much the product of a particular history. And yet it yields this magnificent praise-poem: 'Nothing but heather! How marvellously descriptive and incomplete!' In a way, that's Crichton Smith's method too. He takes the utterly material, immediate reality, without sublimating it into anything like a patriotic reflex, and yet he delivers the sense of what's subtle, replenishing, actually present in it.

SANDY: It takes a poet like MacDiarmid or Crichton Smith to see that – whereas everybody else would just think, 'There's nothing there, it's empty, barren, dead...'

LINDA: Tell me about painting Iain's portrait, Sandy.

SANDY: When I painted his portrait, he had recently retired and the sessions in Oban were great fun. We've talked about his sense of humour and I hope the painting shows something of this. I first visited Lewis in 1977. When I came off the ferry, the mists lifted and there was this terrible bleakness. The landscape behind him is an evocation of Lewis, in the Outer Hebrides. And the desolation of that landscape, symbolising again the forcible removal of the people from the islands, returns us to the Clearances again, which these Gaelic poets still felt so intensely.

George Mackay Brown (1921–1996)

LINDA: How would you introduce George Mackay Brown to someone who had never read his work?

ALAN: It's unique. It starts in a culture of conservatism – the very reductive, essentialist conservatism of an ideology that has sprung for centuries, for millennia, from farming and fishing communities and all that means about the role of women and men, cows and bulls, horses, cats and dogs, physical facts of human biology and the local economy. And it encounters the absolutes of the modern world. A poem like 'Uranium' is a reminder that, however sophisticated we might think ourselves, however urban, theoretical, however cocooned from reductive essentials, those essentials are not merely something to fall back towards, but something present, even now. And there is always a threat to the uniquely human balance of things. It's about finding that balance, sometimes negotiated with humour and generosity, sometimes knife-edge, the threat of the razor, the rocks if you fall. There's comedy – the comedy of the village, of social manners, tea-drinking, the postman, the drinkers, the tinkers, the crofters who stay at home and the fishermen and the seafarers with a kind of wanderlust. And there's a tragic vision to do with violence, sacrifice

and mystery. Intuitively, George was aware of the truth of Walter Benjamin's distinction between the two types of storyteller – one who stays at home and learns the ways of the locality and all the characters and histories of the place, the intimate secrets, ghosts and broken laws in their past, and the other who travels the world and learns of other places, other peoples, different cultures and languages and ways of doing things. But at its heart there is a replenishing sense of common human needs and desires that doesn't have to be reductive or essentialist. In fact, it can be the most secure ground to build a sense of difference upon, and to elaborate different ways of doing things, around that secure sense of structure and pattern.

LINDA: Where was he born? What is his story?

ALAN: George Mackay Brown was born on 17 October 1921 in Stromness, in the archipelago of islands called Orkney, off the north coast of Scotland. He was the youngest of six children. His father, John Brown, was a postman and tailor from Stromness and his mother Mhari Mackay was from Brall, Strathy, Sutherland, on mainland Scotland. She spoke only Gaelic until she went to school. When they married, Mhari was 19, John was 34. George had one sister, Ruby, who was the eldest, and four brothers, Hugh, John, Harold (who died in infancy) and Richard (called Norrie). In 1940, his father died suddenly, while he was at work on the island of Hoy. George was 18. He quit secondary school and stopped to take account of his life and his future. The following year, another big blow hit him in the form of his first attack of tuberculosis. He spent six months in Kirkwall, the largest town in Orkney, in a sanatorium.

During his recuperation, he started to write and send in occasional articles to *The Orkney Herald* and in 1944, he became a correspondent for them. In 1951, he attended Newbattle Adult Education College, in Dalkeith, near Edinburgh, where he met Edwin Muir (1887–1959), who was working

as warden there and was also an Orcadian. He had another severe TB attack in 1953 and entered another sanatorium, where he stayed for a year and became the editor of the hospital's magazine.

In 1954, his first collection of poems was published: *The Storm*, with illustrations by Ian MacInnes.

SANDY: Ian MacInnes was the art teacher at Stromness Academy and later he became head-master there. He was an exceptional character – a Labour Party candidate who fought a good fight against Liberal leader Jo Grimond. MacInnes was a fund of knowledge about Orkney. I remember him vividly from the time Norman MacCaig and I spent a couple of days with him at the St Magnus Festival in 1981. He was a big man and completely hairless!

ALAN: Well, in 1956, George's eldest brother Hugh died after a series of heart attacks. George entered Edinburgh University, and did two years post-graduate study on the poet and Jesuit priest Gerard Manley Hopkins (1844–1889).

But he returned and lived almost all the rest of his life in Orkney; a poet, novelist, short story writer and local newspaper columnist whose creative mind returned again and again to related themes. The daily rituals of the ordinary world, the meaning of sacrifice and martyrdom in the political arena and in religious myth, stoic strength and re-generation, the quality of sacredness in the secular 20th century. He converted to Roman Catholicism in 1961. His personal isolation and loyalty to pastoral ideals (like that of his mentor, Edwin Muir) are very different from the sense of contemporary reference in his peers, and his beliefs in the proper relation between individuals and society were deeply conservative. But if that all makes him sound terribly austere, it should be said that there was a real sense of daily pleasure in his life. He enjoyed the domestic things, the walk to the shops,

the pint of beer in the hotel bar, listening to the radio. He's a lesson in the joys of modesty.

SANDY: He was famous for his reticence about travelling. The story is that he hardly ever left Orkney and he only ever left Scotland twice – once to collect a poetry prize and once when the guy driving the car in the Borders went into England by mistake! Certainly, when I was in Stromness with him, making preparatory drawings for his portrait, there were letters arriving from Adelaide in Australia, San Francisco, you name it, from places all over the world, from arts festival organisers inviting him to come and be the guest-of-honour poet. And George would read these letters with a puzzled frown and ask, 'But what would I want to go there for?' I wonder if he even bothered to reply…

ALAN: Yet despite his conservatism – or maybe because of it – his poetry, stories and especially the novels *Greenvoe* and *Magnus* have important things to say about the ecological and political crises of the 20th century, the value of sacrament and the sacral world and the social obligations of the individual and the community. His output is varied and maybe patchy, ranging from work of crystalline brilliance to what you might call almost twee. At its weakest, it's formulaic and pious, and that sense of piety is evident in the way he revised and rewrote poems in later life, cutting out references to specific sexual desires and replacing them with more conventional symbols. But he was a self-conscious celebrant of art and a deft portraitist in verse as well as prose, commemorating the islanders, going back to the great Norse sagas, and developing a poetry written in sparkling, precise English, wonderfully cadenced. His favourite composers were Sibelius and Mahler, and you get a sense of that cold, austere northern world that Sibelius evokes, and of that extending, slow, darkly worrying pessimism that comes through in Mahler's symphonies, and sometimes their almost

painful beauty and emotional tension. And their love of nature. Sibelius's tension of form and Mahler's love of the circus – they're both present in George's work.

His student research on Gerard Manley Hopkins sharply indicates his eye for the precise word, phrase, cadence, the bounce and turn of poetic language, its movement and artifice. He was capable of engaging profound matters with a delicate touch, and finding qualities of permanence in the acts of ordinary days.

And he maintained a wonderfully rich relationship with the landscape of Orkney. One of his favourite places was Rackwick, which he discovered in 1946 while on a picnic to Hoy. He found it beautiful and later talked about the influence this place had on his writing; it was as if, having seen it actually that first time, it then occupied his imagination forever.

SANDY: It's curious that he and Edwin Muir and Muriel Spark all found such value in religion. For them it was a positive thing. Whereas, for Iain Crichton Smith, Prebyterianism was an entirely negative force, despite the family context where relations would conform to their religious dogmas. Muriel Spark said something to the effect that if you're going to take on a religion, you might as well go for one that had all the grandeur and ritual of Catholicism, all the baroque trappings and colour. And you feel that does inspire George, it kind of works into his vision of human grandeur in the greater scheme of things, despite the littleness and sometimes pettiness of a local situation, the gossiping, the drunkenness, the limitations. It's almost a cosmic contradiction of the pettiness of that world. There's a sense of something greater.

ALAN: Most of the modern Scottish poets are atheist or agnostic – MacDiarmid, MacLean, MacCaig, Morgan…

SANDY: Maybe it's more complex than that,

however. The idea of the crucifixion is a highly developed image in the western tradition and of course it comes right out of the Catholic millennium, before the Reformation. Catholic Italy and Catholic Spain, it comes from there. MacCaig was a Presbyterian atheist – he called himself a 'Zen Calvinist'! But MacDiarmid certainly flirted with the idea of Catholicism as a young man and there's more than a touch of the martyred poet, the romantic agony, the crucified sacrifice, in some of his work. And that's there in MacLean's poetry too.

ALAN: And if you go right back to MacDiarmid's early lyrics – 'The Innumerable Christ' or 'The Dead Liebknecht' or the end of *A Drunk Man Looks at the Thistle* where the poet says he must die to 'break the living tomb' of his people...

SANDY: I'm thinking that that sense of crucified humanity comes through in George's sense of sacrifice in a novel like *Magnus* at about the same time as John Bellany is painting his great, rich, terrifying version of the crucifixion, *Allegory*. Bellany

might have been brought up a strict Presbyterian but he draws on this tradition of Mediterranean Catholicism in a big way. You could say that he's a Protestant who paints like a Catholic.

ALAN: It's curious that George Mackay Brown or even Muriel Spark, seem to be drawing on a Mediterranean, Roman Catholic tradition and not the Celtic one. There's a very different sensibility in Norman MacCaig's poem 'Celtic Cross', one of the few where he draws generations of human life into his poetry in a really comprehensive sense, a religious sense of the worth of all of it. It's not an orthodox religious poem by any means but it brings something of a Celtic Christianity and a post-Reformation sensibility into line. It's very different from the religious faith in George Mackay Brown. This is how it begins:

> The implicated generations made
> This symbol of their lives, a stone made light
> By what is carved on it.

The poem asks you to imagine 'What a stone says

2.26 John Bellany b.1942 Allegory 1965

and what a stone cross asks' and suggests that this statement and question are elusive, almost abstract things yet forcefully represented in the stony fact of the cross itself: 'Only men's minds could have unmapped / Into abstraction such a territory.' The 'involutions' of song voiced over generations seem to connect with the presence of the Celtic cross through long eras of historical time:

> The stone remains, and the cross, to let us know
>
> Their unjust, hard demands, as symbols do.
>
> But on them twine and grow
>
> > beneath the dove
>
> Serpents of wisdom whose cool statements show
>
> Such understanding that it seems like love.

SANDY: That's essentialist but also, somehow, generous. Celtic art is much more about carving than about painting. What we have from the Celtic period is stones, carved stones. That's a huge legacy. And for George, the pictorial and colourful aspect of Catholicism was maybe a new thing, a religion grafted onto an ancient sense of ritual, without breaking it. You can't take a step in any direction in Orkney without hitting your toe on a Skara Brae or a Maeshowe or a 4,000-year-old broch – the trappings of the ancient civilisations are everywhere.

ALAN: Well, that essentialism is there for sure. Feminists might find it difficult to like George sometimes. This is the man who writes of women as 'walking wombs' and 'seed jars' –

SANDY: That's very characteristic of Cuban culture, with its mix of Spanish Catholicism and African religions – the idea that women are the essential creators and all the resulting imagery associated with that. In Cuba, the womb itself is the symbol for creation in a great deal of contemporary painting and sculpture. The National Art School in Havana, built in the early years of the revolution, is designed in the shape of a number of women's breasts, all built around a central

fountain – which is a representation of a vagina. And all this is done so openly and brazenly, Cuban-style!

There's a thought-provoking essay by Don Skoog about art, politics and cultural identity in Cuba, where he quotes Alma Guillermoprieto, who was a dance teacher at the School, where she says that its design

> alluded to Cuba's joyous sexuality: each classroom – a cupola crowned by a small pointed skylight – had the unmistakeable shape of a breast. At the centre of the main plaza, water gushed from a fountain that evoked the form of a conch or papaya – the latter word so closely associated with the female pudenda in Cuba that it cannot be uttered in polite company.

ALAN: So maybe George isn't so far out on a limb as he sometimes seems! Yet again, that very forcibly reminds you of the essential conservatism of the farming, fishing, agricultural world he identified with. And the essential facts are always present. Think of the currency of concern about warfare and weaponry. It never goes away. The nuclear politics of the modern world impinge on George's world very clearly in a poem like 'Uranium'. Here, he has emblem-like images for different historical ages: the stone age, the bronze age, the economies of fishing and farming, the 'Door of Salt' and 'The Green Door' but the final image of the poem is a

2.27 The National Art School (Instituto Superior de Arte) Havana, Cuba 2008

warning, a shimmering door we should not wish to open:

A horseman

Returned across the desert this morning.

On the far side

He had stood before the magnificent Door of Fire.

SANDY: Yet you know, he could also be a very broad humorist. Remember those sly caricatures of social ladies taking tea?

Afternoon Tea

Drank Mrs Leask, sticking out her pinkie.

Drank Mrs Spence, having poured in a tinkle-tinkle of whisky (I've such a bad cold!)

Drank Mrs Halcrow, kissing her cup like a lover.

Drank Mrs Traill, and her Pekinese filthied the floor with bits of biscuit and chocolate.

Drank Mrs Clouston, through rocky jaws.

Drank Mrs Heddle, her mouth dodging a sliver of lemon.

Drank Bella the tea wife, who then read engagements, letters, trips and love in every circling clay hollow.

ALAN: The names of places and people all contribute to that particularity and make the imagery somehow more colourful because more specific. I imagine that for many, many people, George's writing is the reason they'll go to Orkney. The first book of his I ever read was *An Orkney Tapestry* and I was hooked there and then. It's such a wonderfully layered and quilted book of stories, poems, history, people, perceptions.

SANDY: And yet it's curious that there are no really great visual images of Orkney in painting. Perhaps this is another reason why George's writing is so valuable and so haunting. Because visually, the islands are so stunning and memorable, both in dramatic ways and in quiet, unobtrusive and gentle ways – you'd think it would

be a painter's haven. But no. It's true that Bet Low made a number of painting expeditions to Orkney. Perhaps she is the exception. But the question is, I suppose, in the period from the end of the 19th century well into the 20th, why was there no Scottish Nolde, for example? Why didn't Gillies or Cadell or Peploe make that trip across the Pentland Firth?

ALAN: One name that does come to mind is Stanley Cursiter.

SANDY: Yes. He was born in Kirkwall. After painting those iconic works of Scottish Modernism, 'Crossing Princes Street' and 'Rain on Princes Street' (both 1913), he retreated to a conservative form of landscape painting. His depictions of Orkney are fine but they're a million miles away from the avant-gardeism of his early work. For Cursiter, Orkney is a nostalgic vision, a safe home, an idyll.

ALAN: It's a bit flash-in-the-pan, isn't it? He was a modernist for a few days then retreated to the establishment and cultivated a conservative style for the rest of his time.

SANDY: In fact he became the Director of the National Galleries in Edinburgh. In other words, the epitome of an establishment figure!

ALAN: He wrote a book entitled *Scottish Art*, published in 1949.

SANDY: Aye, but look at it. He makes no mention at all of John Tonge's pioneering appraisal of Scottish art of 1938, apart from noting it in the bibliography. Cursiter cuts the story off at about 1900 – half a century before he's writing, and so ignores Modernism altogether. You could say that he's putting the clock back by 50 years! Even when he's talking about McTaggart, right at the end of the book, it's in pretty limp terms: 'He painted pictures of rural subjects, mostly children but quickly came to give the figures and their setting a sense of light and air which was

notable.' He observes 'a nostalgic feeling for his boyhood's days' adding that 'the surge of the sea on western shores made him inevitably a landscape painter and more particularly a painter of the sea.' Then he waxes lyrical: 'No one has translated better the quality of Scottish atmosphere, the subtle distinctions between east and west coasts, the sparkle of the Atlantic shores, the grey mists of the north sea.'

ALAN: He's missing something.

SANDY: He's missing the point. Cursiter doesn't say anything about either McTaggart's innovations in painting or about his engagement with Highland people. If he had recognised that, that would be the equivalent of speaking in Scots or in Gaelic. Men and women of good taste wouldn't go there and Cursiter is speaking to polite society. But to be fair to Cursiter, he does make this point in the last paragraph of his book: 'There is a tendency to regret the loss to Scotland of painters who in their early work had shown so much promise, who went to London and, under the influence of popular success and conditions at the Royal Academy, came to paint pictures more attuned to English taste. The qualities they developed are not the qualities most admired in Scotland.'

ALAN: That's exactly what should have been the theme of his book – not just noted as a parting shot on the last page!

SANDY: And yet, this is the same man who in 1937 in a lecture, 'The Place of the Art Gallery in the Life of the Community', argued for a gallery consisting exclusively of modern Scottish art and craft. Maybe we shouldn't be too hard on him!

LINDA: But Orkney didn't produce Modernist art?

ALAN: There is the film maker Margaret Tait, who lived in Orkney and made a number of films that really did explore Orkney visually, drawing on cinematic ways of seeing. There was *Orquil Burn* in 1955, a 35-minute film in sound and colour and in 1977 she made two films about Kirkwall and then three more in 1981, all under the general title *Aspects of Kirkwall*. Then she made *Land Makar* in 1981, a study of an Orkney croft, 32 minutes in colour and sound. So there you have a body of work in film that really went unrecognised until the retrospective film screenings at the Edinburgh Festival in 2004. Her only feature-length film was *Blue Black Permanent* (1992), an eerie portrait of a coastal world, in which a woman commits suicide and her daughter is haunted by the memory in the context of her own domestic life. There's nothing exaggerated or melodramatic about it, yet it's intensely realised and full of loneliness.

SANDY: Tait's films are fascinating but they don't really convey a sense of the visual as primary, in the manner of Bergman or Kurosawa. They have a different texture, more intimate, less epic. Very different from George Mackay Brown.

ALAN: MacDiarmid spotted her work very early, published her poetry in his magazine *The Voice of Scotland* in the 1950s and Tait made a film portrait of MacDiarmid which catches precisely the otherworldliness and uncanniness of some of his poetry and his own personal anarchic, impish humour. It's a much more revealing portrait than any formal interview. It uses a particularly intimate sense which film can catch very effectively.

LINDA: You've studied that film closely, haven't you?

ALAN: When I attempted to describe Tait's film of MacDiarmid, the result took shape as a poem. In some ways, the lines of the poem might be read as paraphrases of the film-scenario, as if they formed a shooting-script. Yet as a poem, emphases have been given to what seemed most emphatic in the film itself. What I thought the film-maker (Tait) wanted to emphasise about the poet (MacDiarmid) are brought out and dwelt upon in the poem. Therefore the poem is a record of my impressions of watching the film and tries to suggest some of the things the film suggests to me: how the work of

the poet (especially MacDiarmid, but you can generalise from that) and that of the film-maker (specifically Tait, but you begin to think about what film can do working with poetry generally, well beyond the bounds of convention) interrupts the ordinary, insists on noticing anomalies, makes time into something charged, pressured with creative potential, and positive good humour. This is the poem.

Tait's MacDiarmid

Piano notes, forthright, and chords, both bold and
 curious,

then song, a voice, a Scots voice, opening the air.

And in the air also, there is The Voice of the BBC

on radio waves, the information, official and
 approved –

(the books of poems, information, unofficial, the
 wedge) –

a radio, newspapers, poems and songs: What might
 you do, unorthodox,

against time and within it, measured and
 spontaneous, delicate and strong?

The vision moves along the clocks where they sit on
 the mantlepiece,

as their long and short hands move, around, then
 the vision moves

back along the other way, and it slows you down to
 see that:

time moving, the fire burning in the hearth, the
 grate,

the pot plants growing in their earth containments.

A man on the edge of a pavement,

on the rim of the squared slabs, balancing between

the raised stone platform by the road and

all its passing traffic, then stepping up and

walking on a wall, or down some stone steps,

down to the edge of the sea, by the rippling waves,

the dark encroaching waters of the sea, the man
throwing stones into the sea –

A glimmer of laughter, a ripple of his shoulders,
neck down, head dipped, a dodge, a piece of cheek
or mischief, disguising an accomplishment
 unspoken.

The door to the house opens.
He goes in. The door closes.
The thick carved wooden knocker is there
on the outside of the closed door.
The light goes on through the window,
the curtains are open – there is the unseen,
there is the invitation of the visible –
The multitude of books, inside!
The film by which we see them.

SANDY: Come back to Bergman for a moment. Bergman's favoured place was the island of Faro, very similar to the Orkney islands. I'm sure he would have found Orkney totally congenial. *The Seventh Seal*, for example, could have been made on Orkney.

If Bergman had been Scottish I'm sure he would have located his films in Orkney or in Shetland. When you think of how influential cinema has been in the 20th century in terms of introducing national cultures to each other – Satyajit Ray in India, Kurosawa in Japan, Fellini in Italy, Andrej Wajda in Poland and so on – what has Scottish film making achieved in comparison?

ALAN: Maybe that's another strength of George's writing – its filmic immediacy.

SANDY: You could imagine him collaborating with Bergman on a film – something like *The Virgin Spring* or *The Seventh Seal*...

ALAN: Certainly, when he's writing about Magnus, the martyred man on the shore, the imagery is similar to Bergman. *Magnus* links the warring

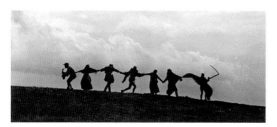

2.28 Ingmar Bergman 1918–2007 Dance of Death from The Seventh Seal 1957

factions of ancient Orkney with the modern world of Nazi Germany in a Brechtian way, confronting you with the fact of human sacrifice and violence. It is still undervalued. Even in poems referring to his own era, there's a mythic dimension and a clarity like a brilliantly visualised black and white film, full of contrast, light and dark. Maybe it's also to do with keeping a sense of the freshness of childhood vision.

Hamnavoe Market

No school today! We drove in our gig to the town.
Daddo bought us each a coloured balloon.
Mine was yellow, it hung high as the moon.
A cheapjack urged. Swingboats went up and down.

Cocoanuts, ice-cream, apples, ginger beer
Routed the five bright shillings in my pocket.
I won a bird-on-a-stick and a diamond locket.
The Blind Fiddler, the broken-nosed boxers were
 there.

The booths huddled like mushrooms along the pier.
I ogled a fish in its crystal cell.
Round every reeling corner came a drunk.
The sun whirled a golden hoof. It lingered. It fell
On a nest of flares. I yawned. Old Madge our mare
Homed through a night black as a bottle of ink.

That's traveling to a faraway place, for most of us, but not only in geographical terms – it's also traveling in time, to a historical time caught in the poet's imaginative act, refracted through that to the present moment of our reading.

LINDA: Sandy, tell us about painting his portrait.

SANDY: Well, George was quite a character. I got to know him in the early 1960s, when I was an undergraduate student and he was a postgraduate student at Edinburgh University.

ALAN: That was when he encountered the other poets in Milne's Bar.

SANDY: Yes. Every time he went into Milne's Bar, or the Abbotsford, or the Café Royal, he was always wearing his weather-beaten, camel coloured duffel coat. He had this big shock of curly black hair and a great promontory of a Viking chin – and he could drink everyone under the table!

ALAN: And yet, to begin with, he must have been extremely shy. There's an elegy he wrote for Norman MacCaig which describes the scene:

Milne's Bar, Rose Street, Edinburgh –
A Saturday afternoon in 1956.

Sitting here and there about the unlovely tables,
Sydney Goodsir Smith, Tom Scott, Norman
 MacCaig, Robert Garioch, George Campbell Hay,
 Alexander Scott
And other bards
Whose lyrics, scratched onto the backs of envelopes,
Would never fly into books.

A cry on the steps, 'Chris, he's here!'
And the bards rise to greet their king, Hugh
 MacDiarmid,
Just off the Biggar bus.

(This Orkney bard sits alone.
 He is too shy – as yet – to visit the bards' table.
Enough to look at them, with longing.
Their words have flown out of books
 To sit, singing, on the branches of his blood.)

SANDY: By the end of the 1960s, he had come to the end of his work at the university – I don't think he ever completed his PhD – and we didn't see much of him after that. There would be an annual visit, in the late summer. At the time I was painting the portrait of Norman MacCaig, I would be telling him, 'George, you've got to come down again, for your portrait.' And he'd say, 'Oh, yes, I'll be coming, I'll be coming…' But he never came. So, ultimately, I thought, 'That's it. There's only one way. I have to go to Orkney and track him down in his lair!'

George lived in this little council house, just round from the harbour. And it was a great reunion, comprising strong tea, chocolate biscuits and the occasional mug of home-brewed ale!

George's nephew, Erlend, after studying at Edinburgh College of Art, had returned to Orkney and became the first director of the Pier Arts Centre. He'd been inspired to become a painter by Ian MacInnes. Erlend told me a few tales of his Uncle George. For years George lived with his mother, who would harangue him: 'Oh, George you're drinking too much, son, you've got to cut this out…' And George was particularly embarrassed about this. One night he was just about to down a glass of whisky but he gave up on that idea and poured the whisky into the goldfish tank. According to Erlend, that was the end of the goldfish.

ALAN: George referred to a whisky bottle as 'the smiler with the knife'.

SANDY: That's the poet's eye.

ALAN: It's a kind of image-making that opens up a truth. And that was what Ted Hughes and Seamus Heaney responded to so immediately in George's poetry. Hughes said that George's very early poem 'Thorfinn' from 1956 'really went into me. I can see all sorts of hints and suggestions that I've taken myself'.

SANDY: I met Ted Hughes when he was reading at the St Magnus Festival in 1984. The first five or 10 minutes of the reading were interrupted by a workman with a road-drill making a hell of a racket on the pier outside. Julian Bream, another Festival performer and one of the greatest of all guitar players since Segovia, was sitting right in front of me and he got up and went outside and asked this guy to stop. He stopped immediately. George was slightly in awe of Hughes, I think, but Hughes was evidently appreciative of George's work and acknowledged how pleased he was to be there, on such a literary island, with George right there in the audience.

ALAN: It is a very literary archipelago, when you think of Robert Rendall, Ernest Marwick, Edwin Muir, Eric Linklater. We had a very good PhD student here at the university recently who completed his work on The Literature of Orkney. It would make a good book. The tourist office should have a literary map of the islands, for curious and literate tourists.

SANDY: Seamus Heaney said that George's 'vision has something of the skaldic poet's consciousness of inevitable ordeal, something of the haiku master's susceptibility to the delicate and momentary.'

ALAN: You can see that in a poem like 'Hamnavoe' – which is the name he always used in his writing for Stromness. It begins with the image of his postman father:

> My father passed with his penny letters
> Through closes opening and shutting like legends
> > When barbarous with gulls
> Hamnavoe's morning broke

And the poem builds up through a whole series of vivid images: horses touching sparks from the cobbles with their steel shoes, fishing boats driving home through furrows in the sea:

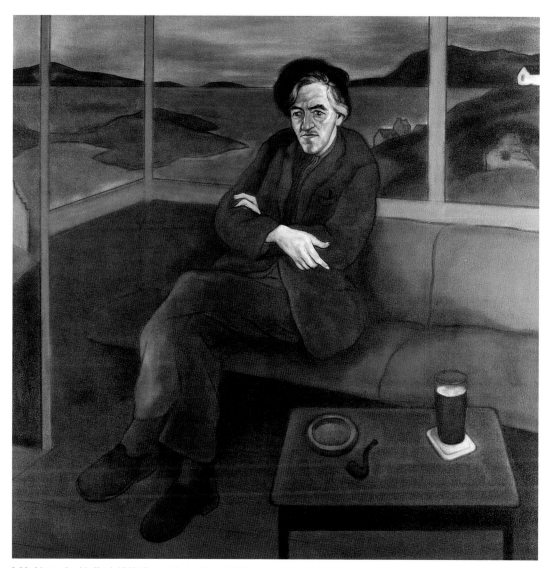

2.29 Alexander Moffat *b.*1943 George Mackay Brown 1980

In 'The Arctic Whaler' three blue elbows fell,

Regular as waves, from beards spumy with porter,

Till the amber day ebbed out

To its black dregs.

There are houses going blind – that is, with their curtains pulled closed, all along 'one steep close, for a / Grief by the shrouded nets.'

The kirk, in a gale of psalms, went heaving through

A tumult of roofs, freighted for heaven. And lovers

Unblessed by steeples, lay under

The buttered bannock of the moon.

And all these images combine to create a vivid context for his father:

And because, under equality's sun,

All things wear now to a common soiling,

In the fire of images

Gladly I put my hand

To save that day for him.

SANDY: In 1997, *For the Islands I Sing* was published, an autobiography found among George's papers after his death – this is in spite of the now famous quote, of himself saying: 'I will not ever be making a full-blown autobiography. They're mostly lies anyway... pieces of vanity and self-deception.'

ALAN: It's not a very reliable autobiography though. Luckily, there is an excellent biography by Maggie Fergusson, that really gives a full account of his life. It's a strange, singular, solitary life, not lacking in contacts, friendships, other people – women, men, friends, sometimes very close. And yet he emerges from the picture perhaps the most solitary of all our poets. We had a student some time ago, thinking about George's conversion to Catholicism and his returning again and again to the ancient stories and pre-Christian images, the tales of *The Orkneyinga Saga* and the standing stones of Orkney, and one day he snapped

his fingers and grinned and cried out, 'I've got it! That's it! He's a Pagan Pape!'

SANDY: There's something in that!

ALAN: Maggie Fergusson describes how he came to the end of his life. On 12 April 1996, he began to grow weaker and was driven from Stromness to Kirkwall, to the hospital. On the journey he commented on the beautiful evening, saying the air was like champagne. The next day, just before he lost consciousness, he spoke his last words to the doctor and nurses attending him. '...Lying back against his pillows, he said: "I see hundreds and hundreds of ships sailing out of the harbour." He died peacefully, 'in the language of the sagas, he passed "out of the story"...' At his funeral, his friend the composer Peter Maxwell Davies played his haunting, lovely piano piece, 'Farewell to Stromness'.

LINDA: Alan, you knew George over the years didn't you?

ALAN: I only met him twice, but yes, it was a long conversation. I met him first in 1976 when he was very encouraging of my own apprentice writing, as it were. Then again in 1995, when I was visiting Orkney and he remembered my visit of 20 years before. And then in February 2007 I was back in Orkney and went to his grave at Warbeth Cemetery near Stromness down by the sea. He's there beside his Mum and Dad and the words on his stone are so simple and right: 'Carve the runes,' they say. 'Then be content with silence.' So I wrote a poem about that, from a little sequence called 'Orkney Postcards':

Threaded on Time

Driving after dark through Hamnavoe at a snail's
 pace,

manoeuvring the narrow winding main street, past
 empty

close-mouths, alleyways, voes running down to the
 sea

where the sea's running up: this tidal little town,
 on waterfront

and hillslope, steep thin streams murmuring descent.

Ferry, ocean, travellers, return upon their different
 tides and seasons.

And I. 1976: That long summer's exploration landed
 me,

one afternoon, with GMB, after a flurry of letters,

this long conversation, as the gift of a salmon arrived,

and knowledge of the hesitancy needed in this given
 world,

added to by his kind words, supporting. Then 1995:

and me a married man, and GMB again that
 afternoon,

slowly recollecting, piece by piece: 'That salmon, yes,

and you were here with someone, then... But now
 I'm fallen

"into the sere and yellow"...' Now, 2007: a blue
 plaque

on the wall. That's good. And on a sunny,
 windswept afternoon,

there's Warbeth spread before me like a harbour or a
 comfy bed

new-made. Beside his Mum and Dad, but with the
 adult words he made

around his stone: a silence to be content in. The salt
 is in the air.

The Sense of Place

ALAN: Most of what we've said here relates to John Berger's description of landscape and what he calls the 'address' of a place, and its occupation of time. In an essay called 'A Story for Aesop' Berger writes that paintable landscapes are those in which what is visible 'enhances man'. In any landscape, 'mood' might change but 'the *address* of the landscape' does not change:

By 'address' I mean what a given landscape addresses to the indigenous imagination: the background of meaning which a landscape suggests to those familiar with it. It begins with what the eye sees every dawn, with the degree to which it is blinded at noon, with how it feels assuaged at sunset. All this has a geographical or topographical basis. Yet here we need to understand by geography something larger than what is usually thought. We have to return to an earlier geographical experience, before geography was defined purely as a natural science. The geographical experience of peasants, nomads, hunters – but perhaps also of cosmonauts.

We have to see the geographic as a representation of an invisible origin: a representation which is constant yet always ambiguous and unclear because what it represents is about the beginning and end of everything, what we actually see (mountain, coast-lines, hills, clouds, vegetation) are the temporal consequences of a nameless, unimaginable event. We are still living that event, and geography – in the sense I'm using it – offers us signs to read concerning its nature.

SANDY: We can also trace this line of thinking back to Berger's essay on Paul Strand. In that essay, Berger makes an observation that seems essential to what we're saying here. He says that where Strand 'has chosen to place it [the camera] is not where something is about to happen but where a number of happenings will be related. Thus without any use of anecdote, he turns his subjects into narrators. The river narrates itself. The field where the horses are grazing recounts itself. The wife tells the story of her marriage. In each case Strand the photographer has chosen the place to put his camera as listener.' And then he says, 'the photographic moment for Strand is a biographical or historic moment whose duration is ideally measured not by seconds but by its relation to a lifetime.'

ALAN: So when we come back again to 'A Story for Aesop' the point applies very clearly. Berger says, 'The address of many jungles is fertile, polytheistic,

mortal. The address of deserts is unilinear and severe. The address of western Ireland or Scotland is tidal, recurring, ghost-filled. (This is why it makes sense to talk of a Celtic landscape.)' So I guess what we've been doing is looking at these poets, Sorley MacLean, Iain Crichton Smith and George Mackay Brown, in the context of their recurring, tidal, ghostly, ancient yet contemporary landscapes, in the Highlands and Islands of Scotland. MacLean's great poem 'Screapadal' describes the beauty of a cleared landscape and seascape, and points out that that beauty was left by the factors and their employers, who drove the people out. They could not take that beauty away. But it is under threat now as it was in the late 20th century when MacLean wrote the poem. The consequence of the destructive nature of nuclear power and nuclear weaponry and the kind of holocaust that you can imagine would be to strip even the beauty from the landscape.

SANDY: Iain Crichton Smith also has that sense of the address of the landscape in his work, no matter how much Scotland is seen as a wasteland, the place of personal breakdown, or the location that gives rise to the unanswerable questions –

ALAN: Remember those lines in the poem where he describes an almost timeless nocturnal wilderness, bare moor, hill and trees, and an owl winging onto a branch with its prey, then he says:

> All *seems immortal*
>
> but *for the dangling mouse.*

SANDY: And George Mackay Brown's 'Uranium' presents you with those absolute questions that maybe were what drove him to Catholicism for absolute answers, but the questions remain for us...

ALAN: Aye. They're still with us. And that's what the poems and paintings can do, to help us deal with them. Maybe they'll never be finally answered. But the work of art is there to help us with the problem.

SANDY: So it's the specific place, the locality, the landscape and terrain and geography and all the rest of it that informs and nourishes the vision of these poets and artists. At the same time, their poetry and art is a universal thing, it draws from whatever locale is particular to its author and becomes something that might be read or experienced *anywhere*, literally, anywhere in the world. Samuel Beckett's 'Homage to Jack B. Yeats' seems to me to be the key text to all this:

> What is incomparable in this great solitary *oeuvre* is its insistence upon sending us back to the darkest part of the spirit that created it and upon permitting illuminations only through that darkness. Hence this unparalleled strangeness which renders irrelevant the usual tracing of a heritage, whether national or other.
>
> What is less magic than this extraordinary craftsmanship, as if inspired by the thing to be done in its own urgency?
>
> As for references that have been unearthed – Ensor and Munch at the top of the list – the least that can be said is that they are not much help.
>
> The artist that stakes his being comes from nowhere. And he has no brothers.
>
> Shall I embellish? There is neither place nor time for reassuring notes on these desperately immediate images. On this violence of need which not only unleashes them but disrupts them beyond their vanishing lines. On this great internal reality which incorporates into a single witness dead and living spirits, nature and void, everything that will cease and everything that will never be. And finally on this supreme master who submits to what cannot be mastered, and trembles.
>
> No.
>
> One can simply bow, wonder-struck.

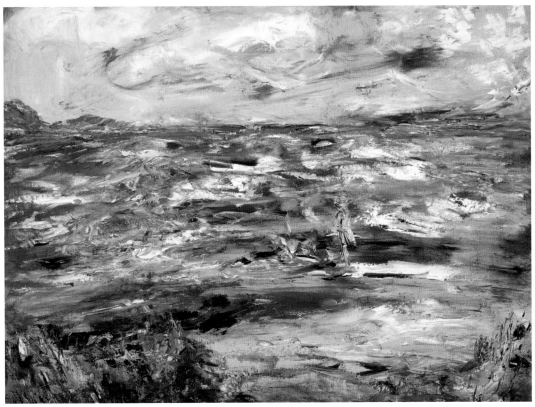

2.30 Jack B Yeats 1871–1957 Queen Maeve walked upon this Strand 1950

Part Three
Poets of the City

The Cities of Scotland

ALAN: We noted earlier that one of the most important things to remember about Scotland in the 19th century is the speed of industrialisation, so that the majority of the population, who had been living in the country, in a farming or agricultural or fishing economy, derived economically from a feudal society or clan-based social structure, was suddenly transformed. By the end of the 19th century, the majority of Scottish people were living in the cities. We've looked at poets and artists whose work is rooted in the Highlands and Islands of Scotland. Now we'd like to turn to the cities.

LINDA: So how is the experience of city life represented in the poetry and painting of modern Scotland?

SANDY: We could begin by taking a look at each city in turn. They all have different stories. Glasgow and Dundee were the most heavily industrialised, both built around their rivers; Aberdeen and Edinburgh retain an open air, visibly linked to the country or the sea, Edinburgh to the port of Leith and the Pentland Hills behind, and in Aberdeen, the north sea comes right into the centre of the city via one of the busiest harbours in Europe. I think there's a ship going out or coming in every 60 seconds! Meanwhile behind the city you can follow the rivers, the Don and the Dee all the way back up into the Grampians. That's a marvellous part of the country. And then with Glasgow, you have a westward-facing character – and there's the Clyde, taking shipping across the Atlantic and beyond – it's the most American city in a sense. It was one of the first cities to use a road grid-system. And with Dundee, the jute barons were looking after the trade with India, facilitated by the natural port that was provided by the River Tay.

ALAN: Each city has its own poets and artists and its own character.

LINDA: So how would you describe these identities? Sandy, in terms of the art schools in

each city, are they distinctive or is there a common vision, a coherent national picture emerging?

SANDY: Let's look at the four major art schools: Aberdeen, Edinburgh, Dundee and Glasgow. Each of them knew they were very different, strongly related to their own location. When Ian Fleming moved from Glasgow to Aberdeen, he didn't bring a Glasgow perspective and impose it on Aberdeen, he allowed Aberdeen to speak for itself, to reveal itself to him as a new visual context in which to work.

For most of the 20th century, all the art schools shared a common curriculum with regard to painting. The importance of drawing was heavily emphasised and an almost ruthless pursuit of excellence was demanded. A mastery of craft was expected and from that foundation, visual thinking allied to the imagination could then be applied to create works of art. The art schools shared a collective belief in ways of painting which were Scottish and had been handed down and would be handed on. Yet the end results were profoundly different.

The richness and variety of painting in Glasgow, its engagement with both social and political issues, popular culture and literature, all this remains poles apart from the preoccupations of the Edinburgh school, where refinement of taste and an adherence to the decorative values of French Modernism held firm. It could be argued that Glasgow artists deployed a directness of expression stressing instinct and imagination where accessibility and communication were paramount. I suppose for the Edinburgh painters, Glasgow was vulgar. The Modernist aversion to illustration and to narrative had little effect on painters in Glasgow, whereas in Edinburgh, abstraction and formalism were absorbed and promoted. Images of people predominate in Glasgow, maybe because of the impact of big city life, its humour and humanity. Representations of the figure, from Cowie and Crosbie in the 1930s, Colquhoun, MacBryde and Eardley in the 1940s to Donaldson in the 1970s and Campbell, Currie and Howson in the 1980s, all articulate the essential humanism of painting in Glasgow.

3.1 Ian Fleming 1906–94 Black Wall, St Monans 1958

3.2 David Donaldson 1916–96 Rabbi Jeremy Rosen *c.*1969

More recently, powerful images of the female body in the work of Margaret Hunter, Alison Watt and Jenny Saville challenge the notion that Glaswegian painting is an all-male affair.

With the notable exception of John Bellany, paintings of the human figure were hard to find in Edinburgh. Gillies, Maxwell and Redpath and thereafter Houston and Blackadder concentrated on landscape and still life, incorporating aspects of both European and American Modernism into their work.

In the years after the Second World War, abstraction was much more readily assimilated in Edinburgh. William Gear, Alan Davie and Charles Pulsford all made significant statements in this field in the 1950s, as did Ken Dingwall and Alan Johnston in the 1970s and 1980s.

In Aberdeen, the environment of the north-east coast exerted a powerful influence. In the work of artists such as Alexander Fraser and the Orcadian Sylvia Wishart, a unique atmosphere of sea and sky provides a framework for their imagery. Ian Fleming, who left Glasgow to become Principal of Gray's School of Art from 1954 to 1972, found new subject matter amongst the fishing harbours and weathered objects washed onto the northern beaches. Will MacLean is another who has responded in his own way to a dialogue with sea and sky. And Ian Mackenzie Smith's poetic abstractions, distinguished by their use of grey tones, rather than intense colour, refer to the elemental state of weather experienced on the edge of the north sea. This is quite self-conscious, almost in a literary way. For example, on a recent visit to Gray's School of Art in Aberdeen, I was struck by how many of the students had been directly inspired by the poetry of George Mackay Brown.

Turning to Dundee, the general approach could be described in terms of a kind of realism, with a meticulous attention to detail uppermost. It's no surprise to learn that Edward Baird and James MacIntosh Patrick taught in the Art School in the late 1930s; their influence seems to linger to this day. It's worth noting that Baird was both a socialist and a Scottish nationalist who believed that a good picture should be the outcome of hard labour.

The expressive gesture or sumptuous colour found in Glasgow or Edinburgh is replaced in the work of Neil Dallas Brown by earthy monochromes and a subject matter which is often dark and sinister.

That these differences exist, or have existed, and have contributed to the overall richness and diversity of painting in Scotland, is an important factor in our story. Whether or not this diversity

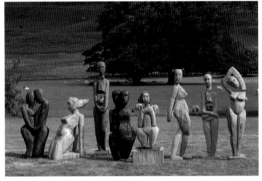

3.3 Margaret Hunter b.1948 Maidens' Chambers 2006

3.4 Anne Redpath 1895–1965 In the Chapel of St Jean, Tréboul 1954

3.5 Edward Baird 1904–49 Unidentified Aircraft 1942

3.6 James MacIntosh Patrick 1907–98 The Tay Bridge from My Studio Window 1948

will withstand the current bureaucratic standardisation imposed upon art schools by politicians and administrators wholly ignorant and dismissive of the traditions and cultural contribution the art schools have made, is cause for concern.

Dundee

SANDY: Dundee is associated with the production of jute, from which you made sacks and matting. In fact, artists used to get the toughest flax canvas from Dundee, from the jute industry. That industry is completely gone now. There's hardly any actual production left in Scotland. A hundred years ago, we were the China of the western world. There was nothing we didn't produce – engineering and scientific invention were linked to making things. James MacIntosh Patrick's *The Tay Bridge from my Studio Window* reminds us of that recent past. Nostalgic, perhaps, but none the worse for that.

It's a terrible irony that the most famous cultural production to emerge from Dundee is *Oor Wullie* and *The Broons* and the D.C. Thomson publishing industry with *The Sunday Post* and *The People's Friend* and *The Scots Magazine*. Talking about this kind of popular art form, I suspect that Dudley D. Watkins

was a formative influence on the young Steven Campbell…

ALAN: I have a kind of affection for these things.

SANDY: Of course you do, and why not? But at the same time as Thomson was producing those publications, the jute and marmalade barons were becoming acquisitive art-collectors while the keelies and workers were getting drunk and stabbing each other on Saturday nights and reading *The Broons* and *Oor Wullie* on Sunday morning.

ALAN: Or their wives and children were…

SANDY: Industrial cities have violent reputations and Dundee is no exception. It didn't have a university till the 1960s. The thing is, how many people knew about the toffs enjoying their art collections? Bismarck thought that you had to limit education for the working class, make sure that people didn't know how the economy worked, or what the arts could do, because education would simply lead people to want a better way of life and to demand decent wages and conditions and so on. After the unification of Germany, he made sure that there was no new university erected in the industrial Ruhr, where you had the largest concentration of workers in Europe at that time. And there was

nothing unique about Germany in this. The British ruling classes thought exactly the same.

ALAN: It's not just about education. It's simply information – information that isn't easily available or made very public knowledge. It's there, it's not confidential – well, a lot of it is available – but it's not passed on as something that might inform your actions. How can it be, when the airwaves are so clogged up with all sorts of soft-soap pap and what my Grandfather used to call 'yankee-doodle'?

SANDY: And we know now about the Westminster spin on information that might have led people back in the 1970s to be better informed about the economic facts to do with Scottish independence. Information was released at the end of the 25 year embargo on cabinet minutes and this was widely reported in the newspapers in 2006. It was shown that the Westminster politicians – Callaghan's mob, Labour ministers – deliberately set out to obscure the facts that revenue from North Sea oil could easily have fuelled an independent Scotland.

LINDA: Let's get back to Dundee!

ALAN: Okay. MacDiarmid in the 1920s has a little poem in English that begins, 'Dundee is dust / And Aberdeen a shell…' But it is not simply barren. When I think of Dundee two names come immediately to my mind: the poet, James Young Geddes and the painter, Stewart Carmichael.

LINDA: You must be pretty unusual in that regard!

ALAN: I'd like to start with these two figures because Geddes is unquestionably the most radical Scottish poet between Burns and MacDiarmid and Carmichael is one of the first truly Modernist Scottish artists, a painter of real stature.

SANDY: And it's MacDiarmid, again in the 1920s, who first spotted the talent of Stewart Carmichael. Here's what he said: 'Carmichael's studio in the Nethergate is like an oasis in a desert – one of the very few spots in Dundee where there is any spiritual life.' He called Dundee 'the dreariest waste of materialism that contemporary Scotland possesses', going on to describe the physical conditions of poor and debilitated people, working for low wages and living in appalling conditions – 'one tenement has no fewer than three stories below ground'. While the municipal art gallery is filled with 'incredibly ugly' and 'fatuous' works and 'blatant portraits of all manner of local nonentities cheek-by-jowl in the most extraordinary fashion with a minority of works of genuine – a few of really high – merit.' He continues:

> There are a few wealthy 'private patrons of art' in Dundee, but most of them are connoisseurs or picture-lovers, and, in each of these categories, the 'inferiority complex' is generally in full blast. This accounts for the fact that there is a market, however limited, in Dundee for modern French stuff, Cézanne, Van Gogh, and the like. But between plutocratic extremes and proletarian nescience there is practically no public interest to sustain native art-products.

ALAN: Stewart Carmichael is an exceptional figure in the world of these people. He is, MacDiarmid says, 'very notably and entirely a Scot' in the sense that carries you back to pre-Reformation Scotland, 'when Scotland was one with Europe' and his 'attitude of consequence' is best seen in his 'friezes of Scottish History, the Makars, Scottish Women with Jenny Geddes – not Queen Mary – in the centre.'

> But his most distinctive vein is represented by his symbolical compositions. Here the poet side of his nature emerges. It is not surprising that these pictures should be held in little esteem today and their real value missed. But as manifestations of the Scottish Psyche – as glimpses into the soul of Celtic imagery – they stand in a category of their own… Paintings such as *Birth*, *The Friends of Genius* (*Poverty and Disaster*), *Chance*, *The Wife of Judea*, and a score of others confront us with this aspect or that of a powerful imagination that has difficulty in compressing cosmic conceptions or remote spiritual problems into terrestrial human terms at all. These are wild, weird designs, full of unique psychological interest. If I was asked 'What is a Scotsman?' I could scarcely do better than show my interrogator one of these compositions…

3.7 Stewart Carmichael 1867–1950 Self-Portrait in the Artist's Studio 1947

SANDY: Carmichael was born and died in Dundee. When he was 19 he moved to London and between 1888 and 1891 he travelled in Europe – in Antwerp, Brussels, Paris and Siena – but then he returned to Dundee and devoted himself to Scottish art and

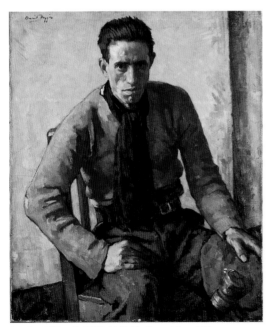

3.8 David Foggie 1878–1948 The Young Miner 1926

literature. For a time, he was married to the Scottish nationalist activist, writer and artist Wendy Wood. He exhibited widely, in Paris, Brussels and London as well as Glasgow and Edinburgh and Dundee but he was dedicated to his native place and became governor of the Dundee College of Art from 1936 till his death. So here you have an artist of international reputation and recognition, committed to his particular Scottish locality and to an all-encompassing political overview of Scotland, who has simply dropped off the radar. It's time we saw more of his work. And also of his great friend David Foggie (1878–1948), who, as a young man, had studied in Antwerp, Florence, Paris and Holland. Foggie was a man of socialist principles and he was appalled by the suffering caused by the General Strike in 1926. During the strike, he helped to support one mining family by paying all of them to sit for him.

David Foggie's grandson has pointed out to us that the relationship between literature and the visual arts was a subject dear to his grandfather's heart. Foggie was close to a large group of writers, thinkers and politicians and he made portraits of many of them, including Compton Mackenzie, Eric Linklater and Wendy Wood and the 1933 drawing of MacDiarmid is especially successful. He was a critic and commentator with outspoken opinions that sometimes got him into hot water, especially his comment that 'Cézanne could not draw'!

LINDA: Tell us a bit more about James Young Geddes.

ALAN: James Young Geddes (1850–1913) was also dedicated to Dundee in his own way. His father was a tailor and James was in the family business by the age of 16. He was active in local debating societies and Burns clubs. His business life prospered but he lived to see the deaths of three of his own children and two of his sisters, and only published three books of poetry. He became bailie of Alyth in the 1880s and was keenly aware of local issues about land access and sanitation, working on various

school boards and police boards and in civic duties, writing for *The Dundee Advertiser*, engaged by international questions of labour and health while deploring the sentimental kailyard writers and advocating a Scottish cultural renaissance. His three books, *The New Jerusalem* (1879), *The Spectre Clock of Alyth* (1886) and *In the Valhalla* (1891) are astonishing works. There's a simple, direct sense of moral value in their descriptions of social conditions, factory works and so on – but it comes through implicitly, so it's never banal or overstated. It's a social morality that reminds me of William Blake in his poem 'London'. There's a sense of the visual and nightmarish, nocturnal, industrial cityscape reminiscent of Dante's *Inferno*. And there's a radical development in poetic form: Geddes has read the great American poet of democratic idealism, Walt Whitman – but he's read him not only for that political vision but also for his radical poetics, the long line, reaching out like an incantation, building anger and indignation up as it keeps it in check, just under the surface of what's being described pictorially. Amazing stuff!

LINDA: He hated the industrial city?

ALAN: No, not really. He is clearly outraged at the injustice of it but he's an optimist. He thinks there's progress possible here and he's fundamentally good-humoured, unlike some of his contemporaries and predecessors, Robert Buchanan or James ('B.V.') Thomson, say. So this is a poetry that comes right from the social vision of Burns, it's in that tradition of imagining social justice, but it's also in tune with Whitman's radical new poetics.

SANDY: And it's connected with the radicalism that was very much in the character of Dundee. Various figures publicly declared their commitment to social reform in 18th-century Dundee and ended up in Botany Bay. There are statues to two of Scotland's great political radicals in Dundee's Reform Street: George Kinloch and Robert Rintoul.

ALAN: His major poems are *The New Jerusalem*, a satire on religious piety where Heaven is described with lovely scenery and central heating in the houses but everything is controlled by smug, self-righteous bureaucrats. It's followed by 'The New Inferno', where Satan takes us on a tour of a Hell in which industrialism has actually created a heaven for human labouring people. Each poem is a warning to counterbalance the other. Apathy is the enemy, as it is in *The Spectre Clock of Alyth*, where the town councillors and city fathers are as run down as the public clock itself. What's surprising is the optimism about the idea of mechanical and industrial progress. There's a fine poem of religious doubt, 'The Shoreless Sea' and elsewhere Geddes condemns the lack of human compassion so often crippling religious dogma and especially Calvinism. In 'The Second Advent' he imagines Christ returning to Dundee, where, predictably, he is condemned by the established church. There is also an astonishing poem called 'The Farm' that uses Whitman's long, variable line to darker effect than is common in Whitman. It presents a decent couple dreaming of using the profits from their pub to buy an idyllic farm, but the line draws out the weary movement towards the utter failure of their dream. It is exhausting rather than exhilarating: Whitman reversed, a tragic vision of frailty and diminishment. But his greatest poem is 'Glendale & Co' – again using the Whitman line but in a tense, focused, passionate condemnation of what capitalism is, when uninformed by moral conscience. Company reports, statistics, surveys, Whitman's lists are brought into play as the company of Glendale is shown to be a vast city in itself, whose factories 'cover acres' and whose effects are poverty, the slums, horrific squalor and dehumanising deprivations. Glendale himself may seem decent enough but he is part of the great machine that alienates owners and workers.

SANDY: You think of how many people have heard of William McGonagall and his associations with Dundee and the Tay but how few have heard of

Geddes! It's time to reassess Geddes in the whole context of modern poetry, isn't it?

ALAN: Along with Stewart Carmichael in modern painting – and who knows how many others we haven't heard of yet? There's a lot of work still to be done.

SANDY: What's wrong with Scotland that neither had a productive and visible career here? If you were in a little town in France, or in Ireland, and you went into the local tourist office, don't you think there would be a leaflet showing you where to go to find the Carmichael Gallery, where his work would be on show? In Sligo you've got the Yeats house and library and a new gallery devoted to the work of Jack Yeats – both Yeats brothers are represented, confidently, familiarly. And it's not as if the central government in Dublin have ordered this to happen. There must be some kind of local initiative. But that initiative can only happen if everyone, throughout the country, is encouraged to place a proper value upon their own culture.

ALAN: That's not what happens in a philistine society, where there's an encouragement of the opposite attitude to the arts. A reactionary, prejudiced, ignorant attitude really leads to a sense of hopelessness, and aided and abetted by the mass media, this has its effect among the artists themselves…

SANDY: It's strange, isn't it, that so many major Scottish artists have worked outside their country in the last hundred years? Think of them – James Pryde, Alan Davie, Eduardo Paolozzi, William Crozier, William Gear, Bruce McLean, John Bellany and there are many others.

They all continued to operate as Scottish artists, in London or wherever. It's not as if they abandoned their Scottish voices. And even if they did want to take on and challenge the very best, there is still the underlying fact that they felt that Scotland was too small-minded for them to really develop their artistic vision.

ALAN: That's James MacMillan's line too. Maybe it's because so few people cared about them or cared about the art they could produce. So few people wanted to foster anything that could help them fulfil their artistic vision and produce the work they were capable of.

LINDA: Is that true of poets as well?

ALAN: Well, you think of the major writers who aren't usually seen as part of the story because they lived furth of Scotland. Pre-eminently W.S. Graham – Sydney Graham – a long standing friend of Edwin Morgan. If you read the correspondence between them you see how strongly supportive and insightful Graham was of Morgan's work and how important Morgan understood Graham to be. More than that, there's the sense that Graham under-stood Morgan's insight and capacity and character very early on. In a letter of 1949, Graham says that although they've only met once or twice, he knows that Morgan is 'one of the people I would want to write for.' That's amazing. At this point, Morgan

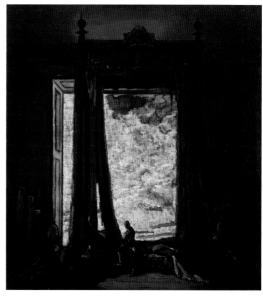

3.9 James Pryde 1866–1941 Lumber: A Silhouette 1921

had only just begun writing and translating and Graham had just written 'The Nightfishing'.

Graham belonged to a group that included Norman MacCaig and other Scots poets called the 'New Apocalypse'. Their writing was marked by an emphasis on wild imagination and inchoate imagery, uncontrolled dream rather than tarmac and electricity documentary that was all the rage with Auden and his English contemporaries. MacCaig told me once that early W.S. Graham was apprentice work until you got to 'The Nightfishing'. At that point, MacCaig said, you knew were dealing with someone who could seriously write. In a singular, inimitable way, the texture of his poetry as he develops becomes all the more Scottish. He said once that there was 'more poetry in Scotland to be made of words instead of heather and homerule and freedom' and he would never deny his nationality. In that letter to Morgan, Graham says he's been reading the Gaelic poems in *The Book of the Dean of Lismore*, in terrible, dull translations that nevertheless allow him to glimpse what the quality of the poetry in Gaelic must be. And he asks Morgan if he knows a good Gaelic scholar who could help him with versions he might write in English, just as Pound had translated from the Chinese in that key slim volume *Cathay* (1915), which the sculptor Gaudier-Breszka read in the trenches of the First World War. Graham never lost that loyalty to Scotland and he should be considered in the company of his contemporaries and peers. In the major themes of his work – exile, loneliness, haunting – he is palpably close to Iain Crichton Smith and Sorley MacLean. In the sense that he's concerned with the uncertainty of language and voice and the precision of poems, he might be closely compared with MacCaig. And where Morgan and MacDiarmid are continually expansive and referential in their exploration of the world's cultures and languages, Graham might offer a salutary contrast as a poet intensely concerned with his limitations – the cage of the

English whose bars are marked by the capital letter beginning every line of every one of his poems. Nothing conversationally facile there – they're all made things.

SANDY: I think a number of those Scottish poets recognised Graham's quality and wrote poems dedicated to him, or wrote about his work, including Hugh MacDiarmid. And a younger generation also acknowledged the power of his writing. And we shouldn't forget that he was a pal of Colquhoun and MacBryde during their wild days and nights in Soho.

ALAN: Aye. If I were compiling my most essential little anthology of Scottish poems I'd never want to be without, I'd include Graham's poem about the loch he knew as a boy, in the hills above his industrial home town of Greenock, 'Loch Thom'.

Loch Thom

I

Just for the sake of recovering
I walked backward from my fifty-six
Quick years of age wanting to see,
And managed not to trip or stumble
To find Loch Thom and turned round
To see the stretch of my childhood
Before me. Here is the loch. The same
Long-beaked cry curls across
The heather-edges of the water held
Between the hills a boyhood's walk
Up from Greenock. It is the morning.
And I am here with my mammy's
Bramble jam scones in my pocket.
The Firth is miles and I have come
Back to find Loch Thom maybe
In this light does not recognise me.
This is a lonely freshwater loch.
No farms on the edge. Only
Heather grouse-moor stretching

Down to Greenock and One Hope
Street or stretching away across
Into the blue moors of Ayrshire.

2

And almost I am back again
Wading the heather down to the edge
To sit. The minnows go by in shoals
Like iron-filings in the shallows.
My mother is dead. My father is dead
And all the trout I used to know
Leaping from their sad rings are dead.

3

I drop my crumbs into the shallow
Weed for minnows and pinheads.
You see that I will have to rise
And turn round and get back where
My running age will slow for a moment
To let me on. It is a colder
Stretch of water than I remember.
The curlew's cry travelling still
Kills me fairly. In front of me
The grouse flurry and settle. GOBACK
GOBACK GOBACK FAREWELL LOCH THOM.

SANDY: But Graham is only one of a large number of Scots writers who lived most of their adult lives abroad, in the 20th century.

ALAN: There was Norman Douglas, for example, whose novel *South Wind* is a thorough rejection of the Calvinist ethos. And more recently there's Muriel Spark, who always thought of herself as a poet, and whose novels – not only *The Prime of Miss Jean Brodie* but also *The Ballad of Peckham Rye* and others – draw very much on the Scottish Ballad tradition.

SANDY: When you think of Muriel Spark as a young, divorced mother, her social standing – never mind her desire to become a writer – would have seemed unwelcome in Scotland. She would

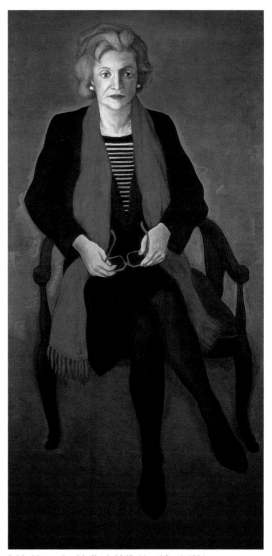

3.10 Alexander Moffat b.1943 Muriel Spark 1984

have been ostracised, wouldn't she? It was never an option for her.

ALAN: It was a big enough struggle in London for her, in her early days.

SANDY: I remember Bill Crozier saying to me that once he'd received his diploma, a couple of hours

3.11 William Crozier b.1933 Burning Field, Essex 1960

after the graduation ceremony, he packed his suitcase and went down to Central Station, to get out of Glasgow, where the prevailing attitude was so negative. That was 1952, and even by 1965, when John Bellany left, I think he felt it would be impossible to develop his work in a country where narrow-minded judgemental Presbyterianism ruled the roost.

ALAN: It's a question that has not yet been answered adequately. I was at a political debate recently and asked some of our leading politicians and party leaders responsible for policy how it is possible that someone might go through the entire education system in Scotland – primary, secondary and tertiary – and come out of it knowing nothing about Scottish literature or the arts of Scotland – nothing at all. A few years ago, an Irish President said that the arts are the genius of your country and education is the key with

which you unlock the door. But it isn't happening here. So many politicians, educationalists, so many people generally, just don't seem to have got the idea. And that's simply going to be repeated in every generation until we do something about it.

Aberdeen

SANDY: In Aberdeen I think you're always, to an extraordinary degree, completely conscious you're next to the sea. There's something elemental about the city that way.

ALAN: The buildings are made of granite and it glitters as though it's just that morning been frosted with salt.

LINDA: How about the poets?

ALAN: There's a long history of poets associated with Aberdeen, from John Barbour (c.1320–1395), who wrote the great heroic episodic epic poem *The Bruce*, to Byron, (1788–1824) but there are four writers I mainly associate with Aberdeen – G.S. Fraser, Alexander Scott, Lewis Grassic Gibbon and Iain Crichton Smith. Gibbon, of course, bases his city in the third of the novels in the *Scots Quair* trilogy, *Grey Granite*, on Aberdeen but it calls in aspects of other cities, too. I think the police charge, when the mounted police beat down with their truncheons the marching industrial workers, is based on an incident Gibbon reported when he was a journalist in Glasgow. But *Grey Granite* is certainly one of the major Scottish engagements with the city in modern fiction.

SANDY: So the writers of the 1920s and 1930s weren't very complimentary about the cities. And in a sense that's entirely justifiable.

ALAN: Of course. But when you get to G.S. Fraser, Alexander Scott and Iain Crichton Smith, a real affection for Aberdeen comes through.

LINDA: Isn't there also an idea that Aberdeen is famously mean?

ALAN: Gibbon tells a ghastly Aberdeen joke about

a widow being given the casket of her late husband's ashes after his cremation. She keeks in and looks up at the undertaker with a miserable frown: 'Aye,' she says. '*But faar's the drippin'?*' ['Where's the dripping?']

SANDY: This meanness also extends to the Aberdeen committee who commissioned Pittendrigh MacGillivray to deliver a statue of Byron. MacGillivray, who was born in Inverurie, wanted to do it in bronze but the committee wanted it in granite because they believed that the granite merchants would then subsidise the cost of it! MacGillivray was incensed at what he saw as 'tight-fistedness' and he let his opinions be known with a racist comment pretty typical of the era: 'Aberdeen is a fine city and although they do say that no Jew can make a living in it, there yet must be many people in it of dignified character and noble ethics other than those of the majority who rule the Byron committee. The big work in Aberdeen' – in the grounds of the grammar school – 'is not my personal handiwork and falls as a work of art considerably short of what it might have been from my hand.' However, the finished sculpture, completed by Alex Leslie from MacGillivray's maquette, remains an impressive work of art.

ALAN: That's a perfect example of an artist totally frustrated and overruled by ignorance and lack of proper encouragement. There's another story about Naomi Mitchison, who worked extensively in the Highlands and Islands trying to set up community halls and places where the residents might get together and debate issues that affected their lives, places where, for example, later theatre touring companies like 7:84 might put on a production for people who normally wouldn't go to a theatre. She was very impatient for something to be done on one occasion. Her biographer, Jenni Calder, recounts that J.A. Ford, Scottish Office assessor, remembered a meeting in Stornoway in which Naomi was getting carried away with ideas

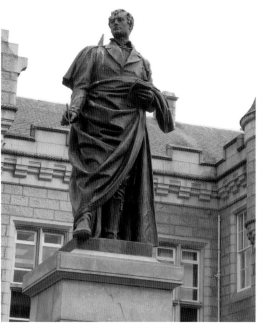

3.12 Pittendrigh MacGillivray 1856–1938 The Byron Statue c.1913

for expanding agriculture and forestry. He pointed out there was a limited amount of money in the till. Naomi's rejoinder was: 'Fuck the till!'

LINDA: Tell us a bit more about the poets.

ALAN: G.S. Fraser (1915–1980) is rather an overlooked figure. He was an astute literary critic. He wrote one of the earliest and best introductory books about Ezra Pound (1960) in a great series called 'Writers and Critics' published in Edinburgh by Oliver and Boyd. It was commissioned by A. Norman Jeffares (Derry Jeffares) and David Daiches – two of the most influential and beneficial literary critics, who really brought Scottish and Irish and, indeed, Commonwealth or 'post-colonial' literatures, effectively into the view of an international critical readership. C.P. Snow was involved in editing that series too. Anyhow, G.S. Fraser wrote a big survey of modern literature in *The Modern Writer and His World* (1953) though it was

very Anglo-American in perspective and he does not really deal with modern Scottish literature at all. Born in Glasgow, he grew up in Aberdeen and trained as a reporter on the *Aberdeen Press and Journal*. He served in the British Army in Cairo and Eritrea, and went as a cultural advisor to the UK Liaison Mission in Tokyo from 1949 to 1951. He was associated with the New Apocalypse poetry movement, like Graham and MacCaig, early on. Fraser suffered a breakdown, which his widow, Paddy, attributed in part to a quality of characteristically Scottish self-suppression. He recovered, though, and worked teaching English literature at the University of Leicester from 1959 to 1979. There's an autobiographical account of his own early life and a continuation of the story in a memoir by his widow published online at: http://jacketmagazine.com/20/fraser.html

Fraser published very little about Scottish literature, unfortunately. There's a rather intemperate essay about MacDiarmid's later poetry which misses the point a bit. But he was himself a poet of real distinction. Aberdeen was his favoured place, and he writes about it well, in 'Home Town Elegy (For Aberdeen in Spring)':

Glitter of mica at the windy corners,

Tar in the nostrils, under blue lamps budding

Like bubbles of glass the blue buds of a tree,

Night-shining shopfronts, or the sleek sun flooding

The broad abundant dying sprawl of the Dee:

For these and for their like my thoughts are mourners

That yet shall stand, though I come home no more,

Gas-works, white ballroom and the red brick baths

And salmon nets along a mile of shore,

Or beyond the municipal golf-course, the moorland paths

And the country lying quiet and full of farms.

This is the shape of a land that outlasts a strategy

And is not to be taken with rhetoric or arms.

LINDA: Alexander Scott was pretty much Fraser's immediate contemporary, wasn't he?

ALAN: Yes. And like Fraser, he was a university man and distinguished poet but unlike Fraser, Scott was dedicated to the development of teaching Scottish literature as a university subject. Scott (1920–1989) was born and grew up in Aberdeen and went to university there from 1939 to 1941 and from 1945 to 1947. From 1941 to 1945 he was on war service; he led an attack at the battle of the Reichswald and was awarded a Military Cross. He taught at Edinburgh University in the late 1940s but moved to Glasgow and became the first-ever Head of the Department of Scottish Literature in 1971 when that department was established. That's still the only separate Department of Scottish Literature in the world. Scott was a legendary teacher and lecturer, poet and playwright and his biography of the poet William Soutar, *Still Life* (1958) is a fine work. His poems cover a wide range of forms and subjects. At Glasgow, he was friendly with Edwin Morgan and shared something of Morgan's openness to the world, generous sense of humour and wry, sometimes reductive, keen scorn for the pretentious. But Scott is much more deeply rooted in the Scots language than Morgan, especially the idiom and sound-world of Aberdeen and the north-east. His poem 'Heart of Stone' is actually a portrait of Aberdeen, a longish poem that was commissioned as one of a series to accompany photographic essays or films of particular poets' favoured places. This was in the 1960s. MacDiarmid wrote one on 'The Borders', Norman MacCaig wrote 'A Man in Assynt' describing the north-west of Scotland and its history from geological ages past through the clearances to the present day, and Alexander Scott wrote 'Heart of Stone'. It's a vivid painting of the city:

SANDY: That's all sound and smell and taste as well as vision – clearly Aberdeen. And an Aberdeen not so far removed from the one

The sea-gray toun, the stane-gray sea,	
The cushat's croudle mells wi the sea-maw's skirl	[pigeon's coo mingles with the seagull's skreech
Whaur baith gae skaichan fish-guts doun the quays	[both go scavanging
Or scrannan crumbs in cracks o the thrang causeys,	[scraping…busy causeways
A lichthous plays the lamp-post owre a close,	
The traffic clappers through a fisher's clachan	
Whaur aa the vennels spulyie names frae the sea,	[alleys steal
And kirks and crans clanjamfrie,	[churches and cranes jumbled-up
Heaven and haven mixter-maxtered heave	[mixed up together
To the sweel o' the same saut tide.	[swell of the same salt tide

represented by artists such as Ian Fleming or Ian Mackenzie Smith.

ALAN: Iain Crichton Smith is very different. His use of the English language creates a more alienated, edged, oblique, intimate sense of the city. In his autobiographical sequence of poems, *A Life* (1986) he recollects his years as a student there, 'The glitter of the water and the wake…', how 'The cafés glitter' and 'The statues cast their shadows across parks'.

> Aberdeen, I constantly invoked
> your geometry of roses.
> Your beads of salt
> decorate my wrists
> and are the tiny bells
> of grammar schools.

And he goes on:

> Aberdeen,
>
> I loved your granite,
> your salt mica.
>
> Your light
> taught
> me immortality.

That's such a strange way of saying things, isn't it? By no means a straightforward description, but the remembering, adult poet providing an evocation of the city, and of the freshness and – well, I guess the word is, innocence of the young man. It's almost surreal in its clash and assembly of words and bright phrases, but it's very intimate and close to the personal sense of engagement and presence.

Edinburgh

LINDA: I'm trying to imagine what it would be like to see Edinburgh for the first time, just as a contrast to Dundee and Aberdeen…

SANDY: There's so much that might be said, we better limit ourselves to some essential things. First of all, for better or worse, Edinburgh is the capital city of the nation. The old parliament walls are still visible and surround the present-day Faculty of Advocates. St Giles, the High Kirk, is a stone's throw away on the Royal Mile. There's the Old Town and the New Town – the character of the city encompasses both the ancient capital city, the Royal Mile from the Castle on its volcanic cliffs, down to – well, both the royal residence, Holyrood Palace, and the Scottish Parliament.

ALAN: Towering over the Old Town is Arthur's Seat and Salisbury Crags. In James Hogg's *The Memoirs and Confessions of a Justified Sinner*, that's where the sinner meets his nemesis.

SANDY: The path leading up and around the Crags is known as 'The Radical Road' and in the late 18th century, contemporary with Robert Burns, the

reformer Thomas Muir and his 'Friends of the People' group – radicals influenced by Thomas Paine's *The Rights of Man* – that was their secret meeting-place. It was a revolutionary moment in European history, inspired by the American revolution, and many Scots were aware of that fact.

ALAN: In the early 19th century, when that radical rising had been put down by the authorities, many of those reformers were imprisoned or sent into exile. Muir himself was sent to Australia. I believe it was Walter Scott who suggested that the prisoners in Edinburgh, instead of merely being kept locked up, could be usefully employed paving that road,

and indeed that's what happened. So when you're walking on that road, you're moving through layers of history. It represents a number of different kinds of resistance. There's a children's song that begins, 'Round and round the Radical Road, the radical rascal ran...'

SANDY: On the other side of the tracks, so to speak, the New Town presents a very different character, with its symmetrically patterned streets and squares. Duncan Macmillan says this of the Enlightenment ideals that informed the construction of the New Town: 'The streets may be geometric. Streets usually are. But there is scarcely a corner of

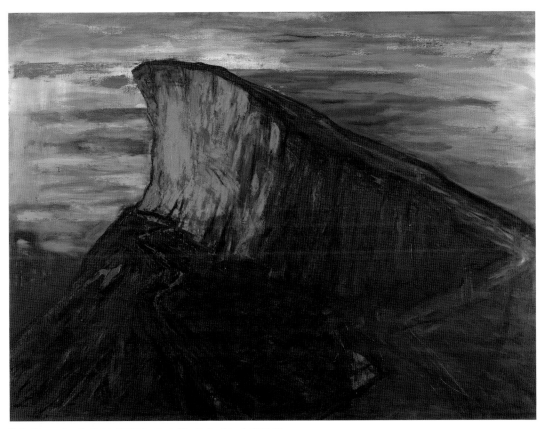

3.13 Alexander Moffat *b.*1943 The Rock (The Radical Road) 1989–90

the New Town where you cannot see either one of its collectively-owned gardens or wild nature beyond the city. That is what sets the geometry of its streets apart from those in any comparable urban planning. It is the model of a philosophic city, a metaphor for human order in harmony with the wider order of nature and carried out on a scale so huge that in the weight and volume of stone moved it is comparable to the Pyramids.'

At the beginning of the 19th century, Edinburgh was like Berlin in that the major cultural buildings, such as the National Gallery, the Royal Scottish Academy and New College, all designed by William Playfair, were sited in the exact centre of the city.

We find the same in Berlin. It's no surprise that Playfair was a friend of Karl Friedrich Schinkel, the architect who did much to create the special character of central Berlin. In both cities, the arts are deliberately placed at the centre of public experience.

ALAN: You know that at one point the streets of the New Town were designed to match the pattern of the Union Jack? One of the key elements of the Old Town was that in the tenements, on floor over floor – or floor under floor, because some go down under the level of the ground on one side, down into concrete canyons below – you had all sorts of

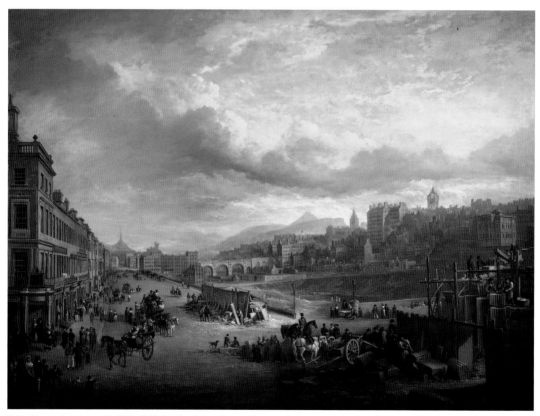

3.14 Alexander Nasmyth 1778–1840 Edinburgh from Princes Street with the commencement of the building of the Royal Institution 1825

people living together. This was in the 18th century. You find this social city vision in poems by Allan Ramsay and above all Robert Fergusson – Fergusson's 'Auld Reekie' is a city where publicans and lawyers, politicos and prostitutes, drinkers and doctors, lived more or less next door to each other. There was this – I don't know what to call it – collage of different kinds of people, all living together. Then the New Town was built and the richer folk went off and lived on the north side. I have a poem of my own that describes the Old Town of Edinburgh that you might like. It begins with an obscure reference perhaps I should explain. D.O. Fagunwa was a fabulous African writer whose dream-like novel *The Forest of a Thousand Daemons* was translated into English by the Nigerian Nobel laureate Wole Soyinka. Soyinka said that he had to spell the word 'Daemons' in the title with the 'ae' and not simply as 'Demons' in order to suggest the magical antiquity of Fagunwa's vision. So I wanted to hint at the labyrinthine imagination that suggests affinities between the shadowy forest-world of Fagunwa and the multifaceted, shadowy character of Edinburgh's Old Town. It's also worth reading Fagunwa's book for its own sake!

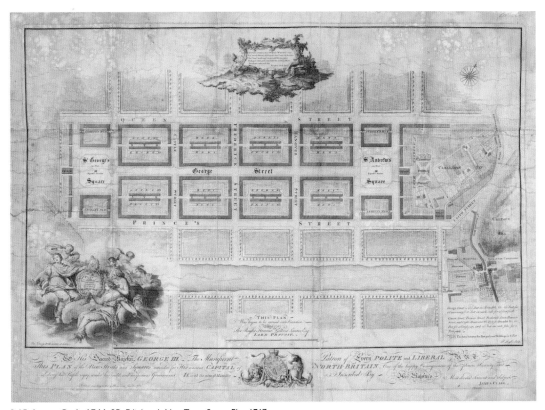

3.15 James Craig 1744–95 Edinburgh New Town Street Plan 1767

Edinburgh, High Street: Nocturne

A forest of a hundred thousand dæmons —
D.O. Fagunwa's African head held undergrowths
and tunnels that my present occupation is
to notice and to indicate, right here, mediaevally
 moving
in the castellated cobbled and diagonal
of sloping street suffused below the yellowish
diffusing streetlamp there that's just beside my
bedroom window. The snow was fully occupied
around the corner of the building and I walked
from living room to hall to kitchen back to hall
to bedroom, looking out examining the tiny flakes
that made another atmosphere, beyond the
double glazing: the dark is filled with white flecks,
 but not
quite fully occupied itself, while all the spirits of the
 place
are on the mile and moving, in subterranean ways
and wynds, below the mile. 'You have a whole
 theatre here.'
The oblong lights in residential flats in buildings
stories high will all go out at last and all
those occupants will go beneath the earth.
The tourists walk below and take the guided walks
 and know
there is a question mark that cannot be subtracted
from their answers, whispered: where? what more?
what lies beneath? A drunken soldier swore he'd
 found
a tunnel in the dungeons of the castle at the height,
which led him to a maze of unmapped arteries
 beneath,
that he emerged at Holyrood, under some confusion.
An evening might leave you like that, but the groan

of buses and cars and taxis, sirens at midnight, 2
and 3 a.m.; road-menders widening the pavements
 and
re-cobbling: the grumbling sounds of day and night
seep into the stones and the cold volcanic earth
 beneath.
Apocrypha and atmosphere. Kitsch and tartan
 plastic dolls.
Voodoo kilted effigies and bagpipes playing all the
 time,
somewhere nearby just out of sight of hearing —
A sloping world where all secure dualities
 (Argyll/Montrose)
are partnered in an incomplete notation, a sinking,
structuredly preserved configuration, and as the stars
look down, a brittle, bright, tough-souled and dark
and dangerous, and friendly, night-time
 constellation.

SANDY: So you are commenting on the fact that
19th-century Edinburgh is a split city, a divided city,
where rich and poor are separated by design, as it
were, in the very architecture of the street-plans.
And that's a major difference from the old
Edinburgh, where people of different economic
classes all lived together in the tenements. There's
a bourgeois conformism which persists in
Edinburgh and is almost entirely of the Anglo-
Scottish variety. For those who cared, and there
were many in Edinburgh, for the whole business of
Scottish self-representation, Walter Scott is terribly
important through the 19th century. The city's
landmark icon proclaims him: The Scott
Monument...

ALAN: Which I understand was the model for
Thunderbird 3...

SANDY: ...Waverley Station, even what was called
the North British Hotel – these speak of the legacy
of Scott and the 19th-century's patriotic Unionism.

ALAN: But the older Edinburgh also persists. In MacDiarmid's little poem called 'Edinburgh, Midnight' – which we quoted before, talking about Dundee and Aberdeen, he says that of all cities, Edinburgh 'is a mad God's dream' where, 'From soaring battlements, / Earth eyes Eternity.'

SANDY: That's the pre-Union, or pre-Unions, you might say even prehistoric, geological Edinburgh, the city underneath the city. But of course the Castle is basically a military barracks and the highest flagpole in Edinburgh is up there, and it never, ever flies the Saltire – it's always the Union Jack! If we looked up and suddenly actually did see the Saltire flying, you wouldn't need to go to a radio or television or your mobile phone, that would be the sign that Scotland had achieved independence! That would be our equivalent of the storming of the Winter Palace or the tearing down of the Bastille!

ALAN: Or the Irish in the General Post Office in Dublin in 1916...

SANDY: Norman MacCaig used to say that the problem with Edinburgh was that it's a capital city but not the capital of anything. But there's also the unmentionable underside of Edinburgh – Irvine Welsh's Edinburgh, the post-war housing schemes which encircle the city...

ALAN: Which is also an extension of the doubled, schizoid city of Robert Louis Stevenson and James Bridie's Doctor Knox of *The Anatomist*, Muriel Spark's duplicitous, scheming city, and the Edinburgh of Ian Rankin's nocturnal policeman Inspector Rebus...

SANDY: We'll come back to Edinburgh when we're talking about Robert Garioch and Sydney Goodsir Smith and Norman MacCaig.

Glasgow

SANDY: Glasgow was the second city of the empire and the largest city in Scotland. Someone once said that without Glasgow, Scotland would never have entered the 20th century.

ALAN: That 19th-century legacy of industrialisation really propels Scotland forward and transforms the national character.

Also, unlike any other Scottish city, large numbers of emigrants from Ireland, Russia, Poland, Lithuania, Pakistan, India, China and so on, make up a substantial proportion of the population. It's Scotland's most multicultural city.

SANDY: Muirhead Bone and Ian Fleming were both representing that industrialised city in the early 20th century.

ALAN: The skyline of Glasgow from the south, looking north, gives you a sense of the city's character: you can see the Science Centre tower, the university spire, the Finnieston Crane, and in the east, there's the cathedral, the Necropolis and the Victoria Infirmary, and the conurbation spreads

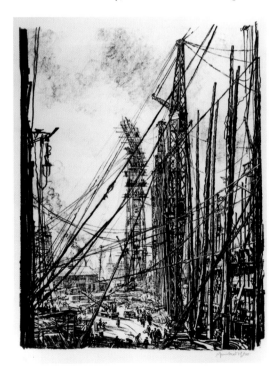

3.16 Muirhead Bone 1876–1953 A Shipyard Scene with a Big Crane 1917

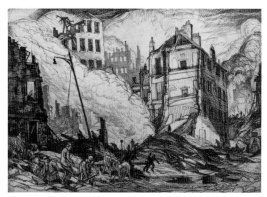

3.17 Ian Fleming 1906–94 Air-Raid Shelters in a Tenement Lane
1942

out in that direction and if you imagine beyond the
university, the Great Western Road is heading away
up to the north-west and the Clyde Estuary opens to
the west and south-west. It's a massively
contrasting city, ancient in its foundations – it's
said that St Mungo met Arthur's Merlin, way back
then. It has its economic foundations in 18th-
century merchant city traffic in slavery and tobacco;
it's architecturally magnificent in its 19th-century
aspect; and it's another city again in the early 20th-
century world of tenement slums and the late 20th-
century urban renewal, the urban motorway
systems and new towerblocks. It's very powerfully
working-class in some ways. Very powerfully
middle-class in others. Edwin Morgan once said
that Glasgow was the best of plays because you can
watch it and act in it at the same time.

SANDY: We should mention John Quinton Pringle
again here. He developed a painterly technique
close to pointilism and applied it to the local and
domestic scene. Pringle (1864–1925) was born in
the east end of Glasgow, the second son of a family
of seven boys and one girl. After he finished
school, his father arranged for him to learn his
trade as an optician and for the next 20 years he
worked in a dark and dingy shop under the railway
bridge near Glasgow Cross. At the same time, he

began to attend evening classes at the Glasgow
School of Art, winning the South Kensington
national competition Gold Medal for life drawing
in 1891. He went into business for himself in 1896
in a fine, light-filled shop in the saltmarket, which
he also used as a studio. As a businessman and
artist, it's worth noting that his aim was to have 'no
longing, no desire to sell, but live all alone, nature
singing all the time to me'. It has been said by
Muirhead Bone, amongst others, that the painters
of the Glasgow School were unfortunately not
capable of mirroring much of the town life around
them and that they did not paint Glasgow. Pringle,
however, is the exception, given that he had been
painting back courts since 1886. He remains a
special painter, whose delicate touch, use of
colour and keen observation gives his work a
timeless quality.

If you read MacDiarmid's poems and Edwin
Muir's descriptions of Glasgow, though,
it's a pretty unattractive place. In his book, *Scottish
Journey* (1935), Muir spends a lot of time on the
horrendous squalor he encountered there after
coming from the pastoral haven of an Orkney
childhood.

The Glasgow tenements were famously
recorded in photographs by Thomas Annan, taken
in the 1870s. The buildings were still there in the
1930s, when Muir encountered them.

ALAN: I remember in my early teens, in the late
1960s, walking among those tenements a week or
so before they were brought down. I simply wanted
to see them before they were demolished and so
I got the train into Glasgow from Lanarkshire.
What I saw was pretty much what you see in
Annan's photographs. There's a sentence in
Muir's book I remember: 'The London slums are
dreary; but the Glasgow slums always hold a sense
of possible menace; they take their revenge on the
respectable and the rich if in nothing else in
compelling them to grow a still thicker hide of
insensibility and suppression.' That's a very nasty

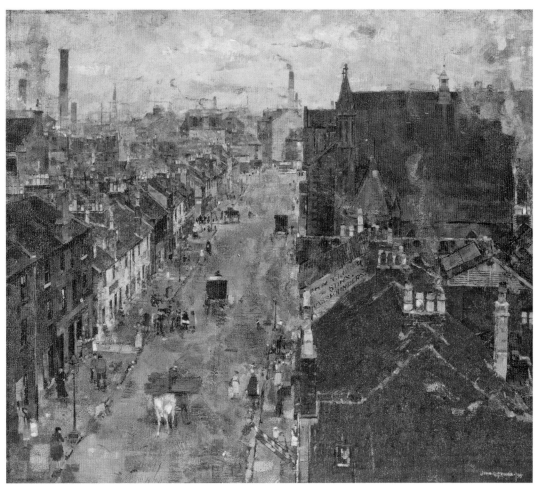

3.18 John Quinton Pringle 1864–1925 Muslin Street, Bridgeton, Glasgow 1895–6

indictment of the way the city was then. But the tenements I saw had a friendly aspect, a neighbourliness. But Muir was not alone in this. Lewis Grassic Gibbon's 1930s Glasgow was similarly appalling. 'One cannot watch and hear the long beat of traffic down Sauchiehall, or see its eddy and spume where St Vincent Street and Renfield Street cross, without realising what excellent grounds the old-fashioned anthropologist appeared to have for believing that man was by nature a brutish savage, a herd-beast delighting in local discordance and orgiastic abandon.'

LINDA: Wow. That's pretty severe!

SANDY: It's still happening. Every Friday night. I've seen it for myself!

ALAN: There's worse. There's a fantastic essay Gibbon wrote about Glasgow in the early 1930s that opens up with pure scorn and hatred talking about all the Scottish cities. Here's how it starts:

> Glasgow is one of the few places in Scotland which defy personification. To image Edinburgh as a disappointed spinster, with a hare-lip and inhibitions, is at least to approximate as closely to the truth as to image the Prime Mover as a Levantine Semite. So with Dundee, a frowsy fisher-wife addicted to gin and infanticide, Aberdeen a thin-lipped peasant woman who has borne eleven and buried nine. But no Scottish image of personification may display, even distortedly, the essential Glasgow. One might go further afield, to the tortured imaginings of the Asiatic mind to find her likeness – many-armed Siva with the waistlet of skulls, or Xipe of ancient America, whose priest skinned the victim alive, and then clad himself in the victim's skin... But one doubts anthropomorphic representation at all. The monster of Loch Ness is probably the lost soul of Glasgow, in scales and horns, disporting itself in the Highlands after evacuating finally and completely its mother-corpse.

SANDY: He then quotes his own alter ego James Leslie Mitchell, who said that Glasgow was 'the vomit of a cataleptic commercialism'.

ALAN: 'It may be a corpse,' he says, 'but the maggot-swarm upon it is very fiercely alive.'

LINDA: Again you have a kind of hellish picture...

SANDY: And there are plenty more hellish pictures when we examine the city as a primary subject for writers and painters, especially in the 20th century. The city was modern life. By 1900, New York had been transformed by light and in the 1920s, the city of light became the subject of Fritz Lang's *Metropolis*. Lang shows the inhabitants of the city dazzled by an ecstasy of brightness. Yet despite its glitter, the big city had a bad reputation. The complex and contradictory social world of the city, with human beings lodged within a system, became a big theme for artists. The search for a way to represent the city took different forms in different cultures. American artists looked for light. Germans looked for a figure strong enough to refute the banality of mass society. The Italian Futurists wanted to come to terms with the modern world and the impact and energy of the city. Scottish visual art doesn't really reflect any of this. The great city subjects – the unemployed, striking workers, nightclubs, factories, boxing matches, striptease bars, the architecture of the new – there's no equivalent of the Eiffel Tower or the Brooklyn Bridge appearing in Scotland or in Scottish art.

With the possible exception of McCance, the apocalyptic vision that you find in Muir and MacDiarmid and Gibbon isn't really there in the visual arts. And if you think of the subject of the sex-murder in modern art – Fritz Lang's *M*, Alfred Döblin's great novel *Berlin Alexanderplatz*, Alban Berg's horrific opera *Lulu*, Pabst's film *Pandora's Box* and the work of Otto Dix or George Grosz – you find the hidden lusts and depravities of bourgeois society all brutally and clinically exposed.

ALAN: It's pure surgery!

SANDY: Or think of Büchner's *Woyzeck*, which was written in the 1830s and wasn't performed until 1913. There's very little to put beside that from

3.19 Alexander Moffat b.1943 Berliners 2 1978

modern Scottish art or literature – or modern English art, for that matter!

ALAN: Thinking of Irvine Welsh and Ian Rankin, sometimes it's as if their writing is infected by glamour – whether Welsh's sensationalism or Rankin's subscription to the conventions of the crime genre – they don't really tackle that kind of murderous depravity with the critical and self-consciously political intention you get in Döblin or Grosz or Dix or Berg or Büchner.

SANDY: In the 1920s, you know, both Grosz and Dix were taken to court on several occasions for offending public decency. Galleries had to with-draw their work from public viewing. Neal Ascherson was based in Berlin as *The Observer's* East European correspondent during the student uprisings of the late 1960s, led by Rudi Dutschke and Ulrike Meinhoff. On his return to Edinburgh several years later I made a series of large paintings entitled 'Berliners' which combined Neal's time there with the Berlin of the 1920s, quoting from both Grosz and Dix.

ALAN: One the most famous depictions of Glasgow is in Alasdair Gray's *Lanark* (1981), where he says that the city has never been fully represented in literature or the arts, neither to the people who

live in it nor to an international readership. That's fair comment from the character who speaks it in the novel, but it's not really true. Glasgow certainly had – maybe still has – an international reputation that followed the best-selling 1935 publication of *No Mean City* by Alexander MacArthur and H. Kingsley Long, produced for a mass readership to sensationalise the gang life of the Glasgow slums. The legacy of that is partly mixed in with the international appeal of the television series *Taggart* – the Glasgow underworld. But there were also a number of very good writers, novelists particularly, dealing with aspects of Glasgow, middle-class and working-class people – I'm thinking of Dot Allen, Edward Gaitens, George Friel, Gordon Williams and pre-eminently Robin Jenkins – as well as poets, from John Davidson through to Morgan himself and a new generation of writers based in Glasgow, contemporary with but younger than Morgan. Things really changed in the 1970s and 1980s, with Morgan, Gray and Liz Lochhead, James Kelman, Jeff Torrington and others…

SANDY: Once again there are important contrasts to be made between Edinburgh and Glasgow.

You mentioned John Davidson, who was an exact contemporary of Lewis Spence.

ALAN: You couldn't think of two more contrasting poets. Davidson (1857–1909), writing about industrial Greenock and moving to London, rejecting Scotland in a sense, but bearing that proto-Modernist, utterly cold sense of scientific objectivity. He wrote a poem called 'Snow' with none of the Dickensian sense of the picturesque or homely and everything of the crystalographer's precision. He felt desperately isolated. 'Mankind has cast me out' is how he begins his own 'Testament'; and 'The Testament of a Vivisector' is one of the most horrific poems of all time, still totally challenging convention. It was too much for him. He couldn't live in the Godless universe of the modern world and he committed suicide in 1909.

And then there's Lewis Spence (1874–1955), writing a kind of resurrected Scots, as if an authentic voice were speaking from centuries ago in a very dusty, but brightly-lit, Edinburgh morning. MacDiarmid recognised them both. He acknowledged Davidson as a major influence on the modern movement and saw Spence as an important precedent in his attention to Scots as a literary language, but he distanced himself pretty quickly from the antiquarianism, the musty whiff

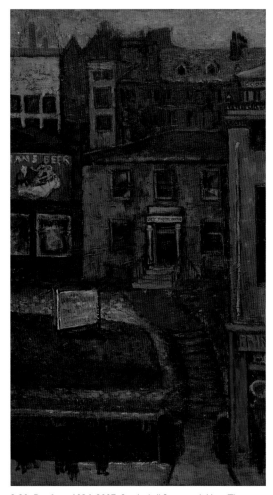

3.20 Bet Low 1924–2007 Sauchiehall Street with Unity Theatre 1947

of the worst aspect of archivalism in Spence, and remembered Davidson's death from his childhood in one of his most memorable poems. He says that Davidson's death was 'like a bullet hole in a great scene's beauty' or as if he'd seen 'God, through the wrong end of a telescope.'

SANDY: There is another startling contrast that helps define and differentiate the two cities: think of their theatres and theatre traditions. The Citizens' Theatre developed in the Gorbals so that working people might afford to enter and see plays of international standing in immediate, professional productions. There were also workers' theatre projects such as Unity, led in the 1940s by Ewan MacColl. And Ena Lamont Stewart's *Men Should Weep* dates from this time, as do the plays of the coalminer Joe Corrie. Meanwhile the Edinburgh Festival was setting itself up and it chose to ignore Scottish art or Scottish plays or Scottish music or literature. As far as Unity Theatre was concerned, the Arts Council withdrew their grant – they were trying to keep them out of the Festival! Russell Hunter, a Company member at that time, remembers, 'Scottish actors were not thought to be good enough to appear at an international festival...'

ALAN: You have to ask what sort of people were sitting on that Arts Council committee at that stage? They must have been virulently anti-Scottish.

SANDY: It's taken a long time to counter that snobbishness about Scottish actors and artists and playwrights, and the Scots voice, the Scots language itself.

ALAN: And in the struggle to develop and provide a foundation for Scottish art forms, we should recognise Alex Gibson's work in Glasgow to set up Scottish Opera – something that the Edinburgh bourgeoisie never got round to!

SANDY: But is that any worse than the snobbish prejudice against opera in Scotland that has been demonstrated in recent years by New Labour, for example?

Norman MacCaig (1910–1996)

ALAN: We mentioned earlier that MacCaig is probably best known as a poet of the country, the Highlands around Lochinver and Assynt, but he's also very much a poet of Edinburgh, an urban creature. His father was an Edinburgh chemist, cool and fastidious; his mother came from the Hebrides, a Gaelic-speaker who was always playing with language when MacCaig was growing up. He himself lived in Edinburgh and worked there as a primary school teacher.

SANDY: In a way, MacCaig's Edinburgh is the city of the Enlightenment – it's the city which saw the creation of English rhetoric, *belles lettres*, a disposition towards the language of speculative thought that distanced itself from speech. There's a familiar story about how the Enlightenment philosophers would try to weed out the Scots words and phrases in their writing. Now, MacCaig doesn't do that but the English language in his poems is very particular, very fastidious...

ALAN: The long reach of this stretches through to the Anglocentric emphasis in our education system in the 19th and 20th centuries. But Enlightenment English, the language itself, reaches poetic supremacy in MacCaig's poetry, because that's where it returns to speech. Nobody beats MacCaig in his modulation of voice. For my money, none of his American or Irish contemporaries comes close – not one of them! But his poetry is also redolent of the Highlands, in its ironies, shrewd judgements, its sense of the elemental, and it takes us from there back to the city, refreshed.

There's a perfect example dated January 1991 from the 2004 edition of *The Poems* which gathers previously unpublished works.

Five minutes at the window

A boy, in loops and straights, skateboards

down the street. In number 20
a tree with lights for flowers
says it's Christmas.

The pear tree across the road shivers
in a maidenly breeze. I know
Blackford Pond will be
a candelabra of light.

A seagull tries over and over again
to pick up something on the road.
Oh, the motorcars.

And a white cat sits halfway up a tree.
Why?

Trivia. What are trivia?
They've blown away my black mood.
I smile at the glass of freesias on the table.
My shelves of books say nothing
but I know what they mean.
I'm back in the world again
and am happy in spite of
its disasters, its horrors, its griefs.

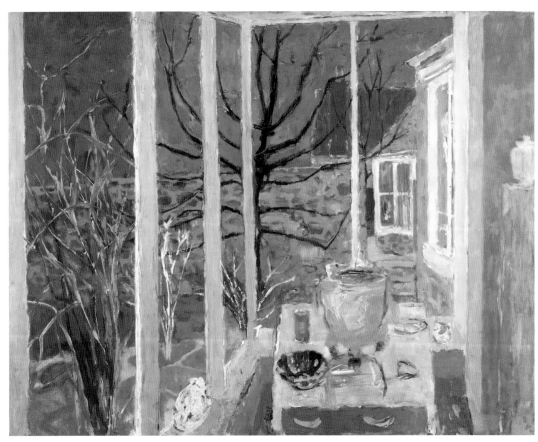

3.21 William Gillies 1898–1973 Studio Window, Temple c.1970–73

MacCaig's poems are so marvellously dependable. Again and again, they transform the incisiveness of perception into the pleasure of illumination.

SANDY: Something similar is going on in the paintings by William Gillies where he's simply looking out the window or at objects on his kitchen table and taking pleasure in what he sees.

Gillies of course was a great admirer of Georges Braque and strongly influenced by him. I think MacCaig also had that same sense of seeing things in that immediate way. But more than that. Both Gillies and MacCaig knew that by painting them or writing about them, these simple things could be transformed, changed into a work of art and that something new and valuable happens in that transformation. Braque was MacCaig's favourite painter.

ALAN: These simple pleasures help to make MacCaig a very social poet, a poet who likes the things that allow people to talk to each other, despite all the things that keep people apart. There is a very moving poem called 'Two friends' in which he remembers MacDiarmid and a friend from the Highlands. They never met each other, but the last word each of them spoke was his first name, and in that, MacCaig says, they were somehow speaking to each other:

> I am proud to have given them a language
>
> of one word, a narrow space
>
> in which, without knowing it,
>
> they met each other at last.

The shape of his career is clear enough. His first two books, *Far Cry* (1943) and *The Inward Eye* (1946), were associated with the New Apocalypse movement, which insisted on the significance of the unconscious, the surreal, the predominance of imagery and movement over form and reason. A friend of MacCaig's borrowed these first books and returned them with the comment, 'And when are you going to give us the answers, Norman?'

MacCaig said it was the only criticism he ever found valuable. He acted on it.

Nearly 10 years passed before *Riding Lights* (1955) appeared, the first book he allowed to be republished in his *Collected Poems*. He described the poems in *Riding Lights* as the result of his 'long haul towards lucidity.' Another 10 years followed, in which relatively strict metrical forms shaped his poetry, then free verse began to predominate with the 1966 volume *Surroundings*: that was MacCaig's main formal mode thereafter. This sequence of events is important but it's more important to note that the work he chose to preserve in his later collected editions is all poetry of experience – the earliest poems he acknowledged date from when he was in his mid-40s, well after Dante's midway point of life.

In the 1950s and 1960s, MacCaig was generally accommodated by Anglocentric critics and anthologists such as Anthony Thwaite and A. Alvarez, and maybe that's because he wrote in English and didn't like bombastic nationalism – a good example is the poem, 'Patriot', in which he says that his 'only country' is 'six feet high' and love it or not, he'll die for its independence.

SANDY: Alvarez's anthology *The New Poetry* shows practically nothing of MacCaig as a Scottish poet. It's as if his nationality was a hindrance to his validity as a poet.

LINDA: What were MacCaig's politics?

SANDY: Well, he certainly wasn't a Marxist! He once told me he went to an enormous rally in a shipyard in Glasgow with MacDiarmid – MacDiarmid was speaking – there must have been 20,000 people there – and MacCaig said to me with a completely ironic, quizzical eye and tone of voice, 'I suppose they were all communists...?' He was profoundly sceptical about that degree of mass commitment. But he was clearly for Scottish independence.

ALAN: Any overview of his poetry reveals its deeply

national inclination. 'How Scottish are you?' an interviewer once asked him. 'Hundred per cent,' he replied. MacCaig's delight in the sheer variety of particularity afforded by the natural world is continuous with long traditions of Irish and Scottish poetry. Walking in the Highlands he sees a herd of deer make the v-sign with their ears and run off as the whole long day releases its miracles ('One of the many days'). The wealth of brilliant metaphor in his poems is clearly associated with Gaelic 'kennings' where a phrase describes a thing metaphorically, as in the title he took for his book *Tree of Strings* (an English translation of a Gaelic kenning for a harp). But there is never any sense of chauvinistic nationalism in MacCaig. Everything is attached to a wider world of reference and delight. In 'Pibroch: The Harp Tree' he writes about classical bagpipe music as something whose formality, precision, crystalline colours and labyrinthine fugues would have delighted J.S. Bach and he imagines Bach and a pibroch made man-like enjoying a glass of Rhenish wine together.

SANDY: MacCaig worked most of his life as a schoolteacher but failed to gain promotion until the end of his career. MacDiarmid said that was because he was a conscientious objector during the Second World War.

ALAN: He was a man of formidable principle. He refused to fight because he objected to killing people. He was imprisoned in Wormwood Scrubs and in Edinburgh Castle. At one point, an officer ordered MacCaig's group to stand to attention but MacCaig wouldn't have any of this. He simply refused to stand up at all! He said he wasn't in the army, so this man had no authority to make him do anything!

LINDA: How do his Highland poems connect to his Edinburgh poems?

ALAN: There are things about them that connect which can be heard, to do with the relationship between language and things. There's the actuality

of things on the one hand, and on the other, there's a sense of the diffidence, or the caution, the inexactness of language itself, how language operates, or how it tries to indicate things, or tries to encompass them. His poems are always in some sense about this, about the uncertainty of language, the patience you must have to speak accurately and honestly, and the respect you must have for other things to let the language do its job. He advises us to listen to his words carefully, for some of them are spoken 'not by me, but / by a man in my position' ('A man in my position'). He's a poet whose painterly immediacy is matched by philosophical speculation. There's a poem called 'Linguist' where he says this:

> If we lived in a world where bells
> truly say 'ding-dong' and where 'moo'
> is a rather neat thing
> said by a cow,
> I could believe you could believe
> that these sounds I make in the air
> and these shapes with which I blacken white paper
> have some reference
> to the thoughts in my mind
> and the feelings in the thoughts.

He's also a very funny poet. His *Collected Poems* is a magnificent encyclopedia of metaphors and similes but it's also one of the funniest books in the world. For example, in 'City Fog':

> Even the Tollcross clock
> looks glum, as if it knew
> five past ten might as well be
> ten past five.

In 'Hogmanay' a cock fed oatmeal damped with whisky crows 12 times and falls on its beak, to be matched later by the man who fed it, falling, glass in hand, on his back – the images become surreally mingled in MacCaig's equally inebriated vision.

In 'Notations of Ten Summer Minutes' odd happenings in a Highland village are almost arbitrarily noted down and chink and jingle against each other like gold coins in a pocket. MacCaig's happiness – it's not rapture, it is invariably attentive – is infectious. When you share a smile with him in these poems, it's a good thing.

His humour has a grim side too, like the 'homicidal hilarity / of a laugh in a ballad' ('Space travel'). In 'Orgy', ants eating doped bees discover 'that the innkeeper was the inn'. 'In a snug room' presents a sleek, self-satisfied and complacent man thinking of the flattering reference to him in the morning papers, the companionable lunch he's just enjoyed, the profitable deal he's just signed, the donation he's sent to his favourite charity, his 'true love' coming towards him in a taxi – 'And Nemesis slips two bullets / into her gun / in case she misses with the first one.' This humour is macabre and dark, but even here the startlement of a new perception immediately becomes the warmth of a concurrence of recognition.

Like many great Scottish writers, though, that humour is in the service of making a serious point. Also, there's a great elegance. And in the latter years of his life, there's an element of regret that comes through. There are dark phases that you'll find there. And you'll find it there even in a poem as funny as 'Toad'. It always make me laugh when I think about the first line of that poem, 'Stop looking like a purse.' Who in the world would start a poem like that, with the sentence 'Stop looking like a purse'…?

Toad

Stop looking like a purse. How could a purse
squeeze under the rickety door and sit,
full of satisfaction, in a man's house?

You clamber towards me on your four corners –
right hand, left foot, left hand, right foot.

I love you for being a toad,
for crawling like a Japanese wrestler,
and for not being frightened.

I put you in my purse hand, not shutting it,
and set you down outside directly under every star.

A jewel in your head? Toad,
you've put one in mine,
a tiny radiance in a dark place.

The darkness is there, even in poems like that. And that connects to the city poems. Even a poem that seems to be simply a joke shows this. It refers to the old film, *King Kong*.

19th floor nightmare, New York

The party had been a drunken one
so she sleeps a deep sleep
on the 19th floor
of the Mandragora Hotel.

And she dreams, she dreams
of bodiless horrors
and horrible bodies.
She can't breathe, her arms
are made of lead.

But when a fur-gloved hand
lands on her face, she wakes
at the end of a scream.
Lordy, Lordy, she says,
Just a dream, just a nightmare.

Trembling she gets up
and goes to the window.
Trembling, she pulls open the curtains
and looks out, straight
into the left eye of King Kong.

It's a joke. It's a funny poem, sure. But King Kong

is also New York. King Kong is the city, an inhumanly large city. And MacCaig is a poet who speaks intimately, convincingly, about the human scale of things. New York really seems too much, compared to Edinburgh. In another poem he says that the sun comes up on Edinburgh – but Manhattan comes up on the sun! Elsewhere he talks about a New York cop: 'built like a gorilla – but less timid'! Although New York's 'uncivilised darkness / is shot at by a million lit windows', nevertheless, 'midnight is not / so easily defeated' ('Hotel room, 12th floor'). He visited New York and he visited other places but Edinburgh was a human-scale city to him and it still is. And the city does still retain that sense that it's walkable.

MacCaig once said, when I asked him about MacDiarmid's later long poems, 'I hate 'em! Hate long poems, hate long novels, hate long anything. I like short things.' So I ventured to say, 'Well, your *Collected Poems* is a pretty long book, full of short poems.' And he just said, 'Aye.' I asked him who were his favourite composers. 'Scarlatti,' he said, bringing out the word as if it was a weapon. I told him I thought Scarlatti was just a mathematician. 'A bloody good mathematician!' he said. I asked him what he thought of Mahler. 'Hate him,' he replied. 'Hate long symphonies too.'

SANDY: MacCaig really points forward to poets of a younger generation in the way he refuses to write about the enormous abstractions of the world and concentrates his attention on particular things, often small things, often things on a domestic scale. In 'London to Edinburgh' for example, MacCaig gets that balance between the two capital cities. He says that he's 'waiting for the moment / when the train crosses the Border', rushing towards Scotland at seventy miles an hour, and moving into his own future 'that, / every minute, / grows smaller and smaller.' The border is still there, you see, it's still an important factor. No matter how Anglicised Scots become, they never really become English!

ALAN: So for MacCaig, there is a sense of measurement, of the human scale of things measured against the natural world and its elemental inhumanities. When you're with him in the Highlands, you're in a world of mountains that seem to change shape as you walk them, moving like music, a world of bell heather, stags and sparrows, the 'rubber-lipped' cod, basking shark, crickets, toads, frogs, puffins, Highland games, rowan trees, cormorants, eagles, a kingfisher 'jewelling upstream' seems 'to leave a streak of itself behind it / in the bright air' ('Kingfisher'). A waterfall plunges into a ravine like 'coins into a stocking' ('Falls of Measach'). We might visit glens and corries, fishermen's pubs, hear of absentee landowners, meet crofters, poachers, fishermen, aunts, uncles and friends.

But the other aspect of MacCaig's poetry deals with the city, Edinburgh. This is almost equally important, and as he always approaches it with that same sly, gaunt and evaluating eye, it is equally freshly perceived. In MacCaig's poetry, Edinburgh is inhabited, lived-in. It's not just a spectacle for tourists. He takes you through the Old Town and the New. The Old Town is skewered by the Royal Mile (half kitsch, half history), running from the soaring Castle down to Holyrood Palace, surrounded by fabulously Gothic turretted tenements, bridges, twisting roads, tunnels and arches and the imposing heights of Arthur's Seat and Salisbury Crags looming nearby. Across the railway tracks and Princes Street Gardens, the New Town is precisely designed in classic 18th-century elegance, airy and open to the cold wind off the Forth and the plains of Fife beyond. Like a seam of gold through the chilly gentility of this side of the city runs Rose Street, a parallel to the Old Town's Royal Mile, an 'amber mile' of pubs frequented in the 1950s and 1960s by un-genteel drinkers and numerous writers to many of whom MacCaig was a familiar figure. To me, he was unfailingly friendly.

SANDY: Every way we imagine Edinburgh, whatever it is, it's not modern. It resists Modernity.

Glasgow is a much more modern city. There's very little of Glasgow that predates, say, 1850. And it's revealing that when MacCaig goes to New York and sees a city that is conspicuously new by comparison, where practically no building is more than a hundred years old, he doesn't like it! He wants to get back to Edinburgh! The legacy of the city is somehow unavoidable. I've lived in Edinburgh most of my life and still the first writers I associate with the city are Hogg and Stevenson.

ALAN: Dark.

SANDY: It's as if the city is an immovable, unshakeable object that hasn't been redefined by any 20th-century writer or any contemporary writer. Even Irvine Welsh doesn't redefine it. MacCaig dwells in a very ancient city.

ALAN: MacCaig went to school in Edinburgh and then to the university, where he read classics, graduating in 1932. At university he met Isabel Munro, whom he described as 'an extraordinarily good dancer' and therefore a proper match for himself, 'a hot boy at the jigs'. They married in 1940. He worked in primary schools until his retirement. Visits to Italy and New York prompted their own poems and in the 1960s he became the first writer-in-residence at the University of Edinburgh and, in the 1970s, at the University of Stirling. Here his progress reports on students were classically brief, for example: 'A mouse. Not just a mouse – a quiet mouse.' His acerbity was respected. Many of his students loved him as his school pupils had revered him. Edinburgh was MacCaig's home and he was happy there. His retirement was filled with public honours and poetry readings at which his tall, angular frame and sardonic asides, momentary bursts of infectiously anarchic laughter, occasional *gravitas* and frequent wit were increasingly popular. He was sought-after and savoured.

SANDY: There are only maybe 20 or 30 poems in MacCaig's *Collected Poems* that describe Edinburgh

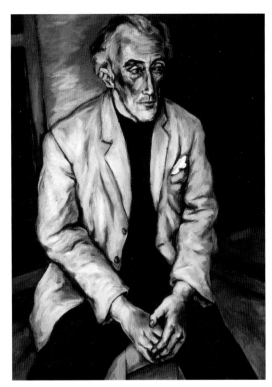

3.22 Alexander Moffat b.1943 Norman MacCaig 1968

specifically but I think the city comes across from a reading of MacCaig's work every bit as vividly as the Highlands. I think he loved Edinburgh.

ALAN: No city sophistication or academic expertise excuses a person from simple recognition of human fact. He is never the alienated solipsist. His addiction to the sardonic is purifying; he is warm but sharp, gentle but thorny.

SANDY: When I was painting his portrait, he would come down to my studio on successive Sunday afternoons, and one time he arrived with this very small radio. Prior to this he'd sat and told me his life story, from start to finish. But this time he had the radio, so he turned it on. It was the first part of Wagner's *Ring* – sung in English – and they were broadcasting this act by act, every Sunday

afternoon, at the time he came to sit for me. I said to him one day, 'It's being sung in English, you know. Are you following what they're singing?'

'I'm not interested in the words!' he said. 'They're awful. It's the music that counts.'

Robert Garioch (1909–1981) and Sydney Goodsir Smith (1915–1975)

ALAN: It's the music that carried Robert Garioch into writing. His Mum was a music teacher. He name-checks Debussy, Berlioz, Orff, Verdi, Beethoven, Shostakovich, Wagner, Tchaikovsky. And he has a poem, 'The Big Music', which celebrates the art of the pibroch. Music is clearly very important for him. In the poem called 'Sisyphus' he said it was the music of the first line that compelled or propelled him into writing the rest of it:

> Bumpity doun in the corrie gaed whudderan the
> pitiless whun stane.
>
> Sisyphus, pechan and sweitan, disjaskit, forfeuchan
> and broun'd aff,
>
> sat on the heather a hanlawhile, houpan the Boss
> didna spy him,
>
> seean the terms of his contract includit nae mention
> of tea-breaks,
>
> syne at the muckle big scunnersom boulder he
> trauchlit aince mair.

He wrote the first line of that poem as a representation of the stone coming down the hill and he said that he then had to write the rest of the poem about Sisyphus trying to get the stone going back up. Garioch is even now a neglected author. In fact, I think this whole generation of poets is under-researched. I think their full quality and full scale has yet to be measured by scholars, by academics, and by poetry-readers generally. One of the things that makes his poetic works unique is his entire sequence of sonnets based on Edinburgh, as indeed Edwin Morgan has written a series of Glasgow sonnets.

SANDY: I think in the 'Edinburgh Sonnets' he gets into the back streets and sees everything, the kids playing, the hubbub of the small wynds and closes, the city's characters up to their curious ploys. Garioch's relationship with Edinburgh is very different from MacCaig's, much closer to Sydney Goodsir Smith's.

ALAN: They're both writing in Scots, for a start, and they're both up-front with their humour.

SANDY: Garioch translated a series of sonnets written by the Roman Poet, Guiseppe Belli (1791–1864), which unforgettably connects Rome and Edinburgh and city life and human pathos. I gave a photograph of the Belli monument to Garioch when I got back from a visit to Rome and he was delighted to have it. The monument is in a district of Rome – or a 'quartier' as the French would say – very much a working-class district. Belli is regarded as a poet of the people. He was anti-clerical and writes in a working-class Roman dialect, so again there's a demotic, completely vernacular idiom that Garioch identifies with in his translations of Belli into Scots. Here's one example:

The Puir Faimly

> Wheesht nou, my darling bairnies, bide ye quaet:
> yir faither's comin suin, jist bide a wee.
> Oh Virgin of the greitin, please help me,
> Virgin of waymenting, ye that can dae't.
>
> My hairts, I wuss that ye cuid ken hou great
> my luve is! Dinnae greit, or I sall dee.
> He'll bring us something hame wi him, ye'll see,
> and we will get some breid, and ye will eat...
>
> Whit's that ye're sayin, Joe? Jist a wee while,
> my son, ye dinnae like the dark ava.
> Whit can I dae fir ye, if there's nae yle?
>
> Puir Lalla, whit's the maitter? Oh my bairn,

ye're cauld? But dinnae staund agin the waa:
come and I'll warm ye on yir mammie's airm.

ALAN: The way he uses the dramatic monologue – it's the voice of the mother, talking to her children, while their father's away – gives you that sense of her helplessness and their poverty, without any sentimentalising or over-dramatising. The original poem is set in Rome, of course, but the context or the idiom is simply that of the city and Garioch gives it an Edinburgh voice. It's a complete translation in that respect. It breaks my heart every time I read this poem because it's so desperately moving. Garioch was one of the shyest, and in some ways, the most retiring, of men. Perhaps

that's another unfashionable quality of his work – self-effacement.

SANDY: In a way, with that kind of touching observation, life in the streets and so on, Garioch takes us back to Robert Fergusson. The visualisation of social life in poetry and painting developed significantly in Scotland in the mid-18th century. David Allan, Wilkie, Walter Geikie, all painted scenes of everyday social activities. A link between painting and poetry was established that was possibly unique in European art and literature at the time.

Garioch's work is miles away from the conventional idea of the 'Grand Work of Art' or the Romantic Sublime. His Edinburgh poems are immediate, local, quickly sketched or snapshot-pictures of the way things were that particular day. They're like Geikie's etchings or John Sloan's prints of New York city life in the early 20th century, in the detail and vividness of their depiction of everyday events and their embracing of

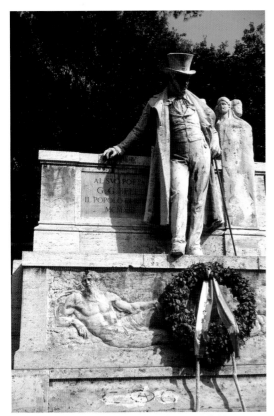

3.23 Michele Tripisciano 1860–1913 Giuseppi Belli Monument, Rome 1913

3.24 Walter Geikie 1745–1837 I Can Whistle Fine, Now, Grannie 1831

the vulgar and impolite. He has an affectionate regard for the people he's describing. He's not out to do them down or be condescending to them. But he enjoys satirising the pretensions of the genteel or the proprieties of the prim-mou'd folk, the 'douce' Edinburgh gentility, the toffs!

ALAN: He translated brilliantly from a number of sources – older Scottish poetry in Latin, by George Buchanan and Arthur Johnstone, ancient poetry from Pindar and Hesiod, and the modernist Parisian poetry of Apollinaire. The achievement of these translations helps us see Garioch in a deeply humanist tradition, playful and serious, caught up in events of the day but rooting them in poetic contexts that go back in time and across borders in a modern way. He had a reputation as a comic writer with what we call a pawky sense of humour, but there are depths there that have to be reckoned with. This is particularly true with regard to his war experiences. He was a prisoner of war in Italy and the wee poem, the 'Letter From Italy' reflects that, and there is a prose memoir of his experiences as a prisoner of war, an important book called *Two Men and a Blanket*.

Letter from Italy

From large red bugs, a refugee,
I make my bed beneath the sky,
safe from the crawling enemy
though not secure from nimbler flea.
Late summer darkness comes, and now
I see again the homely plough
and wonder: do you also see
the seven stars as well as I?
And it is good to find a tie
of seven stars from you to me.
Lying on deck, on friendly seas,
I used to watch, with no delight,
new unsuggestive stars that light
the tedious Antipodes.

Now in a hostile land I lie,
but share with you these ancient high
familiar named divinities.
Perimeters have bounded me,
sad rims of desert and of sea,
the famous one around Tobruk,
and now barbed wire, which way I look,
except above – the Pleiades.

ALAN: But the humour is real. Garioch was one of the funniest poets, especially in his representations of Edinburgh. It's there, for example, in 'Elegy', where he reflects upon that world of Scottish educators, the teachers, the dominies. They're not entirely extinct. Let's see what Garioch has to say about them:

Elegy

They are lang deid, folk that I used to ken,
their firm-set lips aa mowdert and agley,
sherp-tempert een rusty amang the cley:
they are baith deid, they wycelike, bienlie men,

heidmaisters, that had been in pouer for ten
or twenty year afore fate's taiglie wey
brocht me, a young, weill-harnit, blate and fey
new-cleckit dominie, intill their den.

Ane tellt me it was time I learnt to write –
Round-haund, he meant – and saw about my hair:
I mind of him, beld-heidit, wi a kyte.

Ane sneerit quarterly – I couldna square
My savings bank – and sniftert in his spite.
Weill, gin they arena deid, it's time they were.

ALAN: Another aspect of Garioch's relation with Edinburgh is shown in 'At Robert Fergusson's Grave'. It indicates a kind of continuity. We've talked about MacDiarmid and work of the 1920s bringing about a radical break with what had gone

before. That break helps us now to re-evaluate the continuities of literary tradition. Garioch's poem links back through Edinburgh, through Burns, through to Fergusson. He is able to reassert a continuity in the Scottish poetic tradition that would have been covered up if Scotland had stayed merely 'North Britain'. This is a very distinctive thing, to do with Edinburgh as the capital city of an older Scotland, which Burns and Fergusson were both keenly aware of.

At Robert Fergusson's Grave
(October 1962)

Canongait kirkyaird in the failing year
is auld and grey, the wee roseirs are bare,
five gulls leam white again the dirty air:
why are they here? There's naething for them here.

Why are we here oursels? We gaither near
the grave. Fergussons mainly, quite a fair
turn-out, respectfu, ill at ease, we stare
at daith – there's an address – I canna hear.

Aweill, we staund bareheidit in the haar,
murnin a man that gaed back til the pool
twa-hunner year afore our time. The glaur

that haps his banes glowers back. Strang,
 present dool
ruggs at my hairt. Lichtlie this gin ye daur:
here Robert Burns knelt and kissed the mool.

That sense of tradition also comes through in the poem 'Dr Faust in Rose Street' and Garioch is incredibly nimble and adroit when he's referring to current events, occasions and local places in poems like 'Embro to the Ploy' or 'Modern Athens' or his 'Twa Festival Sketches' – all poems descriptive of Edinburgh. In the first of the 'Festival Sketches' he describes a man selling ballads on broadsheets to a queue of people waiting to get into a theatre to see a performance of the poems of William

McGonagall. The theatre is a converted church and the man selling the broadsheets is being moved on by the police. The ironies are rich and Garioch relishes all of them. And he takes that stance further when, as he very occasionally does, he speaks for Scotland more generally. In 'Scottish Scene' for example, there's no doubt that he's addressing the national question, but he does so ironically, with a sense of humour that somehow manages to be generous at the same time as it's deflating the pretentiousness of the 'antithetical Scot' as a national paradigm.

They're a gey antithetical folk are the Scots,
 jurmummelt thegither like unctioneer's lots
 or a slap-happy family of bickeran brats...

Garioch says he'll call on Jehovah for help 'to learn ye and yir upstairt gang / that I'm in the richt and ye're in the wrang.'

Jehovah and I are gey faur ben
 sen I chose ti be yin of his chosen men.
 And I dinnae fecht fir masel, forbye;
 we fecht fir Scotland, Jehovah and I...

'Duty is duty,' he concludes, 'but it's nae joke / to sort thae curst antithetical folk.'

SANDY: He could be wonderfully reductive, completely deflating any pretentious self-importance, and you need that to counterbalance anything that might seem too grandiose or overblown. He was always rather suspicious and sceptical about MacDiarmid's claims to greatness and poems of epic proportions.

ALAN: I love these little squibs, throwaway poems for particular occasions.

After a Temperance Burns Supper

It's all very well,
It's all very well,
It's all very fine and dandy

Till you have to take the last bus home
With a bellyful of shandy.

But obviously, if he was inspired by MacDiarmid, his real heroes were Robert Fergusson and possibly Allan Ramsay, and his precedents go right back to William Dunbar. Two of his major poems, 'The Wire' and 'The Muir', show that he could handle a very different, serious sense of address and had the poetic means to do that. They are very impressive poems.

SANDY: Garioch was a very private man. George Mackay Brown was quite introverted but once he'd had a few pints, he loosened up. But Garioch was much more reticent. The *Oxford Dictionary of National Biography* reports: 'On 26 January 1942 he married Margaret Lillie (1914/15–c.1979), a schoolteacher, in Edinburgh. They had at least one child, Ian.' – I mean, the *Oxford Dictionary* isn't even exactly certain how many children he had! He kept his own counsel. But I got to know him quite well and he often invited me to his house. This was much to the surprise of Norman MacCaig. Norman's eyebrows went up and he said, 'I've never been in his house!'

Garioch was a bit of a carpenter. You know the rocking chair I show him in, in the portrait? He made that, and the little things in the background like the table lamps. I think he made all of those. In fact, he got his hands on a small printing press in the early 1940s and brought out that little book of his own and Sorley MacLean's poems, called *17 Poems for Sixpence*. It's worth a lot more than sixpence now! Maybe he inherited his practical skills from his father, who was a housepainter. He was close to MacLean and Hamish Henderson, fellow Desert War veterans.

He was underrated as a serious poet, I think, because he was a very amusing reader. He deliberately cultivated a 'wee man' persona for public readings. He had an oblique sense of humour. And he looked a bit like a character from

Beckett's *Waiting for Godot*. I don't know how long he'd worn his old overcoat. Let's just say, for a long time. And he had one of these wee woolly hats, that you see fishermen wearing, that was always pulled way down, and he carried this Gladstone bag that was usually full of two or three bottles of beer.

ALAN: There's a poem called 'Brither Worm' in which he sees a worm come up between the cracks in the paving stones, so he sees the worm beneath Edinburgh's New Town. He sees underneath all that classical elegance and recognises the same mortality is going to get us all, whether we're New Town or Old Town!

SANDY: I felt the poets were much more passionate about what they were doing than most of the painters I knew in Edinburgh. They seemed much more aware of their own sense of destiny in defending Scottish culture.

ALAN: They were all to some degree aware that they were responsible for protecting and safe-guarding Scottish literature and they were all active in doing that. Think of Garioch's work on the Scots dictionaries, or MacLean's championship of Gaelic, MacCaig's or Morgan's work as teachers, George Mackay Brown's position as a kind of Orkney skald or bardic figure, speaking for his people across generations, or Alexander Scott and Tom Scott both editing important anthologies of Scottish poetry. They all had a sense of their own place in a cultural tradition and national poetic context. Sydney Goodsir Smith edited that very important book of critical essays reassessing Robert Fergusson's poetry and there were the editions of other older Scottish poets some of them edited and introduced for the Saltire Classics series.

SANDY: Sydney Goodsir Smith was probably even more of an Edinburgh poet than Garioch, despite the fact that he was born in Wellington, in New Zealand and didn't arrive in Edinburgh until he was 12 years old! MacDiarmid said of him that 'He early divined that the remnant of real Scottishness was to

3.25 Alexander Moffat
*b.*1943
Robert Garioch 1978

be found in the lower strata of our working-class life, the least anglicised or anglicisable element in our population and in the low-down pubs they frequented, and he was able in his incredible and most improbable language medium to recreate the life of the wynds, closes and drinking-clubs of old Edinburgh in a way that no other of the innumerable writers on Edinburgh has succeeded in doing. We are never far from "The Jolly Beggars" or from Robert Fergusson when one is reading Sydney.'

ALAN: By his 'improbable language medium' he means Sydney's Scots, doesn't he?

SANDY: Aye. He developed this super-charged Scots which was riotous in his so-called novel, *Carotid Cornucopius* – a sort of Joycean extravaganza of the Scots language in which he depicts Edinburgh, himself, and many of the characters and contemporaries – writers and poets such as those we've been talking about, Garioch, MacLean, Denis Peploe, MacDiarmid, are all magnificently caricatured or sketched in exaggerated form in this book. Peploe illustrated Sydney Goodsir Smith's book *The Deevil's Waltz*, which was published by William MacLellan, just after the Second World War had ended.

ALAN: *Carotid Cornucopius* deserves thorough annotation and re-publication!

SANDY: But the point about his language is relevant to his poetry too. In the poem 'Epistle to John Guthrie' he spells it out. If some critics think it's a crime to write in an 'artificial' language, he says, they should remember that no poet ever writes 'common speech' – who ever spoke like King Lear? His own Scots is flamboyantly rhetorical, overflowing with artifice and self-evident 'craft' – and yet it's hugely buoyant and sustained by an energy that keeps everything going. You can see this if you look at the *Collected Poems*, which show you how he began writing in English; and then there's an 'Ode to Hector Berlioz' and he begins writing in Scots, and continues to do so. It's

3.26 Denis Peploe 1914–93 Pote and Penter *c*.1946

3.27 Rendell Wells The Auk 1964

like starting off in black-and-white and then suddenly going into full colour.

ALAN: I wonder if Berlioz helped him to see things in full colour that way? Certainly knowing MacDiarmid was a catalyst for him – and they were great cronies and chums – but Goodsir Smith was not only very well-informed about classical music, he was also extremely receptive to the visual arts. He was an artist himself and an art critic for *The Scotsman* for many years.

SANDY: Denis Peploe said that Sydney 'had always been fascinated by the inter-relationship between the arts and believed in the concept of the artist as an all-round man. He saw no fundamental distinction between music, prose, poetry, painting and sculpture, although he recognised that the analogies which appeared to bring them close serve equally to separate them. One discipline can complement another as long as it does not try to explain it or merely illustrate it.'

ALAN: He was a playwright as well. Forty years before *Braveheart* there was a production of Goodsir Smith's *The Wallace* in which the Scots audience response was overwhelming and prophetic of exactly the kind of reception given to the film nearly half a century later. So you have to ask yourself, why was no theatre or film or television company building on this?

SANDY: Iain Cuthbertson, the fine Scottish actor who played Wallace, said this:

> As rehearsals built towards the first night, the cast's enthusiasm grew. The heroic quality of the play began to stand out, imbuing us all with a strong sense of the work's importance. The Scottish audience backed us increasingly, despite the carping scrievers. In fact, the stage became rapidly an arena for a conflict between the Scots and the tasteful others. One or two nights I do remember Wallace's entrance being greeted by cheers, handclaps and the massive stamping of feet. The theatre was briefly a football ground. Brecht would have loved it.

ALAN: Would he? I wonder. *The Wallace* is not a Brechtian play – it's more of a historical pageant – there's nothing in its technique to suggest the Brechtian emphasis on thinking over blind emotionalism. And many critics of *Braveheart* said that similarly, Mel Gibson's film simply appealed to formulaic responses, mesmerising opiates – nothing Brechtian about that!

SANDY: And yet, that can't be the whole story. First of all, what's happening in the play, the film and the audience in each case demands a cool Brechtian reading. All these – play, film, audiences – act in a political context. And what goes beyond the formulae and the emotionalism is the need that persists, the political need for change that is already there in that context. The audiences recognise that need and respond to more than simply the play or the film.

ALAN: Yes, that's true. Perhaps Cuthbertson was saying that the audience and the actors understood that political context better than the sophisticated critics who were condescending to both play and film. This is what Edwin Morgan draws attention to in his poem about Wallace – something about the story of Wallace, whether it is represented in good art or bad art, still draws attention to a social and political question of injustice and the desire for a right solution. And no amount of criticism can dissolve that.

Cinema sophisticates
Fizzed with disgust at the crudities
Braveheart held out to them.
Over the cheeks of some
(Were they less sophisticated?)
A tear slipped unbidden.
Oh yes it did. I saw it.
The power of Wallace
Cuts through art
But art calls attention to it
Badly or well.

The poem begins by asking, 'Is it not better to forget?' and answers immediately, with total resolution: 'It is better not to forget.' And it ends: 'Think about it, / Remember him.'

SANDY: The film critic Brian Pendreigh saw *Braveheart* in various different countries when it was first released, before it became over-familiar. When it came to the final scene of Wallace's execution, he says, 'No one laughed or mocked then. The only sounds during that scene were muffled sobs.' So there was an immediate response before the critics stepped in. He went on: 'The arguments over historical accuracy were for pedants. What Gibson gave us was a "creation myth" and a pride in being Scottish. No other film had such an impact on Scottish society, politics and culture.'

ALAN: And that's what Goodsir Smith had foreseen in his play back in the 1960s. It's his poetry, though, that really evokes Edinburgh so well. And it's a unique blend of love and affection for the old town and a kind of poetic form that derives less from native Scottish traditions of verse than from the loose-shouldered, conversational free-verse that became more familiar through the American poets of the 1950s and 1960s, the Beat and Black Mountain poets. Goodsir Smith is a great love poet and his greatest work is probably the sequence of love poems, 'Under the Eildon Tree' but there are also splendid, rambling, ratiocinative poems set in Edinburgh and unforgettably evoking the city. 'Gowdspink in Reekie', for example, takes its premise from the idea that the Irish writer Oliver Goldsmith has come to visit Edinburgh and Goodsir Smith takes him on a ramble round the pubs and alleyways of his city. And there's 'Kynd Kittock's Land', which celebrates the Edinburgh of after-hours sex and booze. There's a wonderful affinity with the celebrated poet of drink from ancient China, Li Po. Goodsir Smith creates a similar persona, a lonely lover and drinker in a capital city of a far northern kingdom in some forgotten backwater of history where, nevertheless, these simple universal human passions still apply. Here's a short poem that I've always loved:

There is a Tide

There is a tide in love's affair
Nae poem e'er was made –
The hairt hings like a gull in air
For aa the words are said.

Nou in this saagin-tide we swey
While the world wags and empires faa:
But we that burned high Ilium
What can we rack that ken it aa?

SANDY: In 'Under the Eildon Tree' he has this sequence of poems in which many of the great lovers in legend and history form a sort of marvellous pageant, all seen through the ironic, bleary, wistful, poignant eyes of the Bard. He's self-deprecating, puts himself down in the opening lines, but it's still an acknowledgement of the greatness of these stories and the power of love.

Bards has sung o' lesser luves
Than I o' thee,
O, my great follie and my granderie...

ALAN: It reminds me of Jack Yeats's dedication of his novel *Sligo* (1930): 'To Venus – I leave it to you mam'! In this poem, Goodsir Smith talks about Burns and Highland Mary, Orpheus and Euridice, Cuchulainn and Eimhir and Fann, Dido and Aeneas, Tristam and Iseult and Antony and Cleopatra but my favourite in the sequence is the outrageous poem where he describes his own persona, as it were, picking up 'a bonny coo' – a young prostitute, 'Saxteen, maybe seventeen, nae mair, / Her mither in attendance... Drinkan like a bluidie whale...' in an Edinburgh pub called The Black Bull o Norroway. It's the most full-humoured

and unrepentant of poems, describing 'My Helen douce as aipple-jack / That cack't the bed in ecstasy!' and concluding rueful but unapologetically:

O, Manon! Marguerite! Camille!
And maybe tae, the pox –
Ach, weill!

SANDY: There's also the poem where he pictures himself having a long-lie in, in his bed, 'Sydney Slugabed Godless Smith' –

Liggan my lane in bed at nune
Gantan at gray December haar,
A cauld, scummie, hauf-drunk cup o' tea
At my bed-side,
Luntan Virginian fags
– The New World thus I haud in fief
And levie kindlie tribute. Black men slave
Aneath a distant sun to mak for me
Cheroots at hauf-a-croun the box.
Wi' ase on the sheets, ase on the cod,
And crumbs of toast under my bum,
Scrievan the last great coronach
O' the westren flickeran' bourgeois world.
Eheu fugaces!
Lacrimae rerum!
Nil nisi et cetera ex cathedra
Requiescat up your jumper.

ALAN: There's an utterly impious sense of humour there and a great sense of pathos, of what he calls 'The Tarantula of Love'. I think, even more than Robert Garioch perhaps, Sydney Goodsir Smith is the great neglected poet of Edinburgh. Maybe it's an Edinburgh that's not polite enough for some people to warm to, but there's more than one kind of sensibility in Edinburgh, after all. Scotland should see the world he's written for us. It's rich and racy and a great place to roam around in.

And if you see it that way, maybe it's not so far from Glasgow after all…

Edwin Morgan (b.1920)

ALAN: Edwin Morgan is the last poet of that great generation. He accepted the appointment of the first National Poet of Scotland, effectively the Poet Laureate of Scotland, the first ever, in 2004. And before that he had been the Poet Laureate of Glasgow. So, after our discussion of the poets of the Highlands and Islands, and the poets of the cities of Scotland, Morgan reminds us of the sheer range of experience that poetry is capable of dealing with. There is nothing exclusive, no prescriptiveness, for poetry. Poetry can do anything and take on anything. It's as if there's a terrific appetite for the modern here, a restless curiosity for what's going on in the world and an eagerness to bring it all into view. Maybe that's partly a legacy of Modernism and the principle of collage as a modern art form.

SANDY: Surprisingly, Morgan connects with the post-revolution aesthetic of the Russians, something no other Scottish artist had done. Morgan is tremendously enthusiastic about the work of Mayakovsky and El Lissitsky and Rodchenko from very early on and he keeps their example in his own work, almost as a governing principle. It never grows stale. It's constantly engaged, restless, roving. And it's city-based. It's a modern urban aesthetic. It uses technologies that are new, that didn't exist in the 19th century: typography, film, photography, and so on. Concrete poetry is a merging of visual art and writing. Ian Hamilton Finlay (1925–2006) has had a lot of credit for this but Morgan was the author of a significant body of work as a concrete poet as well.

ALAN: Finlay's poetry and stories were well-received in America and Robert Creeley wrote a good introduction to his Collected Poems which places him securely in an international context as a writer. I think Finlay and Morgan both share this

almost effortless internationalism in their attitude, Morgan as poet and Finlay as artist. MacDiarmid was rather sceptical about the element of play in their work and was sometimes scathing about Concrete Poetry as a genre but nevertheless there is a real engagement between what you might call the literary imagination and visualisation in their work. And both have a distinctive sense of humour.

SANDY: The development of Concrete Poetry is one of the key connections between Morgan's work and that of the visual artists. For example, there's the poem about the Hungarian snake having an after-lunch snooze...

Siesta of a Hungarian Snake

s sz sz SZ sz SZ sz ZS zs ZS zs zs z

ALAN: That's very funny and witty, of course, but the amazing thing about Morgan's 'emergent' poems is how they can sometimes be playful and deeply moving and serious at the same time. He told me once that when his father was ill and dying, he was returning from a visit to the hospital to see him and in the bus coming home, he was watching the rain as it was running down the window pane. The last line of this poem was in his mind and the poem constructed itself like this – playfully, yet with a great sense of the emotional or even spiritual question behind it...

Message Clear

```
    am              i

                          if

  i am                    he

      he r        o

      h     ur   t

      the re          and

      he     re     and

      he re

  a                   n    d

      the r                    e

  i am    r      i          fe
```

```
                        i n

              s        ion and

    i                      d      i e

      am    e res    ect

      am    e res    ection

                          o              f

            the                          life

                          o              f

      m    e              n

           sur e

          the                  d      i e

    i          s

               s     e t     and

  i am the  sur           d

    a   t   res     t

                         o        life

  i am  he r                       e

  i a              ct

  i       r  u         n

  i   m    e  e     t

  i            t              i e

  i       s    t    and

  i am th        o       th

  i am    r         a

  i am the  su        n

  i am the  s       on

  i am the  e   rect on       e if

  i am    re        n     t

  i am      s        a       fe

  i am      s    e    n    t

  i   he  e             d

  i   t  e  s    t

  i        re           a d

    a   th re           a d

    a       s     t on       e

    a   t   re           a d

    a   th r       on        e
```

```
i        resurrect

                    a        life
i am           i  n       life
i am     resurrection
i am the resurrection and
i am
i am the resurrection and the life
```

Both Morgan and Ian Hamilton Finlay were in touch with each other and with their contemporaries in South America, the Brazilian concrete poets, as the movement gathered energy. And this connects with Morgan's liking for the constructivist dynamics of an artist like Eduardo Paolozzi.

It's true that in the late 19th century, there is very little Scottish writing about inhabiting the city, in a way that might allow you to feel at home. Often, as we've seen, the depictions of the city are critical, depictions of squalor and poverty, as well they might be. But with Morgan you have a poet fully inhabiting his city. And also he exposes the great fallacy that is so often heard when some people ask why is this place so gloomy? Why is it so dark? Morgan is variously, magnificently optimistic and unreservedly positive in so many ways. Not that he doesn't take you into the dark places, but he is so frequently a happy, joyful, playful poet – there is a comprehensive balance between the dark and the light.

SANDY: Stay with the dark for a moment. He emerges from dark times, from the Second World War and that 'aftermath' period as historians call it, a period which produced Camus, Sartre, Giacometti, a period when people came face-to-face with the reality of the atom bomb, concentration camps, all the worst things humankind was capable of. Morgan emerges from this.

ALAN: That's right. 'The New Divan', his poem about his experiences in the war, wasn't published until the 1970s, but he began publishing in the 1950s. In 1952 there was the translation of *Beowulf*.

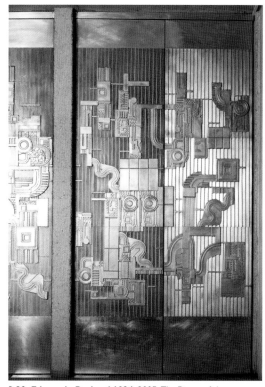

3.28 Eduoardo Paolozzi 1924–2005 The Doors of the Hunterian Art Gallery, University of Glasgow 1976–77

In some ways, that's his war poem, a grey, lowering, headache of a poem, full of death and mud and clashing swords and bone and blood and loneliness.

SANDY: That's contemporary with the work of the two Roberts, Colquhoun and MacBryde. They share similarities in mood and symbolism. There's a sombreness in the work of many of the leading artists of this period. Picasso restricted his palette. Giacometti rejected colour. There's colour in Colquhoun and MacBryde but you feel as if every colour has been mixed through tones of grey. Of course, this is the era of Existentialism and there's a bleakness in the *zeitgeist*. Morgan picks up on this. Maybe there's a special place for the

outsider in this context and as homosexual outsiders, Colquhoun, MacBryde and Morgan must all have felt something of that isolation very keenly but were able to find ways of expressing this in their work, and that's what makes them important.

ALAN: Perhaps it's a more general condition of that time?

SANDY: In 'A Personal Note', written for the catalogue of the MacBryde memorial exhibition of 1972, held in the New 57 Gallery, Edinburgh, John Tonge refers to 'that gifted generation who had emerged during the Second World War and never overcame the tragic experience of those years'.

Robert Colquhoun was born in Kilmarnock, not far from Maybole, where Robert MacBryde was born. They met at the Glasgow School of Art , where they were taught by Ian Fleming and thereafter lived and worked together until Colquhoun's death in 1962. 'The Two Roberts', as they were known, graduated in 1938. Travelling scholarships enabled them to study in France and Italy before the start of the Second World War. They spent the war years in London, where they came into contact with Jankel Adler, who encouraged them to paint from imagination and experience. By the mid-1940s, they were feted by the English art world, receiving commissions for set designs for Massine's ballet *Donald of the Burthens*, music composed by Ian Whyte, premiered at Covent Garden in 1951. Both men drank heavily and their hugely promising beginnings ended towards the end of the 1950s. After Colquhoun's

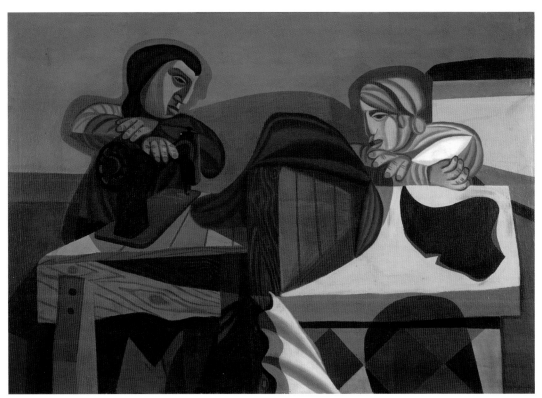

3.29 Robert MacBryde 1913–66 Two Women Sewing *c*.1948

death, MacBryde moved to Dublin, dying in a road accident in 1966. They were largely responsible for the modern manifestation of the myth of the self-destructive Scottish artist. But there's also a hard-won Scottish craftsmanship that gives their work a sense of purpose and strength. It's serious stuff. And the young Edwin Morgan, even if he's not publishing much yet, he's obviously thinking about these things.

ALAN: It wasn't all gloom and despond, though.

SANDY: Indeed! On a lighter note, John Tonge again remembers that the lyric theatre was MacBryde's love: "'You must write a libretto," he told Dylan Thomas one midnight, after a hilarious duet in which, standing on the studio sofa, they serenaded each other in snatches of remembered arias and improvised cadenzas and roulades. "If," stipulated the poet, "you promise to do the sets.'"

LINDA: Bring us back to Edwin Morgan, now, Alan.

ALAN: When you turn from *Beowulf* to Morgan's first breakthrough book, *The Second Life*, in 1968, you're into a very different, up-beat, exhilarating world. The darkness is still there for sure, for

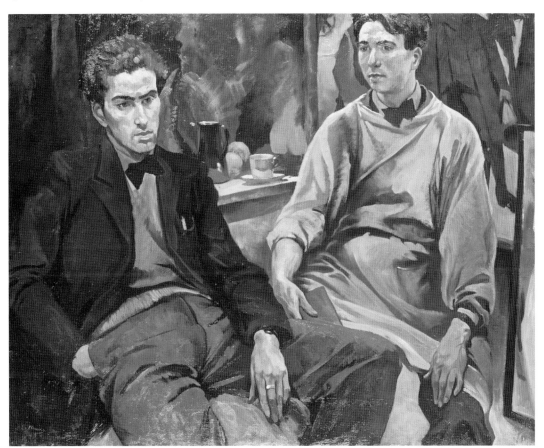

3.30 Ian Fleming 1906–94 The Two Roberts 1937–38

instance in 'Glasgow Green', but there's a vivid
sense of festivity and celebration as well, in 'Trio',
perhaps one of his best loved, widely anthologised
poems. This is how it begins:

> Coming up Buchanan Street, quickly, on a sharp
> winter evening
>
> a young man and two girls, under the Christmas
> lights –
>
> The young man carries a new guitar in his arms,
>
> the girl on the inside carries a very young baby,
>
> and the girl on the outside carries a chihuahua.
>
> And the three of them are laughing...

And that laughter is so joyful it becomes
contagious as you read the poem. It has this
uplifting quality of absurdity and excitement.
For example, when Morgan says that the chihuahua
'has a tiny Royal Stewart tartan coat like a teapot-
holder' and 'the baby in its white shawl is all bright
eyes and mouth like favours in a / fresh sweet cake',
you know you're in good hands. This is a
Christmas poem – but it's not necessarily a
Christian poem and in fact it doesn't matter what
denomination or disposition you might possess.
'Monsters of the year go blank, are scattered back...
whether Christ is born or is not born, you / put paid
to fate, it abdicates / under the Christmas lights'.
It's a poem about the kind of experience that's only
available in the city, under the city lights. And it's a
named city. It could be anywhere but it is,
specifically, Glasgow, the street is named and
familiar. It presents a world of music, of
machinery, of men and women and animals, all
coming together in a strangely balanced,
corresponding way. And in Morgan's key poem
from *The Second Life*, the title poem, he brings in the
cyclical rhythm of the seasons, not as an idealistic
nature poet would do, but rather in terms of the
regeneration of the city, as Glasgow was
regenerating itself in the 1960s.

> Is it true that we come alive

> not once, but many times?
> We are drawn back to the image
> of the seed in darkness, or the greying skin
> of the snake that hides a shining one –
> it will push that used-up matter off
> and even the film of the eye is sloughed –
> That the world may be the same, and we are not
> and so the world is not the same,
> the second eye is making again
> this place, these waters and these towers,
> they are rising again
> as the eye stands up to the sun,
> as the eye salutes the sun.

SANDY: It's more than autobiography and
character, though. You're right – there's a
celebration going in 'Trio' and there's an articulate
autobiographical persona coming through clearly
in 'The Second Life' but there's also something else
– a very engaged, outward-looking, attentive,
enquiring mind, looking at world events
historically, through the current media of the day.
He's reading newspapers, watching TV, listening
to the radio and turning to international events,
characters, personalities, and making all these
things into poems. I'm thinking of 'The Death of
Marilyn Monroe' or his science fiction poems about
the space race, or 'The Death of Che Guevara' or
poems about Fellini, Tarkovsky, the war in Vietnam.

You might go to the cinema and see films by
European directors or read the news and feel that
in Scotland, we are somehow distant from all that –

ALAN: Cairns Craig uses the phrase, 'Out of
history' – the idea that we're not in history, we're
out of it...

SANDY: And yet here was Morgan writing these
poems that blazed a trail by simply connecting us to
people, events, things that were going on in the
world. We were in touch. These things were relevant
to us. He set that example, by introducing a world-

view into his poems, implying that it didn't matter whether you lived in Edinburgh or Glasgow or Inverness, that this was your subject-matter as well.

ALAN: It took Morgan a long time to write about the Second World War.

SANDY: Not until *The New Divan* in the 1970s do we get an extended poem-sequence which folds in numerous shorter poems, descriptions, visions of his own life in the Royal Army Medical Corps in the desert campaign. It's a very intimate picture, almost domestic, yet shocking, both as regards the graphic description of conditions in the hospital tent and in the directness with which he refers to his sexual self-realisation.

ALAN: Considered in this way, the Glasgow Morgan is placed in an international, 20th-century history.

SANDY: Morgan's association with Glasgow goes right back through his biography of course. But also, of all the poets of this generation, he's probably the most sympathetic to the visual arts. In 1976, he wrote a perceptive essay for the catalogue published for Tom Macdonald's one-man exhibition at the Third Eye Centre.

He was clearly impressed by Macdonald's commitment to Glasgow and his presence in the city from the 1940s, when he started exhibiting, to the 1970s. Morgan talks about that era of cultural resurgence after the Second World War that saw the emergence of the New Art Club, the Celtic Ballet, Unity Theatre, the Citizens' Theatre and the periodicals *Poetry Scotland* and *Scottish Art and Letters*. And it's almost as if he's describing a quality of his own work when he says that Macdonald's art is one 'of many metamorphoses'. Its attraction, Morgan says, 'and possibly its strangeness, emerge from its being very much an art that comes on home ground, yet with great awareness of what art in general has been doing.' It's this bringing together of the local and the avant-garde that appeals to Morgan and it's revealing that he quotes from a lecture given by Charles Rennie Mackintosh from

1902 (on 'Seemliness') to elaborate this into a kind of manifesto. This is the passage by Mackintosh that Morgan quotes:

> The artist may have a very rich psychic organisation – an easy grasp and a clear eye for essentials – a great variety of aptitudes – but that which characterises him above all else – and determines his vocation – is the exceptional development of the imaginative faculties – especially the imagination that creates – not only the imagination that represents. The power which the artist possesses of representing objects to himself explains the hallucinating character of his work – the poetry which pervades them – and their tendency towards symbolism – but the creative imagination is far more important.

So for Morgan, what's valuable is never merely the representational but the extra dimension of the creative, something enigmatic, gallus, nightmarish perhaps, certainly uncanny, something that appeals to subconscious reactions. The Clyde engineer in Macdonald is subterraneanly at work with the artist and Morgan praises him as a tutelary spirit of the changing city.

ALAN: One of the key poems in *The Second Life*, 'To Joan Eardley', describes Eardley's painting of children running by the window of a sweetie-shop in the slum area of Rottenrow. The buildings were demolished but Morgan's poem and Eardley's painting preserve the living energy of those children.

To Joan Eardley

Pale yellow letters
humbly straggling across
the once brilliant red
of a broken shop-face
CONFECTIO
and a blur of children
at their games, passing,
gazing as they pass
at the blur of sweets

in the dingy, cosy
Rottenrow window –
an Eardley on my wall.
Such rags and streaks
that master us! –
that fix what the pick
and bulldozer have crumbled
to a dingier dust,
the living blur
fiercely guarding
energy that has vanished,
cries filling still
the unechoing close!
I wandered by the rubble

and the houses left standing
kept a chill, dying life
in their islands of stone.
no window opened
as the coal cart rolled
and the coalman's call
fell coldly to the ground.
But the shrill children
jump on my wall.

And there's the other side of Eardley's work, the seascapes she painted at Catterline on the east coast of Scotland. Morgan has a late poem from 2005 describing one of these.

Flood Tide

Lonely people are drawn to the sea.
Not for this artist the surge and glitter of salons,
Clutch of a sherry or making polite conversation.
See her when she is free: –
Striding into the salty bluster of a cliff-top
In her paint-splashed corduroys,
Humming as she recalls the wild shy boys
She sketched in the city, allowing nature's nations
Of grasses and wild shy flowers to stick
To the canvas they were blown against
By the mighty Catterline wind –
All becomes art, and as if it was incensed
By the painter's brush the sea growls up
In a white flood.
The artist's cup
Is overflowing with what she dares
To think is joy, caught unawares
As if on the wing. A solitary clover,
Unable to read WET PAINT, rolls over
Once, twice, and then it's fixed,
Part of a field more human than the one

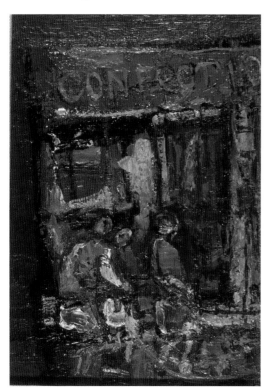

3.31 Joan Eardley 1921–63 Confectio c.1960s

That took the gale and is now
As she is, beyond the sun.

SANDY: Joan Eardley (1921–1963) was born at
Warnham, Sussex, and studied at Glasgow School
of Art from 1940 to 1943. After travelling through
Italy and France in 1948 to 1949, she returned to
Glasgow, working amongst the dilapidated
tenements recording street life through
photography and chalk sketches that were then
translated into larger paintings. These remain her
most popular works. In 1951, she began to paint
the landscape and sea at Catterline, on the north-
east coast of Scotland and later took up semi-
permanent residence there. The large, expressive
seascapes of this period constitute a formidable
achievement and are her greatest works. What she
might have gone on to had she not succumbed to
cancer in 1963 is open to speculation, but there
cannot be any doubt that with her early death,
Scotland lost one of its major painters.

Eardley's formative years were the 1940s and in
the 1950s her sombre colourings aren't so far
removed from that of Colquhoun and MacBryde.
You could argue that her later work, the seascapes
painted on the beach at Catterline are much more
existential and bleak than her urchins, her street-
kids, and they reveal more of her uncompromising
toughness and originality. Morgan's poem gets
that sense of social isolation precisely. She isn't a
painter of the salon and he recognises her self-
determined insistence on the elemental.

ALAN: In fact, that poem is one of a sequence he
wrote in response to a newspaper poll of readers'
favourite Scottish paintings. There has always been

3.32 Joan Eardley 1921–63 Flood Tide *c.*1962

a real engagement with painting in Morgan's work. He donated his own very considerable collection to Glasgow University's Hunterian Art Gallery when he moved to a Nursing Home in the latter years of his life. More recently, as Poet Laureate of Glasgow, Morgan produced a book called *Cathures*. Cathures is the oldest known name for Glasgow, before Glasgow was Glasgow. This book gathers sequences of poems and at the heart of them, there's a sequence that he wrote at the end of the millennium, called 'Demon'. I think these poems relate to Morgan's importance as a poet of the city. But 'Demon' also has this uncanny, nightmarish, hallucinatory quality. It's almost as if it could have been written anywhere and takes place in a dream-landscape.

My job is to rattle the bars. It's a battle.

The gates are high, large, long, hard, black.

Whatever the metal is, it is asking to be struck.

There are guards of course, but I am very fast

And within limits I can change my shape.

The dog watches me, but I am not trying

To get out; nor am I trying to get in.

He growls if I lift my iron shaft.

I smile at that, and with a sudden whack

I drag it lingeringly and resoundingly

Along the gate; then he's berserk: fine!

This is a kind of autobiographical poem but it has this mythological dimension and supernatural sense of mystery.

A Little Catechism from the Demon

What is a demon? Study my life.

What is a mountain? Set out now.

What is fire? It is for ever.

What is my life? A fall, a call.

What is the deep? Set out now.

What is thunder? Your powder dry.

What is the film? It rolls, it tells.

What is the film? Under the Falls.

Where is the theatre? Under the hill.

Where is the demon? Walking the hills.

Where is the victory? On the high tops.

Where is the fire? Far in the deep.

Where is the deep? Study the demon.

Where is the mountain? Set out now.

Study my life and set out now.

What is the Demon? Who is the Demon? The Demon is a kind of furious soul. The Demon is the capacity anybody might have to call on when serenity comes too close to complacency, when you think you've got all the answers, the Demon will be there to tell you, 'Don't be so sure.'

When Morgan celebrated his 80th birthday, a number of his friends gathered together and compiled a small book of tributes, poems, and he contributed this poem to it himself, which at the last minute gave the editors the title for the book, 'Unknown is best' – because that's the principle by which his life has been activated, the principle that he's always lived by. The poem – called 'At Eighty' – begins like this:

Push the boat out, compañeros,

Push the boat out, whatever the sea.

Who says we cannot guide ourselves

through the boiling reefs, black as they are,

the enemy of us all makes sure of it!

And it's this sense of voyaging, of 'Keep going!' that he's praising, commanding:

Out,

push it all out into the unknown!

Unknown is best, it beckons best,

like distant ships in mist, or bells

clanging ruthlessly from stormy buoys.

Morgan writes various kinds of sequence in *Cathures* – monologues effectively presenting self-portraits of figures associated specifically with Glasgow across the centuries, a kind of historical overview of the city from prehistory to now, and a series of more-or-less doggerel poems prompted spontaneously by moments, happenings, events in the city. The importance of relevance and spontaneity and the frivolity of such engagements does not belittle the seriousness or civic aspect of what he's doing in these poems. But the major poem in the whole book is 'Pelagius'. He was particularly happy to find out that his name, Morgan, is in fact the same name as Pelagius, in the etymological roots of both words. So this is a self-portrait of Morgan himself, as an old man now, back in the city, going back to the Pelagian heresy: the idea that there is no such thing as original sin. There is no original sin. We need not suffer guilt simply because we're human beings and alive. There is so much more to be made of this world, in simply human terms.

> I, Morgan, whom the Romans call Pelagius
> Am back in my own place, my green Cathures
> By the frisky firth of salmon, by the open sea
> Not far, place of my name, at the end of things,
> As it must seem. But it is not a dream
> Those voyages, my hair grew white at the tiller,
> I have been where I say I have been,
> And my cheek still burns for the world.
>
> ...
>
> Sometimes when I stand on Blythswood Hill
> And strain my eyes (they are old now) to catch
> Those changing lights of evening, and the clouds
> Going their fiery way towards the firth,
> I think we must just be ourselves at last
> And wait like prophets – no, not wait, work! –
> As prophets do, to see the props dissolve,

> The crutches, threats, vain promises,
> Altars, ordinances, comminations
> Melt off into forgetfulness.
> My robe flaps; a gull swoops; man is all.
> Cathurian towers will ring this hill.
> Engines unheard of yet will walk the Clyde.
> I do not even need to raise my arms,
> My blessing breathes with the earth.
> It is for the unborn, to accomplish their will
> With amazing, but only human, grace.

There are key characteristics of Morgan's work – its embodiment of the city, of Glasgow; its familiarity with modern technology; its readiness to respond to things as they happen. There was a television programme called *The Video Box* which Morgan took as an incentive for a sequence of poems. The box itself was like a passport booth, where people could go in and record on video their impression of programmes of the previous week. Morgan had a series of monologues devised from this idea.

SANDY: These are very inventive, responsive, occasional and playful poems but Morgan's role is bigger than that. He's really the only poet of that generation to take up MacDiarmid's example as someone committed to speaking in public for the value of the arts and education and culture.

ALAN: Edwin Morgan visited Holyrood in November 2006, for the first time. The poem he'd written for the re-opening of the Scottish Parliament, 'Open the Doors!' had been brilliantly read on the occasion by Liz Lochhead on 9 October 2004, but Eddie had not been able to visit till 2006. He immediately made very complimentary remarks about the building itself. As regards the parliamentarians, he came out with a comment that was utterly characteristic in its politeness, modesty and charge of responsibility: 'They're not there yet,' he said. 'But they're on their way!'

3.33 Alexander Moffat b.1943 Edwin Morgan 1980

The poem begins with a great exclamation: 'Open the doors! Light of the day, shine in; light of the mind, shine out!' Then he praises the building itself:

> There is a commerce between inner and outer, between brightness and shadow, between the world and those who think about the world.

> Is it not a mystery? The parts cohere, they come together like petals of a flower, yet they also send their tongues outward to feel and taste the teeming earth.

We have 'slate and stainless steel, black granite and grey granite, seasoned oak and sycamore, concrete blond and smooth as silk the mix is almost alive it breathes and beckons imperial

marble it is not!' Morgan clearly prefers this modern building to marble pillars or Gothic spires. But then he uses these images as a challenge to the parliamentarians:

> What do the people want of the place? They want it to be filled with thinking persons as open and adventurous as its architecture.

> A nest of fearties is what they do not want.

> A symposium of procrastinators is what they do not want.

> A phalanx of forelock-tuggers is what they do not want.

> And perhaps above all the droopy mantra of 'it wizny me' is what they do not want.

> Dear friends, dear lawgivers, dear parliamentarians, you are picking up a thread of pride and self-esteem that has been almost but not quite, oh no not quite, not ever broken or forgotten.

So when he ends the poem, it's cautionary as well as encouraging:

> We give you our consent to govern, don't pocket it and ride away.

> We give you our deepest dearest wish to govern well, don't say we have no mandate to be so bold.

> We give you this great building, don't let your work and hope be other than great when you enter and begin.

> So now begin. Open the doors and begin.

Edwin Morgan, Alasdair Gray and Liz Lochhead

ALAN: Morgan stands as an enabling figure, a catalyst and teacher, in the transitional era from the 20th to the 21st centuries. To understand that fully, you have to appreciate what happened through the 1980s and 1990s. Maybe the best place to start is with three key works of the 1980s: Gray's *Lanark* (1981), Liz Lochhead's play *Mary Queen of Scots Got Her Head Chopped Off* (1987) and Edwin Morgan's *Sonnets from Scotland* (1984) – these works, a novel, a

play and a book-length sequence of poems – define an era of self-determination in Scotland.

In 1979, a referendum was held to see if the Scottish people were in favour of a devolved government. The majority of people who voted were in favour, but a ruling was passed in London that nullified this vote. Also in 1979, the Conservative Party led by Margaret Thatcher were voted into power in Westminster by the majority of voters in the United Kingdom. Remember, the population of England is 50 million and the population of Scotland is five million. The majority of voters in Scotland voted against the Conservatives in 1979. So there were these two enormous impositions upon the declared wishes of the Scottish people. If you had any belief at all in the right of the Scottish people to self-determination, these were important events.

Anyway, in the 1980s the cultural production of Scotland, in creative work and in critical, scholarly engagement with the history of Scottish culture, literature, music, art and so on, all went into a higher gear, and it's maybe helpful to see these three works by Morgan, Gray and Lochhead, as emblematic, or exemplary, of that. Critical work by scholars and academics such as Douglas Gifford, Cairns Craig, Roderick Watson and Marshall Walker contributed to the reassessment of the value of Scotland's culture from a Scottish perspective, and worked alongside the new writing by Gray, Kelman, Leonard, Lochhead, Morgan and others, to reassert and deepen that sensibility. It was also a time in which the historians and specifically art historians were producing work which revalued Scotland and Scotland's art. Edward Cowan, Richard Finlay, Tom Devine and Fiona Watson and others were producing new national histories and John Purser was writing his magnificent radio series and book, *Scotland's Music*; while Tom Normand, Duncan Macmillan, Murdo Macdonald and John Morrison were writing new histories of Scottish art. In a way, all this was picking up from where MacDiarmid's effort had left off.

SANDY: Except it had never really left off.

ALAN: That's right.

SANDY: And furthermore, the explosion of activity in the visual arts in Scotland from the mid-1980s onwards has encouraged serious recognition of Scottish art and culture from outside the country. When Alan Bold said in the 1960s that there were no painters I think he really meant there were no painters of big subjects, of epic confrontations with political or social themes. This was what was lacking in Scotland.

LINDA: Has that changed?

SANDY: With a vengeance. With the exhibition *New Image: Glasgow* in 1985, Steven Campbell, Ken Currie, Peter Howson, Adrian Wiszniewski and others turned the genteel world of Scottish art on its head. Campbell was the eldest of them and by the time he died in 2007 at the age of only 54, he had become the most influential. In *The Sunday Herald* of 26 August, Brian Morton linked Campbell to MacDiarmid:

> In 1925 Hugh MacDiarmid had advocated a strenuous alignment with the ultra-Modernist tendencies for Scottish artists. For artists of Campbell's generation that is no longer an option, since ultra-Modernism hit an inevitable dead-end and turned into that write-off car-wreck called 'Post-Modernism'. Given that, it's worth remembering, as Campbell seems to have intuited, that in the same piece MacDiarmid also recommended that artists should pay close attention to specific and distinctive elements of Scottish psychology.

That is what Steven Campbell addressed, and because he did so in a visual language that seemed to mix up social realism, surrealism and the clunky dynamism of boys' comic graphics, he was easily assimilated by that 'ignorant' public who thought abstract art was 'difficult' and conceptual art not-value-for-money at best or embezzlement at worst. Fact is that Campbell's work is far more dangerous

and subversive than the most extreme wings of either abstraction or conceptualism, so dangerous in fact that if he had not existed, it would have been advisable not to invent him... [H]e is an artist who demands too much confrontation for the current scene, even one dominated south of the Border by YBAs who seem to thrive on confrontation but in practice only at a distance, like well-bred yobs who shout from passing cars.

ALAN: That's very astute, that connection with MacDiarmid and the perception that there is a continuity of Scottish psychology that persists through literary and artistic movements into the present, something that poets and artists can intuitively grasp and represent. We might not be able to define it or say what its essence is but we can see it, as vividly in Campbell's paintings as in MacDiarmid's poetry.

LINDA: 'You know not who I am...' You remember that poem by MacDiarmid that we looked at in the first conversation? You can't say what it is but it exists.

SANDY: Brian Morton ended his tribute like this:

The world might be a more comfortable place without Steven Campbell and the contemporary art scene is certainly more comfortable for the following generation who find themselves understood too quickly and bought up far too fast. We needed him more than we knew and mostly we shied away from admitting that to fulfil MacDiarmid's requirement we had to let loose a kind of violent enquiry, an aggressive beauty and home-made form. Steven Campbell did that. We won't see his like again.

LINDA: Sandy, you knew Campbell well, didn't you?

SANDY: During his student years David Donaldson handed me the task of looking after 'that wild bastard' – as he called him. It proved impossible for Campbell to work in normal studio conditions because of his fierce energy and phenomenal work-rate, so we set him up in his own studio in another building where he could work away morning, noon and night. In the obituary I wrote for *The Guardian* of 3 September 2007, I said this:

A flamboyant figure, often outlandishly attired, Campbell looked as if he had arrived from the Paris or Vienna of the late nineteenth century. Behind the mask, however, lay a fragile, sensitive human being, consumed by existential doubt. His paintings were spaces or theatres of the mind where the viewer would meet and experience bizarre utopias and dystopias, and which created the feeling that the artist's own life and personality were only screened from us by the thinnest of veils.

He was born in Glasgow in 1953, grew up in Rutherglen and worked in Cambuslang steelworks before coming to Glasgow School of Art, where, in the early 1980s, there was a real turning point in the history of Scottish art, fuelled by ideological and aesthetic debate helping to make exceptional art possible. Steven thrived in the apparent anarchy of this situation but his degree show met with incredulity and hostility. He went to New York and locked himself up in his studio for a year, working, refusing all invitations to socialise or take part in exhibitions. Then in 1983 he had his first exhibition and instantly there was this recognition and he took off sensationally, throughout the US and in Europe. In 1987, he surprised everybody by returning to Glasgow. 'I wanted to give myself more space coming back to Scotland... In New York it was all happening so fast. You could get yourself in an awful mess.'

ALAN: He was grouped with Currie, Howson and Wisznewski but each of these artists had a totally different vision and practice. They were never a 'school' – their independence from each other in this sense was fiercely maintained.

SANDY: Aye, as students at Glasgow School of Art they knew each other of course. They were fierce competitors, nearly coming to blows on several occasions.

LINDA: Steven Campbell's paintings aren't like anything else in Scottish art. Where did he come from?

SANDY: He produced lots of stunning pictures

3.34 Steven Campbell 1953–2007 Untitled, from the Fantômas series 2006–7

from the beginning, monumental, vivid in imagery, complex in detail and rich in formal invention, depicting intriguing narratives inspired by the novels of P.G. Wodehouse and Bram Stoker. For someone so acutely aware of his Scottish identity it might seem strange that he should be so influenced by someone like P.G. Wodehouse...

ALAN: That's MacDiarmid again, isn't it? That phrase of MacDiarmid's – 'Not Traditions! – Precedents!' Campbell wasn't working within any confining sense of a Scottish tradition in painting, he was taking precedents from the psychological suggestions and oblique perceptions of Stoker and, I think, from the almost surreal humour of Wodehouse, just taking these precedents from wherever he wanted to and

3.35 Steven Campbell 1953–2007 The Childhood Bedroom of Captain Hook with Collapsible Bed 2007

turning them into an artistic exploration of his own Scottish psyche.

SANDY: He was never apologetic about his identity – 'I'm the only one doing Scottish painting!' he would say. He felt isolated in his later years and I think he was never properly used. He should have been commissioned to paint a large-scale mural for the new Scottish Parliament building. He had an imagination that might have given us something astonishing and memorable but it didn't happen. If you look over his life – and he died much too young, at the age of 54 with a ruptured appendix – there's a defining moment that stands out in the context of our present discussion.

When he returned to Glasgow in 1987, he demolished the received opinion that ambitious Scottish artists had to leave in order to pursue successful international careers. Much of what has been achieved in the visual arts in Scotland over the past 25 years stems directly from Campbell's heroic example. The current vanguard of Scottish artists led by Christine Borland, Roddy Buchanan, Douglas Gordon and Ross Sinclair, among others, remain indebted to him for showing the way.

LINDA: Tell us about Campbell's contemporaries. This must have been an extraordinary time in Scottish art.

ALAN: Campbell's contemporaries – Currie, Howson and Wisznewski – were all significant artists in their own right. For all of them it was a time of reviewing and rejecting the past and making a new start.

SANDY: The young Ken Currie, writing in 1982, concluded that in Scottish painting, 'there are no great ideas expounded, no great themes explored, no issues, no opinions, no protests, no convictions. There is only paint. Formless masses of paint. In the rare moments when subject matter emerges, it is treated trivially.'

Currie was to play a significant role in the huge eruption of activity in the visual arts in Scotland in

3.36 Adrian Wiszniewski *b.*1958 Tuberbabes 2008

3.37 Ken Currie b.1960 Red Clyde: We can make Glasgow a Petrograd, a revolutionary storm-centre second to none 1987

the 1980s. His insistence on a figurative art, a narrative painting, a social aesthetic, all completed on a monumental scale, suggests the adoption of a MacDiarmid-like manifesto for visual arts. Currie's People's Palace History Paintings (1987–88) are remarkable achievements for a young artist. With them, he consciously sets about transforming Scottish painting.

ALAN: With Campbell's psychological exploration of the self and Currie's historical narrative work, you have two complementary aspects of Scottish character. I think if he had lived to see that, MacDiarmid would have understood and approved.

SANDY: It's as if Currie looks at the story of Scottish painting and decides certain things are lacking and that in itself needs to be addressed. The absence of an urban art, a type of painting which deals with the experience of the city, and therefore the modern world, gave Currie his chance. Although he references Berlin and Sarajevo, cities redolent of past and present tragedies, in his work of the late 1980s and 1990s, Currie's city is most definitely Glasgow, a Glasgow which in many ways closely resembles Edwin Muir's descriptions in *Scottish Journey* of 1935.

For Currie and for Peter Howson and others, the city defines and represents social existence. Within this existence, there lurk many realities, including the potential for despair and human destruction. As Tom Normand points out, 'This dialectic between the civilised and the barbaric, between progress and regress, the rational and the irrational, the ideal and the real, remains the fundamental tension that shapes Currie's art.' Currie – and Howson too – in doing this, were bringing to Scottish painting something completely new, something that hadn't been there before.

ALAN: Howson's work always confronts you with the question of power. The bullies, the hard men, the dispossessed, the heroic, even – or especially – the paintings of the pop singer Madonna – they all

3.38 Peter Howson b.1958 From the series 'Army Life' The Regimental Bath 1981

address this question of assertion, of strength and power. It recollects the Brechtian equation about identity and relates to Scotland that way too. Brecht said that identity was a function of position and position was a function of power. It's a pretty brutal thought.

LINDA: So it's about where you are?

ALAN: Of course. Where do you stand, Westminster or Holyrood? Perspective depends on location. Any artist will tell you that.

SANDY: Diego Rivera, Leger, Beckman, all influenced Currie and Howson, and Currie's initial commitment to communism meant that he was able to assimilate the theories of Gramsci, Brecht and Benjamin. Regular visits to Berlin to exhibit his work from the mid-1980s onwards allowed Currie to make other discoveries. He was deeply affected by artists from an earlier period, in this case 15th-century Europe – Cranach, Bosch, Van der Weyden and Van der Goes, gradually assumed a living presence for him:

> I began to identify more with this northern tradition in painting, where questions of the real versus the ideal were in my mind, slowly becoming resolved.

There was a kind of unflinching honesty in their work which shone down the centuries. The language used by these artists seemed completely fresh, relevant and even, dare I say modern.

For Currie, the task of forging a personal style of figuration that would be both convincing and modern remained, but like others before him the way ahead would take into account art made long before the 20th century.

ALAN: Again, it's about the importance of precedents.

SANDY: Of course, a great deal has happened in Glasgow since Campbell, Currie, Howson and Wisznewski revitalised Scottish painting, while at the same time gaining an unprecedented international reputation for Scottish art. Glasgow can now boast of over a thousand practising artists. It can also boast over a thousand millionaires! Without doubt, the re-emergence of Glasgow as a city with strong international links in the visual arts has helped to redefine perceptions of Scotland and this in turn has led to a growing number of young artists coming to live and work in the city. A far cry from the 1950s and 1960s, when there was little or no encouragement for contemporary art!

If you think of Douglas Gordon, in the first decade of the 21st century, he is probably the most celebrated contemporary Scottish artist – his

reputation in the art world is second to none. Yet this does not for one moment diminish his sense of his own Scottish identity and this is clearly recognised internationally.

In his introductory essay to Gordon's work, Klaus Biesenbach, the curator of the Department of Film and Media at the Museum of Modern Art in New York, considers the local and the global and observes that in the 1990s, cities such as Vancouver, Mexico City and Glasgow, which were not traditionally considered influential, developed art scenes that produced many of the decade's seminal artists. He further elaborates by stating that despite the illusion of a universal consumer-culture, all art practice seems local in origin. Gordon, he says, being Scottish, falls under the umbrella of the Anglo-American language and culture ruling the global market, although as a Scot, he is set apart from it by a slight shift that allows him to perceive geographies in terms of centres and peripheries. This disposition gives him a slightly different perspective on film, for example, than the one he would have if he were from Los Angeles, the centre of the industry's universe. So the Scottish viewpoint does matter, more than ever before.

ALAN: Maybe it's easier now for Scotland to be recognised in New York or Australia or China. London still has to catch up with this. It would all be pretty vulnerable, though, unless there was a corresponding political dimension.

SANDY: And there is. There is a continuing and media-conscious political dimension with the rise of the Scottish National Party, from its beginnings in the 1920s right through to the election in 2007 which returned a Scottish National Party government to Holyrood and for the first time saw the deposition of the Anglocentric, Westminster-based Labour Party.

LINDA: Right at the beginning of these dialogues, you were saying that at the end of the 19th and the beginning of the 20th centuries, there was an

3.40 Douglas Gordon b.1966 Confessions of a Justified Sinner 1995

intellectual and social vision, provided by such people as Patrick Geddes and Charles Rennie Mackintosh, and that there was a life-enhancing sensuality brought into the currency of Scottish art by the Colourists. I'm wondering, now that we're talking about the early 21st century, how that legacy has come through?

ALAN: Let me try to make it into an abstraction for a moment, a generalisation. Let's think back over the whole story, from Mackintosh and Geddes through the Colourists to Modernism in poetry and painting, through the contexts of the Highlands and Islands and of Scotland's cities in the aftermath of the Second World War, through from the 1960s to the beginning of the 21st century. We started with the light and colour in those early 20th-century paintings, the sensual pleasure you wouldn't want to be without, but you also need the intellectual engagement with social realities, you need to see the dark things, repressions, violence. You can't just look away from these. Art helps you face up to them. So the currency of art is always valid and that's why it's so important in education.

We live now in an age where the arts are massively trivialised and education undervalued. Unless you realise the good the arts can do, that will only get worse. Look at the way the arts are represented and conveyed throughout our education system, and throughout our public broadcasting and mass media systems. Look at what we take for granted every day, the quotidian, and look at what we consider to be exceptional, the eccentric. What can we say about what we're neglecting? And what about what we're normalising? The opportunity to do more and do better has never been greater – all the new technologies can help – but without a sense of the value of harmony and the value of disrupting that harmony, there's no progress at all. Harmony and its discontents – that's our story.

SANDY: Except that when we began, at the end of the 19th century in Scotland – or 'North Britain' – it was a very forced harmony. More like monotony. There certainly seems in some respects greater potential now for a more fruitful dialogue.

ALAN: In order to live creatively and fully you need to imagine what life might be like in the place where you live, not somewhere else. I think that's been helped, here in Scotland, by our resuming our own parliament in Edinburgh, but there's still a way to go and all the problems that don't ever go away. Alasdair Gray says in *Lanark* that Glasgow is 'the sort of industrial city where most people live nowadays but nobody imagines living.' What he's saying is the most important thing in all art, that art is there to help you to imagine living. It's as essential as procreation, food and shelter. Art – or rather, all the different arts – are there to help people to live. That's what they're for. And there's another essential, universal point in *Lanark*. Gray talks about his main character trying to sketch the Blackhill Locks. He says that he finds it difficult.

> He knew how the two great water staircases curved round and down the hill, but from any one level the rest were invisible. Moreover, the weight of the architecture was best seen from the base, the spaciousness from on top; yet he wanted to show both equally so that eyes would climb his landscape as freely as a good athlete exploring the place. He invented a perspective showing the locks from below when looked at from left to right and from above when seen from right to left; he painted them as they would appear to a giant lying on his side, with eyes more than a hundred feet apart and tilted at an angle of 45 degrees. Working from maps, photographs, sketches and memory his favourite views had nearly all been combined into one when a new problem arose.

The new problem is how to depict people in this vision.

SANDY: New problems always arise with the solution of old problems. That's the condition of making art, and why the artist is never satisfied with yesterday's work. And that should be a model for everyone. The problem is not only one of visual

perspective but also of emphasis and focus in time, in social position, in attempting to grapple with what it's like to be human. That's a terrific summary of the difficulty any artist faces when he or she makes a choice like that.

ALAN: Liz Lochhead has her own city poems and now there's a new development, because these are poems that could only have been written by a young woman, coming after that generation of poets whose voices are predominately male. The voices of women come through from the 1970s and 1980s much more clearly. For example, 'Something I'm Not'. At the heart of this poem is the question, 'How does she feel?' and what prompts that question is 'the sound of their talking' – the music, the tune of the voices of Liz's neighbour and her child. It's both that sense of neighbourliness and that sense that the music of the voice is what conveys a common humanity, a sense that 'Something I'm Not' is something you're going to become a little bit more familiar with, as you read the poem. All other things follow from that sense of connection. Just as the title of the poem,

'Something I'm Not' becomes the first line of the poem, as if the title is not actually a separate thing, but is itself connected...

Something I'm Not

familiar with, the tune

of their talking, comes tumbling before them

down the stairs which (oh I forgot) it was my turn

to do again this week.

My neighbour and my neighbour's child. I nod, we're not

on speaking terms exactly.

I don't know much about her. Her dinners smell different. Her husband's a bus driver,

so I believe.

She carries home her groceries in Grandfare bags

though I've seen her once or twice around the corner

at Shastri's shopping for spices and such.

(I always shop there – he's open till all hours

making good). How does she feel?

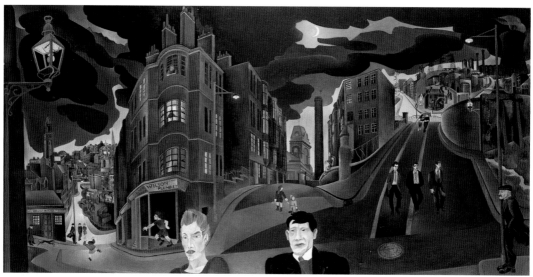

3.41 Alasdair Gray b.1934 Cowcaddens in the Fifties 1964

Her children grow up with foreign accents,
swearing in fluent Glaswegian. Her face
is sullen. Her coat is drab plaid, hides
but for a hint at the hem, her sari's
gold embroidered gorgeousness. She has
a jewel in her nostril.
The golden hands with the almond nails
that push the pram turn blue
in the city's cold climate.

SANDY: There's a younger artist I'd like to mention here, Shauna McMullan, who quotes from Liz Lochhead in her work 'Travelling the Distance'. This is a ceramic sculpture commissioned for the walls of the new Scottish parliament building and permanently in place there. It consists of a hundred short sentences by a hundred Scotswomen whose handwriting has been used as the sculptural model for an anthology of aphorisms representing a diversity of women's lives in Scotland's history. And it includes a few words by you, Linda!

LINDA: I was inspired by Flora MacDonald, the heroine of the Jacobite rising who helped Bonnie Prince Charlie to escape, and I wrote this: 'Who else, would have thought, to dress a Prince as a handmaiden?'

SANDY: Shauna herself says: 'Travelling the Distance' developed from a desire 'to create an alternative definition of a map of Scotland. One that wasn't predetermined or thought out by others, one that was fluid and active and specifically one that drew our attention to the gaps in the recording of women and their role within the creation of Scottish culture, history, politics and life.' She says that she was thinking of handwriting 'as a human medium and as drawing. As each of us thought about what to write we remembered, recollected and described details that we didn't want to be forgotten.'

3.42 Shauna McMullan *b.1971* Travelling the Distance 2006

3.43 Shauna McMullen *b.1971* Travelling the Distance (detail) 2006

ALAN: That's what our book has been about. That's what we've been trying to do in these dialogues and the lectures they're based on. That connection between the act of writing and the work of art – the work that art does – that sense of connection, across differences, takes us back to the three propositions MacDiarmid set out in February 1926, with which we began. Let me recollect those points:

> The Scottish Renaissance movement sets out to do all that it possibly can to increase the number of Scots who are vitally interested in literature and cultural issues; to counter the academic or merely professional tendencies which fossilise the intellectual interests of most well-educated people even; and, above all, to stimulate actual art-production to a maximum.

Well, here are the three questions that arise from this:

1. Have we an increased number of Scots vitally interested in literature and cultural issues?

2. Have we countered the academic or merely professional tendencies to fossilise intellectual interests, even amongst well-educated people?

3. Have we stimulated art-production to a maximum?

LINDA: So long as these questions are unanswered, I guess, the battle continues?

SANDY: We called this book *Arts of Resistance* partly because there will always be a need for the arts to provide forms of resistance to anything that dulls or numbs the intellect and the sensual understanding of the world.

ALAN: They are the only reasoning that matters and the only place where dreams are serious.

SANDY: So, yes, the battle continues, even though much has been won over the last hundred years.

ALAN: 'Literature is the written expression of revolt against all accepted things!' – as someone once said!

SANDY: If you look over the whole 20th century, there have been so many things that could bring you to despair or give you a sense of humanity's hopelessness, our capacity for self-destruction. And yet – and this isn't any compensation, it's just the way things are – if you look at the arts, the courage of MacDiarmid and MacLean, the inventiveness of Morgan, the determination of Bellany, you find ways of seeing what is valuable in life, what's worth celebrating, what counters the destructive forces.

ALAN: And there is no ending to what we can learn from that.

Select Bibliography

ALVAREZ, A, editor, *The New Poetry* (Harmondsworth: Penguin Books, 1962; repr. 1970)

AMIS, KINGSLEY, *The Letters*, edited by Zachary Leader (London: Harper Collins, 2000)

BARENBOIM, DANIEL and EDWARD SAID, edited by Ara Guzelimian, *Parallels and Paradoxes: Explorations in Music and Society* by (London: Bloomsbury, 2004)

BARENBOIM, DANIEL, *In the Beginning Was Sound: Reith Lectures 2006*, printed from internet site: http://www.bbc.co.uk/print/radio4/reith2006. Lecture 4: 'Meeting in Music'

BATEMAN, MEG, 'Skye & Raasay as Symbol in the Poetry of Sorley MacLean', in *The Storr: Unfolding Landscape*, edited by Angus Farquhar (Edinburgh: Luath Press, 2005), pp.91–96.

BECKETT, SAMUEL, 'Homage to Jack B. Yeats', in T.G. Rosenthal, *The Art of Jack B. Yeats* (London: Andre Deutsch, 1993), p.xi

BERGER, JOHN, 'A Story for Aesop', in *Keeping a Rendezvous* (New York: Vintage International, 1991), pp.53–81

BIESENBACH, KLAUS, 'Sympathy for the Devil', in Douglas Gordon, *Timeline* (New York: Museum of Modern Art, 2006)

BOLD, ALAN, *MacDiarmid: Christopher Murray Grieve. A Critical Biography* (London: John Murray, 1988)

BOLD, ALAN, Editorial, in *Rocket*, no.1

BROWN, GEORGE MACKAY, *Greenvoe* (London: The Hogarth Press, 1972)

BROWN, GEORGE MACKAY, *Magnus* (London: The Hogarth Press, 1973)

BROWN, GEORGE MACKAY, *For the Islands I Sing: An Autobiography* (London: John Murray, 1997)

BROWN, GEORGE MACKAY, *Northern Lights: A Poet's Sources*, edited by Archie Bevan and Brian Murray (London: John Murray, 1999)

BROWN, GEORGE MACKAY, *The Collected Poems*, edited by Archie Bevan and Brian Murray (London: John Murray, 2005)

CALDER, JENNI, *The Nine Lives of Naomi Mitchison* (London: Virago, 1997)

CAMPBELL, JAMES, 'The mythmaker' [on Seamus Heaney], *The Guardian*, 27 June 2005 pp.4–5

CARRELL, CHRISTOPHER, editor, *Seven Poets* (poems by Norman MacCaig, Iain Crichton Smith, George Mackay Brown, Robert Garioch, Sorley MacLean, Edwin Morgan; paintings by Alexander Moffat; photographs by Jessie Ann Matthew; essays by Neal Ascherson; interviews by Marshall Walker) (Glasgow: Third Eye Centre, 1981)

CRAIG, CAIRNS, *Out of History* (Edinburgh: Polygon, 1996)

CURRIE, KEN, *Stigma*, no.2 (Glasgow School of Art, November 1982)

CURRIE, KEN, quoted in Alexander Moffat, 'From Utopia to Apocalypse', in Catalogue of Ken Currie Exhibition, Raab Gallery (London, 1991)

DAICHES, DAVID, 'Appendix B' [Introduction to the second edition of 1953] in Hugh MacDiarmid, *A Drunk Man Looks at the Thistle* [fourth edition] (Edinburgh: The 200 Burns Club, 1962)

DAVIDSON, JOHN, *The Poems* (2 volumes), edited by Andrew Turnbull (Edinburgh & London: Scottish Academic Press, 1973)

DAVIE, GEORGE ELDER, *The Democratic Intellect* (Edinburgh: Edinburgh University Press, 1961)

ELIOT, T.S., *The Complete Poems and Plays* (London: Faber and Faber, 1969)

FERGUSSON, MAGGIE, *George Mackay Brown: The Life* (London: John Murray, 2006). See also online source: http://www.georgemackaybrown.co.uk

FRASER, G.S., *The Modern Writer and His World* (1953; repr. Harmondsworth: Pelican, 1964)

FRASER, PADDY, 'Memoir of G.S. Fraser' published online at: http://jacketmagazine.com/20/fraser.html

GARIOCH, ROBERT, *Two Men and a Blanket: Memoirs of Captivity* (Edinburgh: Southside, 1975)

GARIOCH, ROBERT, *Complete Poetical Works*, edited by Robin Fulton (Edinburgh: Macdonald, 1983)

GARIOCH, ROBERT, *A Garioch Miscellany*, edited by Robin Fulton (Edinburgh: Macdonald, 1986)

[GIBBON, LEWIS GRASSIC GIBBON] JAMES LESLIE MITCHELL, *Stained Radiance: A*

Fictionist's Prelude (1930; repr. Edinburgh: Polygon, 1993)

GIBBON, LEWIS GRASSIC, A Scots Quair, (1932–34), edited by Tom Crawford (Edinburgh: Canongate, 1995)

GARIOCH, ROBERT, Smeddum: A Lewis Grassic Gibbon Anthology, edited by Valentina Bold (Edinburgh: Canongate, 2001)

GRAHAM, W.S., Collected Poems 1942–1977 (London: Faber and Faber, 1979)

GRAHAM, W.S., The Nightfisherman: Selected Letters, edited by Michael and Margaret Snow (Manchester: Carcanet Press,1999)

GRAY, ALASDAIR, Lanark: A Life in Four Books (Edinburgh: Canongate, 1981)

GRAY, ALASDAIR, 'Picture Making: Infancy to Art School, 1937-1954', in Free Association, no.1 (2006), pp.31–33

HUNTER, JAMES, Last of the Free: A History of the Highlands and Islands of Scotland (Edinburgh: Mainstream, 2003)

JONES, DAVID GWENALLT (1899–1968), 'Rhydcymerau', in The Penguin Book of Welsh Verse, edited and translated by Anthony Conran (Harmondsworth: Penguin Books, 1967)

KITAJ, R.B., 'Verse 139', in Second Diasporist Manifesto (Yale University Press, 2007)

LARKIN, PHILIP, Selected Letters, edited by Anthony Thwaite (London: Faber and Faber, 1992)

LENMAN, BRUCE, Integration, Enlightenment and Industrialism: Scotland 1746–1832. The New History of Scotland series (London: Edward Arnold, 1981)

LOCHHEAD, LIZ, Dreaming Frankenstein & Collected Poems (Edinburgh: Polygon, 1984)

GRAY, ALASDAIR, Mary Queen of Scots Got Her Head Chopped Off and Dracula (Harmondsworth: Penguin Books, 1989)

MacCAIG, NORMAN, Far Cry (London: Routledge, 1943)

MacCAIG, NORMAN, The Inward Eye (London: Routledge, 1946)

MacCAIG, NORMAN, The Poems, edited by Ewan McCaig (Edinburgh: Polygon, 2005)

MacARTHUR, ALEXANDER and H KINGSLEY LONG, No Mean City (London: Longmans, 1935)

McCAULEY, JAMES, Charles Rennie Mackintosh: Glasgow School of Art. Architecture & Detail (London: Phaidon Press, 1998)

[MacDIARMID, HUGH] C.M. GRIEVE, editor, Northern Numbers, (series 1 and 2: Edinburgh & London: TN Foulis, 1920; 1921; series 3: Montrose, CM Grieve, 1922)

MacDIARMID, HUGH, Contemporary Scottish Studies (1926), edited by Alan Riach (Manchester: Carcanet Press, 1995)

MacDIARMID, HUGH, Scottish Eccentrics (1936), edited by Alan Riach (Manchester: Carcanet Press, 1993)

MacDIARMID, HUGH, editor, The Golden Treasury of Scottish Poetry (1940; repr. Edinburgh: Canongate, 1993)

MacDIARMID, HUGH, Lucky Poet: A Self-Study in Literature and Political Ideas Being the Autobiography of Hugh MacDiarmid (Christopher Murray Grieve) (1943), edited by Alan Riach (Manchester: Carcanet, 1994)

MacDIARMID, HUGH, In Memoriam

James Joyce: From a Vision of World Language, with illustrations by JD Fergusson (Glasgow: William MacLellan, 1955; repr. 1956)

MacDIARMID, HUGH, 'Foreword' in Poets to the People: South African Freedom Poems, edited by Barry Feinberg (London: George Allen & Unwin, 1974)

MacDIARMID, HUGH, Collected Poems, edited by W.R. Aitken and Michael Grieve (2 volumes, 1978) (Manchester: Carcanet Press, 1993, 1994)

MacDIARMID, HUGH, The Letters, edited by Alan Bold (London: Hamish Hamilton, 1984)

MacDIARMID, HUGH, Selected Prose, edited by Alan Riach (Manchester: Carcanet Press, 1992)

MacDIARMID, HUGH, Albyn: Shorter Books and Monographs, edited by Alan Riach (Manchester: Carcanet Press, 1996)

MacDIARMID, HUGH, The Raucle Tongue: Hitherto Uncollected Prose, edited by Angus Calder, Glen Murray and Alan Riach (3 volumes) (Manchester: Carcanet Press, 1996, 1997, 1998)

MacDIARMID, HUGH, Annals of the Five Senses and Other Stories, Sketches and Plays, edited by Roderick Watson and Alan Riach (Manchester: Carcanet Press, 1999)

MacDIARMID, HUGH, New Selected Letters, edited by Dorian Grieve, Owen Dudley Edwards and Alan Riach (Manchester: Carcanet Press, 2001)

MacDONALD, MURDO, Scottish Art (London: Thames & Hudson, 2000)

MacDONALD, MURDO, co-editor, with Joanna Soden, Lesley Lindsay

and Will Maclean, *Highland Art: A Window to the West* (Edinburgh: The Royal Scottish Academy, 2008)

MacDONALD, MURDO, 'Finding Scottish Art', in *Across the Margins: Cultural Identity and Change in the Atlantic Archipelago*, edited by Glenda Norquay and Gerry Smyth (Manchester: Manchester University Press, 2002)

MacGILLIVRAY, PITTENDRIGH, *Catalogue of an Exhibition* (Aberdeen Art Gallery 12 March-9 April 1988 and Barclay Lennie Fie Art, Glasgow, 22 April-14 May 1988)

McGRATH, JOHN and 7:84 Theatre Company, *The Cheviot, the Stag and the Black, Black Oil* (London: Methuen, 1981)

MacIVER, MARY, *Pilgrim Souls* (Aberdeen University Press, 1990)

MacLEAN, SORLEY / SOMHAIRLE MACGILL-EAIN, *Dain Do Eimhir agus Dain Eile / Poems to Eimhir and Other Poems* (Glasgow: Maclellan, 1943)

MacLEAN, SORLEY / SOMHAIRLE MACGILL-EAIN, *Spring tide and Neap tide: Selected Poems 1932–72 / Reothairt is Contraigh: Taghadh de Dhain 1932–72* (Edinburgh: Canongate, 1977)

MacLEAN, SORLEY / SOMHAIRLE MACGILL-EAIN, *O Choille gu Bearradh / From Wood to Ridge: Collected Poems in Gaelic and English* (Manchester: Carcanet Press, 1989)

MacMILLAN, DUNCAN, *Scottish Art 1460–1990* (Edinburgh: Mainstream, 1990)

McNEILLIE, ANDREW, 'Cynefin Glossed', in *Slower* (Manchester: Carcanet Press, 2006)

MASSIE, ALLAN, 'Mutual cultural respect is key to thriving society', The *Scotsman* (Focus supplement), 21 September 2006

MILLER, KARL, editor, *Memoirs of a Modern Scotland* (London: Faber and Faber, 1970)

MITCHISON, NAOMI, *The Cleansing of the Knife and other poems* (Edinburgh: Canongate, 1978)

MOFFAT, SANDY, 'Steven Campbell', *The Guardian*, 3 September 2007, p.36

MORGAN, EDWIN, 'Tom Macdonald 1914–1985', in *Tom MacDonald: Paintings, Drawings and Theatre Designs* (Glasgow: Third Eye Centre, 1986)

MORGAN, EDWIN, *Collected Poems* (Manchester: Carcanet Press, 1990)

MORGAN, EDWIN, 'Lines for Wallace', in *The Wallace Muse: Poems and artworks inspired by the life and legend of William Wallace*, edited by Lesley Duncan and Elspeth King (Edinburgh: Luath Press, 2005)

MORGAN, EDWIN, *Cathures* (Manchester: Carcanet Press, 2002)

MORGAN, EDWIN, *A Book of Lives* (Manchester: Carcanet Press, 2007)

MORGAN, EDWIN, *Beyond the Sun: Scotland's Favourite Paintings* (Edinburgh: Luath Press, 2007)

MORRIS, MARGARET, *The Art of J.D. Fergusson*, with a Foreword by Hugh MacDiarmid (Glasgow and London: Blackie, 1974)

MORRISON, JOHN, *Painting the Nation: Identity and Nationalism in Scottish Painting, 1800–1920* (Edinburgh University Press, 1998)

MORTON, BRIAN, 'The Past Master' [obituary of Steven Campbell], *The Sunday Herald*, 26 August 2007, p.37

MUIR, EDWIN, *Scottish Journey* (London: Heinemann and Gollancz, 1935)

MUIR, EDWIN, *Scott and Scotland* (London: Routledge, 1936)

NORMAND, TOM, *The Modern Scot: Modernism and Nationalism in Scottish Art 1928–1955* (London: Ashgate Press, 2000)

NORMAND, TOM, *Ken Currie: Details of a Journey* (London: Lund Humphries, 2002)

POINTON, MARCIA, 'The Representation of Time in Painting: A Study of William Dyce's "Pegwell Bay: A recollection of October 5th, 1856"', *Art History*, vol.1, no.1 (March 1978)

PREBBLE, JOHN, *Culloden* (London: Secker & Warburg, 1961)

PREBBLE, JOHN, *The Highland Clearances* (London: Secker & Warburg, 1963)

PREBBLE, JOHN, *Glencoe* (London: Secker & Warburg, 1966)

PREBBLE, JOHN, *Mutiny* (London: Secker & Warburg, 1975)

PENDREIGH, BRIAN, 'Braveheart', in 'The Top 20 Scottish Movie Moments', *The Scotsman*, 19 Mach 2007

PURSER, JOHN, *Scotland's Music: A History of the Traditional and Classical Music of Scotland from the Earliest Times to the Present Day* (revised edition, Edinburgh: Mainstream, 2007)

RIACH, ALAN, *Clearances* (Edinburgh: Scottish Cultural Press and Christchurch, New Zealand: Hazard Press, 2001)

RIACH, ALAN, *Representing Scotland in Literature, Popular Culture and Iconography: The Masks of the Modern*

Nation (Basingstoke: Palgrave
Macmillan, 2005)

ROBB, DAVID, Auld Campaigner:
A Life of Alexander Scott (Edinburgh:
Dunedin Academic Press, 2007)

SCOTT, ALEXANDER, Collected
Poems, edited by David S. Robb
(Edinburgh: The Mercat Press, 1994)

SHAKESPEARE, WILLIAM, King
Lear, edited by Russell Fraser (New
York: Signet, 1963)

SKOOG, DON, 'Art, Politics and an
Education in Havana' at website
www.contemporarymusicproject.com

SMITH, IAIN CRICHTON, Consider
the Lilies (London: Victor Gollancz,
1968)

SMITH, IAIN CRICHTON, In the
Middle of the Wood (London: Victor
Gollancz, 1987)

SMITH, IAIN CRICHTON,
An Honourable Death (London:
Macmillan, 1992)

SMITH, IAIN CRICHTON, Collected

Poems (Manchester: Carcanet Press,
1992)

SMITH, IAIN CRICHTON, Murdo:
The Life and Works, edited by Stewart
Conn (Edinburgh: Birlinn, 2001)

SMITH, SYDNEY GOODSIR, Carotid
Cornucopius (Edinburgh: Macdonald,
1964)

SMITH, SYDNEY GOODSIR,
Collected Poems (London: John Calder,
1975)

SMITH, SYDNEY GOODSIR, The
Wallace (Edinburgh: Oliver & Boyd,
1960)

SPENCE, LEWIS, Plumes of Time
(London: George Allen & Unwin,
1926)

SPENCE, LEWIS, Weirds & Vanities
(Edinburgh: The Porpoise Press,
1927)

STEVENSON, ROBERT LOUIS,
letter to S.R. Crockett, Spring 1888,
The Letters of Robert Louis Stevenson
Volume III. Tusitala Edition Volume

XXXIII (London: William
Heinemann, 1926)

STRAND, PAUL, Tir A' Mhurain – The
Land of Bent Grass: The Outer Hebrides of
Scotland (1962; repr. Aperture: New
York, 2002)

TAIT, MARGARET, Subjects and
Sequences: A Margaret Tait Reader,
edited by Peter Todd and Benjamin
Cook (London: LUX, 2004)

TONGE, JOHN, The Arts of Scotland
(London: Kegan Paul, Trench,
Trubner & Co, 1938)

TONGE, JOHN [writing as A.T.
Cunninghame], 'A Personal Note',
in Robert MacBryde, 1930–1966
(Edinburgh: New 57 Gallery, 1972)

WALTER, BRUNO, Theme and
Variations: An Autobiography (New
York: Alfred A. Knopf, 1946)

ZUKOVSKY, LOUIS, 'Influence' in
Prepositions: The Collected Critical Essays
(Berkeley, Los Angeles and London:
University of California Press, 1981),
p.135